MW00572689

My Good Bright Wolf

My Good Bright Wolf

A Memoir

SARAH MOSS

FARRAR, STRAUS AND GIROUX
NEW YORK

Farrar, Straus and Giroux
120 Broadway, New York 10271

An earlier version of "the run of herself" was published as an essay, "A Wolf in the Forest Wants," in *Granta* in 2022. A different approach to parts of "the run of herself" appeared in Sarah Moss's BBC short story series, *Accidents & Emergencies*.

Grateful acknowledgment is made for permission to reprint "Question" by May Swenson © 1954, 1978 May Swenson. From *Collected Poems* (Library of America, 2013). Used with permission of The Literary Estate of May Swenson. All rights reserved.

Library of Congress Cataloging-in-Publication Data
Names: Moss, Sarah, author.
Title: My good bright wolf : a memoir / Sarah Moss.
Description: First American edition. | New York : Farrar, Straus and Giroux, 2024. | Includes bibliographical references.
Identifiers: LCCN 2024016458 | ISBN 9780374614638 (hardcover)
Subjects: LCSH: Moss, Sarah—Childhood and youth. | Moss, Sarah—Mental health. | Memory. | LCGFT: Autobiographies.
Classification: LCC PR6113.O88 Z48 2024 | DDC 828/.9203 [B]—dc23/eng/20240523
LC record available at https://lccn.loc.gov/2024016458

Our books may be purchased in bulk for promotional, educational, or business use. Please contact your local bookseller or the Macmillan Corporate and Premium Sales Department at 1-800-221-7945, extension 5442, or by email at MacmillanSpecialMarkets@macmillan.com.

www.fsgbooks.com
Follow us on social media at @fsgbooks

10 9 8 7 6 5 4 3 2 1

This is a memoir in that it's an account of what I remember. Memory is fallible, eye-witness accounts differ, even or especially the closest people have incompatible stories of shared experience. Other characters in parts of this book have other memories of the events described; I speak only (at last) for myself. I write about contested memory, about cognitive impairment and mental illness, about dissonant voices in my head and in my world. I write about eating disorders and about madness and self-doubt and I am not recollecting in tranquillity. I have worked hard to hold space for the narrator's fallibility and for others' denial of her version of reality.

It seems unlikely that the recollection of dialogue from forty years ago is accurate, although I experience memory rather than invention. Others share my recollection of some more recent conversations. The only wilful invention is in changing names and blurring the identities of innocent bystanders. And maybe I made up the Wolf, or maybe the wolves made up the narrator.

Body my house
my horse my hound
what will I do
when you are fallen

Where will I sleep
How will I ride
What will I hunt

Where can I go
without my mount
all eager and quick
How will I know
in thicket ahead
is danger or treasure
when Body my good
bright dog is dead

How will it be
to lie in the sky
without roof or door
and wind for an eye

With cloud for shift
how will I hide?

'QUESTION', MAY SWENSON

'In her work, as in her private problems, she was always civilised and sane on the subject of madness.'

E. M. FORSTER ON VIRGINIA WOOLF

My Good Bright Wolf

all stories are true

In the middle of the journey of your life – at least, almost certainly more than halfway through – you found yourself in a dark wood.

Who do you think you are, Dantë? Shut up, no one cares what middle-aged women do in the woods.

The straightforward path was lost. You had to find another way.

It wasn't. You could have kept going if you'd tried harder.

You heard ancestral voices. They wouldn't stop, there were more and more of them, cacophonous. Curled in your ears, worming into your brain, breeding in your heart, eating you up inside, a parasite chorus.

You invented us. We're you.
 It's all in your head, you brought it on yourself.

No. You have to be allowed to speak somewhere. There must be some firm ground. Try again.

Once upon a time, deep in the forest, there was a wolf. A woman called for the wolf and the wolf came to her. There was a trail of breadcrumbs to a gingerbread house, there were three bowls of creamy porridge, there was a basket of currant buns—

Rubbish. They killed the last wolf long before you were born. You can't stop thinking about food, can you?

Try again. Remember that you're the narrator here.

Long ago and in another country, a baby was born in the big woods, the youngest of a poor woodcutter's many children. The family lived on the border, what's now the border, between Russia and Latvia.

Soldiers came. A pogrom.

There's no evidence. You don't know what you're talking about. It's not relevant.

The baby's mother put her into the arms of her neighbour, who was leaving. Save this one at least. They took a boat to Scotland. The baby grew up there. During the next war, she took a boat to New York.

Red herrings. Wild goose chases. You're inventing ancestors so you can blame them for the troubles you brought on yourself. Also you've skipped a generation, it was the daughter of the baby in the wood who went to New York.

In New York, the baby in the wood – or yes, all right, the baby's daughter, the dates do work better that way – met a man. A nice Jewish boy with a Russian name.

Ukrainian, you'll find. His brother fell off the paddle steamer leaving Odessa. You don't seem to care very much about the men in this story.

The Scottish Latvian woman and the Ukrainian Russian man married in New York and had two American-Scottish-Latvian-Russian-Ukrainian children. They changed their name to something less Russian. The firstborn was their best boy who became a doctor and married a nice Jewish girl and had nice Jewish children. Four years later they had the Owl.

They spoke Yiddish to each other when they didn't want the children to understand, but they made sure their sons spoke only English, ate American food and wore American clothes, went to summer camp and played baseball and bought corsages for the dates they took to proms.

Have you ever even seen a corsage? You're getting this from films, you have no idea—

The Scottish Latvian daughter of the baby in the wood was a difficult woman and a bad mother. Perhaps her mother had also been a difficult woman and bad mother. Perhaps they had their reasons, under the circumstances, for being difficult.

Excuses, you mean. She was crazy, cuckoo, loony. Wrong in the head. It runs in the female line, that kind of thing.

Soon the Owl saw that his mother was not only a difficult woman and a bad mother but the Wicked Witch of the West, and so he ran away, back over the sea to England, where he changed his name and ate pork and wrote a PhD in social science, tables and graphs for human behaviour, quantities, fact. He disliked England and the English, their lukewarm grey food and plumbing, the way they wouldn't say what they meant, but it was better than sharing a continent with the Wicked Witch. He met the Jumbly Girl, who was from Yorkshire and not Jewish, and he married her and moved to Scotland. He didn't like Scotland either.

Yes he did, he liked the Scottish mountains, he just didn't like the Scots, the same way he liked Switzerland but not the Swiss and later Japan but not the Japanese.

The Jumbly Girl was also writing a PhD, though hers was on medieval art, not one table or graph. She came from Leeds, in Yorkshire, in the north of England. In hard times her people had lived on bread and margarine, gone barefoot.

Nonsense, you've been reading too much George Orwell. Your great-grandfather worked in a tannery, of course no one was barefoot. And they probably chose bread and margarine, they liked awful food. You're just claiming working-class credentials by proxy, as if their hard work excuses your privilege.

They were small businesspeople, enterprising. Some of them left for Australia. Rickets and stunted growth, for those who stayed, stunted education, but still as a teenager your grandfather cycled to Hull and persuaded a trawler to take him on. He didn't want to be a fisherman, he wanted to travel. He saw the coast of Iceland before seasickness got the better of him and he gave up and went home.

That doesn't sound very likely. Why do you need all these travelling forebears? Can't you just admit that you're pathologically restless, can't settle, keep a bag half-packed and a line of sight on the door? Not very nice for your children, growing up like that. It's your problem, a difficult-woman problem, nothing to do with your grandparents.

You had the story about Iceland from your grandfather's own lips, so if eyewitness testimony is truth, even when written down forty years later by someone who was a child at the time and already given to storytelling, it's gospel, gospels being of course also eyewitness testimony written down decades later by people given to storytelling. The rickets and stunting were written in your grandfather's body, in his short stature and bow legs, though there is no evidence of that now, only your word for it. Even now, writing this, tears form as you say that his bones were made ash twenty years ago, as you recall his Easter funeral, the smell of narcissus, the warmth of your infant son against your shoulder. True tears dropping, though like any novelist you are inclined to exaggeration and may be putting it on a little, who knows?

Your tears don't make anything true. You cry on purpose, to get sympathy. There were no flowers in the church, it was the day after Good Friday when churches are bare, and your son slept all morning in his pram.

Your grandfather had a childhood sweetheart. They were twelve when they met, just before he left school. She stayed on, eventually won a rare scholarship to university, but her father wouldn't let her go, no point educating a girl. She did teacher training instead, became a primary school teacher, a better job than her parents had imagined.

As poor boys in stories often do, your grandfather went to be a soldier in the War. Well, joined the Air Force, to be exact, and somehow arranged matters so that the Air Force trained him as an accountant, and also let him travel: Italy, Egypt. You have seen the evidence for this part, the primary sources. Military organizations are good record keepers, when it suits them.

He learnt to ski, to drink wine.

The sweethearts waited until after the war to have just one child, so they could focus everything they had, everything they could work for and buy, on making sure their best girl and her children and her children's children would have a life better than theirs and their parents' and their parents' parents. She had elocution lessons, ballet, tennis. They paid for her to go to the best school in town where she worked very hard and was the best girl and then she went to university where she met the runaway son of the wicked witch.

She didn't, that was later, another university. She met other men first. Maybe she should have married one of them.

The sweethearts did not want their best girl to marry the Jewish American (Russian-Latvian-Ukrainian-Scottish) runaway son of a wicked witch. Your poor children, they said, will be neither one thing nor the other, not like us and not like them. She defied parents who had only ever wanted what was best for their golden-haired best girl, only ever wanted her to be happy. And prosperous and successful and pretty and thin and good at tennis and ballet and elocution and keeping a clean tidy house while married to a Yorkshire Gentile bank manager or maybe a doctor. You do not know what the wicked witch wanted for her runaway son because you never met her, but plainly she did not want him to cross the ocean and marry the not-Jewish best girl and have not-Jewish children and probably that is one of the reasons why he did it.

You were born there, in Glasgow, to the Owl and the Jumbly Girl. You looked like the Wicked Witch, with your dark hair and big nose. You were like her from the beginning. A man can cross oceans and change his name and renounce his faith but he cannot stop his daughter being like his mother.

Women are all the same. Mothers are shape-shifters, poltergeists. You can't escape them, even when they die.

Speculation, all this, or opinion, anyway. Interpretation, one could say. Plainly, probably.

Always distrust adverbs.

You just invented that.

All stories are true.

Some would disagree.

All narrators are Cretan liars.

I

Unreliable narrators: inventing

power cuts

Scotland, winter.

Mid-seventies. Oil crisis, power cuts. Put another jumper on, coats indoors.

You arrived early. You would always arrive early.

Blue hands, smaller than starfish. Blue lips, crying and crying, day and night.

She wanted to feed you. She wanted to be good at it.

You were not good.

Bad at milk, bad at sleep.

Failure to thrive, failure to feed, failure to please.

You made the Jumbly Girl unhappy. You made her cry.

The Owl left in the morning and came home in the evening and she was sitting in the same chair and you were still screaming but now she was crying too.

goblins cry

Your grandmother came.

Your grandmother pushed the pram down the road to the pond. There were seagulls. You liked the seagulls, pointed and called to them.

Your grandmother rocked you. She sang to you.

She fed you, on apple purée because you were bad at milk and the Owl didn't want you to have rice, to love carbohydrates and get fat like the Jumbly Girl.

Rubbish, he has no memory of this.

How does he know it's rubbish if he has no memory of it?

You can't remember it either, you were four weeks old.

She told you. The Jumbly Girl and your grandmother both told you, separately, later, when you wouldn't wean your own baby at four weeks.

Oh no they didn't.

Your stomach hurt.

You can't possibly remember that.

Your grandmother held you while you cried. She rubbed your back. She said Up the airy mountain, down the rushy

glen, we daren't go ahunting for fear of little men. She said *Morning and evening, maids heard the goblins cry.* Don't tell her that one, the Jumbly Girl said. She did not like goblins, did not approve of fruit, certainly did not like poetry.

Nonsense, she's eaten fruit almost every day since rationing ended.

What figs my teeth have met in. Pears red with basking.

Anyway, she did like poetry. Edward Lear, don't you remember? Colour illustrations, all the creatures more cute and less sinister than they sound. The Pobble who has no toes had once as many as we. The Owl and the Pussy-cat went to sea in a beautiful pea-green boat. For day and night he was always there, by the side of the Jumbly Girl so fair, with her sky-blue hands and her sea-green hair.

Odd, now you think, nonsense verse in a house with no tolerance for foolishness.

So maybe you're wrong.

Your grandmother went away, back to her house in the lowlands. Farming country, cows. A sycamore tree full of rooks.

When you were two, the Owl found a song to make you cry.

Poor little lamb has lost its way, baa, baa, baa.

He sang it.

You cried.

He laughed.

He sang it.

You cried.

He laughed.

Was it the wicked witch who laughed at his tears, before he learnt not to cry?

Your brother came, invited, timely, welcome. Angel Boy.

He did not turn blue *you do these things on purpose, to get attention.*

He was good, at milk and sleeping. Soon he had blond curls and blue eyes. What a beautiful baby!

You did not like the Angel Boy.

The next summer, you drove from Manchester to the south of France, all of you in the rusty red car with the shiny black plastic seats, the tent and primus stove and sleeping bags in the back. If you wound down your window, the Jumbly Girl complained that the air banged in her ears. When she wound down her window, the air rushed in your eyes. The shiny black plastic became very hot in the French sun. The Angel Boy always slept in the car but you were bored, demanding, argumentative.

You camped by the beach in France. There were big waves. The Owl took your hand, tried to carry you, but you were too scared, salt in your eyes and the whole ocean coming for you. You kicked and screamed and cried. You were no fun. The Angel Boy was bonny and bouncy and brave. You waited on the beach while they carried the Angel Boy through the breakers and swam away. You sobbed and

wailed that they were going to swim to Africa and leave you.

For them this is a story about your innate neurosis and precocious knowledge of Mediterranean geography. For you it is a story about a child who believes she will be abandoned.

Both, of course. It's both.

They're gods and monsters, your mum and dad, mythological. Larkin was right, they were fucked up in their turn, by fools in old-style hats and coats. Fools who taught them, one way and another, that love takes the forms of surveillance and judgement, that children will stay dependent and needy forever if not forced to grow up. Fools who taught them that care and attention are scarce resources, not to be wasted on the undeserving. And maybe they're not really your parents, the Owl and Jumbly Girl, not really human at all, just voices in your head.

Maybe you invented them, after they invented you.

If you can, it's best to meet your parents again later, when they're older and more gentle, best if you can see the god-mask and the monster-mask and the children they were, howling in the dark and attended by gods and monsters of their own.

homage to the plastic ballerina

You dance for your grandmother, bonny lamb. Like an old-fashioned theatre, her garden has three curving terraces. The dahlia bed, the vegetable bed and the greenhouse for tomatoes lie below the hedge, groomed grass and a fishpond in the circle, paving and a rockery in the stalls. Your grandmother is in the stalls in her favourite pose, sitting with her feet up in a reclining deckchair, knitting in her hands, watching.

You use the whole double curve of the lawn, leaping over or jumping up stone steps lined with alpine flowers, gentians and edelweiss and aubretia. You spin the length of the garden with your arms wide, practising flicking your head at the last minute as you turn although you don't mind if you get dizzy, you just incorporate it into the dance.

You like dizziness. You like the bodily weirdness of going over bridges too fast in the car, getting hiccups, poking your bellybutton for the sharp tug in your guts. You like to hyperventilate until you see dots, to pull yourself higher and higher on the swings as seasickness builds, to practise until you can stand on your head and feel the blood thicken behind your eyes.

You waltz, approximately, pirouette in homage to the plastic ballerina in your music box, polka across the daisies.

There's no music in your head and you're not planning moves, just dancing for your grandmother on a sunlit afternoon, dancing for the tree and the rooks and the sunlight through the leaves, and over her knitting your grandmother admires and applauds.

wolf far thence

It was you who wanted to do ballet.

The lessons were held on Saturday mornings in the community centre, the one behind the library where the Jumbly Girl went on Thursday evenings to do Keep Fit with the other angry housewives. You had to have a pink leotard, white tights and special pink leather shoes with suede soles whose cat's-nose fuzz was soon overlaid with grit from the floor of the community centre. The shoes hurt because your feet were too wide, because even your toes were too big. She had to take you to the special shop in the next suburb for the leotard; the black one you had for school gym lessons wouldn't do, and it was expensive and also made of horrible synthetic fabric, like the carpets in other people's houses and the clothes worn by tarty women.

You were terrible at ballet. You can't say you weren't warned.

You stood in the back row, hoping that if you copied the competent little girls in the middle row and they copied the fragile blondes in the front row, some of it might seep back, the fragility and the blondeness, the Sleeping Beauty Cinderella blue-eyed Gentile suburban über-whiteness.

You couldn't tell right from left, still can't, so you were always a beat behind, had to wait to see which arm everyone

else moved. The teacher shouted at you. Stupid, clumsy. You deserved it. Soon your grandfather would teach you to tell the time, though you'd never know clockwise from anti-clockwise without looking at a clock, and then he would give you a watch for your left wrist. Soon you'd have a big scar on your left leg. Later you'd have rings, also to your left, but for now, unscarred, unadorned, you had no cardinal points for your body.

You had stocky muscle in your arms and legs, all that hiking and tree-climbing, the way you loved to swing for hours, the way you worked on headstands and cartwheels and backbends, the way you tucked your skirt over your knickers so the boys wouldn't see them when you threw yourself into handstand after handstand against the smoky brick wall, hands on the playground tarmac, the way you spent your school dinnertime skipping in the playground with the other girls, chanting, Nebuchadnezzar, king of the Jews, bought his wife a pair of shoes, when the shoes began to wear, Nebuchadnezzar began to swear. Lizzie Borden took an axe, she gave her mother forty whacks. You were one of the best at skipping, could jump double ropes, keep going for hours, but skipping didn't count, cartwheels and headstands and handstands didn't count, what counted was pointy toes and wisps of pink, pallor and delicacy, and you weren't pale or delicate, you were fat.

You had to be kept away from food, couldn't be trusted, just like your mother. It was only the adults' watchfulness that stopped you eating everything and becoming huge, and it worked, mostly. The labels in your shop-bought clothes – underwear, nightclothes, other things were home-made

– matched your age at the time of purchase though you wore clothes for years, until they fell apart.

So? Is that an accusation? Better to throw things away when they're still serviceable, is that what you mean? Wicked waste, typical.

You always had to be told, that food isn't for you, you shouldn't be eating that, stop now, so of course you couldn't do ballet, who did you think you were?

You can't say she didn't tell you.

There were performances, winter and summer, Christmas and the village show, though the village had been swallowed by the city a century since. Although you were always at the back, concealed in the middle of a troupe of regrettably galumphing dolls or mice, you still had to have a new costume each time and she still had to buy the fabric and make it for you.

It was all your idea.

Of course she did it beautifully, double French seams, stripes properly matched, it was just that ballet was wrong, wanting to do ballet was wrong, the sign of a weak mind already in thrall to pink frills and vapidity.

They always let you do the wrong thing, they were scrupulous about it, gave you enough rope to hang yourself as often as you liked and stood back to watch, peanut-crunching crowd.

They meant well.

Folk always do.

You've no one but yourself to blame.

The thing is she was right, wasn't she, her second-wave feminism was on the mark. Those suburban ballet classes

were an induction into forms of femininity that had done her and would do you no good.

You could never be small enough, blonde enough. Your very bones took up too much space. Your hair was almost black, your nose too big for your face, your chin double.

You can't comfort her now, that clumsy dark heffalump who wouldn't give up, wouldn't read the writing on the wall, but if you could go back, if you in midlife could send an emissary, a familiar, to you in childhood – well, why not, it's not as if any of this is true anyway, it's not as if you're not making things up, you and your gods and monsters, your ancestral voices heard from far. Let's do it.

What shall we call into being? We don't want anything cute or cuddly, nothing sweet, this is dark work we have in hand, ugly business. Carrion crow, picking over the bodies after the last battle.

Exactly, ugly business. Why are you doing this, raking up what you claim happened forty years ago? Aren't you ashamed, telling tales? Shouldn't you have got over it, whatever you say it was, by now? Normal people move on, let sleeping dogs lie. There's something nasty here, something wrong in your head.

But the dogs aren't sleeping. Those dogs never slept, all these years a restive pack, eyes open, ears cocked, and you trying to creep past, hoping if you're quiet enough and small enough maybe they won't wake up and bark, maybe they won't lunge and snap, but every few years they came for you, came hunting, came running fleet through the dark

wood to the dog-whistle of your ancestral voices and you fleeing, stumbling, roots reaching for your feet— *Hysterical. Told you so.*

You need a reverse ghost here, a present voice to haunt the past. A raven – a real one, true-life – used to accompany your pre-dawn bike rides to work down the coast path from Hafnarfjördur to the university in Reykjavik in the year of the financial crisis, flying ahead and waiting on a street light, criticizing your slowness or your unsuitable shoes as you approached, fluttering on, but you've used him already, in another book. Could there be a turncoat dog, a double agent, one of those they send with shots of brandy to people under avalanches in the Alps? St Bernards, that's it, but you're terrified of dogs now and were terrified then, would frankly rather die under the snow than have one of those come at you. You've told your husband, if it ever arises – unlikely, you don't ski – just leave me there, no dogs.

Could you have a wolf? It's a little obvious, Red Riding Hood, Three Little Pigs, can't put it on the cover, but there's a real one later, cross your heart. And it was one of the first poems you learnt, But keep the wolf far thence, that's foe to men, For with his nails he'll dig it up again – let's dig, Wolf, let's dig it all up, let's open the graves and see where the voices lie.

Call her up, your wolf, your she-wolf, your wolf in lamb's clothing – mutton dressed as lamb – and send her back down the years. Summon her clacking claws, her coarse pelt, her slinking tail, send her back and say to that sad child: no, you're not allowed to do ballet, not because ballet

is bad or because you are bad but because it will make you miserable now and later; how about circus skills or roller-skating or mucking about with your friends in the street? Let's say: you're strong, not too big. Don't worry about that, it's not interesting. The Jumbly Girl didn't, couldn't, say such things, not to you and not to herself. No one said them to her. Yes, but it's a pity she's so fat, you overheard your grandmother say to a friend who was praising the Jumbly Girl's PhD. Will you only look at the way she thickens and thickens the butter on her bread?

You both had to live in a time and a place where people or at least women didn't like themselves, or if they did, concealed their self-esteem with rigour. Northern England, white, insecurely middle-class, aspirational, justification by works. Your grandfather told you stories about magic animals, a bird who flew from the top of the tallest tree in the tallest wood to rescue creatures in trouble. Your grandfather, maybe, liked himself by then, self-made man, Yorkshire poverty pulling itself up by the bootstraps. His self-confidence was one of the reasons the Owl disliked him. Bumptious little man, the Owl said, who does he think he is? Your wife's father, that's who, the wolf would tell him, your children's beloved grandfather who appears to like them more than you do, so show some respect.

You can't send familiars to other people, it doesn't work, but nevertheless we should have the wolf remark to the Jumbly Girl as she passes: your children can't like themselves more than you like them. For better or worse, the children the Owl and the Jumbly Girl endured were the children they invented.

You're the one inventing things. You're the professional liar. You invented us.

The Jumbly Girl was a feminist, and in those years stuck at home. She taught for the Open University one evening a week, when you stood in the bay window crying as she backed down the drive, as if you thought she wouldn't come back. As if you knew she didn't want to come back. You never saw her read, but there was a worn copy of *The Female Eunuch* next to *The Joy of Sex* on the sitting-room bookcase. Your grandmother had been the first woman to return to work for Leeds City Council after having a baby. Her mother had been a dressmaker, working mothers as far back as the story goes. You come of hard-working women, organized and brisk. The northern Protestant work ethic fused with second-wave feminism. No fragility, no weakness, no excuses.

Pull yourself together, get on with it. Being a good feminist was like being good at anything else; it required self-discipline, self-denial, hard work, and the reward was moral superiority. It wasn't supposed to be fun.

Not much was supposed to be fun, the wolf might observe as she trots by.

Feminism couldn't rescue you, or indeed her, fuming there in suburbia with her PhD going mouldy while she made clothes and kneaded bread and planted vegetables and dug ponds and climbed mountains, played the guitar and the piano, gave parties and dinners, volunteered to teach literacy in prisons until she started volunteering as a magistrate and met some of the men she'd sent there in the first place, not a good look, anything to avoid being stuck between four walls with two small children.

Joy was missing from the story, hers and yours. Let's put some of that in a little barrel and have our wolf carry it back in time. There was a choice between being right and fitting in, and the Jumbly Girl chose to be right and you chose to fit in. Neither of you enjoyed it.

the one playing

The Jumbly Girl didn't like weather, didn't have the Owl's appetite for wind and rain, though she had to climb mountains in all seasons like everyone else, because people who didn't were weak and self-indulgent and lazy. With the Owl out at work, you and the Angel Boy and the Jumbly Girl spent wet weekdays in the living room, which was a combined craft and playroom where she cut and pinned dressmaking fabric among the Lego and felt pens.

Yes, it was a big house. You grew up in a big house.
What a lucky little girl.

She was thrifty, always. Yorkshire lass. Found roll-ends of Liberty lawn at the market, sari silk in Rusholme where there were also milky, syrupy sweets that were sometimes allowed because they were Indian and so it was broadminded to enjoy them when the same ingredients in traditionally English form betrayed nursery tastes, not that the Jumbly Girl didn't love a rice pudding if she thought she could get away with it. Yuck, the Owl said, urgh, disgusting, bland English frogspawn slop, dairy and sugar, pure carbohydrate, and then you wonder why you can't lose weight? On rice pudding days you were good like the Owl, didn't want it anyway, not after having to deal with the version served at school.

You and the Jumbly Girl liked the colours and patterns

and textures of cloth. At four you could pin pieces together, thread a tapestry needle, sew a crooked seam. At five you made cross-stitch bookmarks and coasters. At eight you were making your own soft toy animals and by ten you could scale up a pattern from a book and dress your home-made toy rabbits and cats in frilled pinafores and tailored jackets, give them moving joints, put long silk hair and embroidered faces on rag dolls. You made your own fun, and it was fun, there was and is pleasure in making.

Joy after all then, no?

She made everything: pickled pears, sleeping-bag liners, Aran jumpers, papier-mâché Christmas decorations, your duffel coat with a polished horn toggle you couldn't help but suck. Later: soap, paper, natural dyes for homespun wool. There was a miniature mushroom farm in the window-less pantry, in the cellar an enamel pan used as a dye vat in winter and sometimes as a paddling pool for you and the Angel Boy in summer, in the box room beside the Owl's study a loom strung like your Welsh godmother's harp. But still she simmered, hauling her way up the steep hours of day after day in suburbia, pushing the rock of her resentment towards six o'clock when they had agreed that the Owl would take over. You wouldn't understand until you had your own children, in another era with parental leave and childcare and a partner willing to share the hours, that it wasn't you but mid-century maternity she couldn't bear.

There was no loom. Why have you invented a loom? She didn't have a loom until years later. You're telling lies again, how do you think you make us feel?

Other people, eyewitnesses, would tell it quite differently, this story, you have no right, no right at all, you always make stuff up, you can't resist—

It's not that you don't understand, now, her rage and frustration, her need to get away, that it wasn't personal, that you were in the wrong place at the wrong time (though hadn't she brought you there and then, hadn't she made you; you never asked to be born though to be fair she never asked you to be born either, neither of you intended the situation). She'd say to you once, decades later, while she was doing her level best to care for her own mother, *I just can't bear to have people depend on me, I can't stand it*, and you'd feel the millstone around your neck lift a little: perhaps not your fault, your defect, after all. You were just the one playing the child in the psychodrama of her marriage and maternity, in the story of a generation of women generously educated right to the doctorate by the welfare state and then walled up upon marriage, baited and switched, trapped after all.

Still, you were the trap.

pickles

You had started school. It was at the end of the street, one road to cross – you'd heard the bells and the children playing out for years – which meant you could walk there and back on your own. There was a uniform which most children wore, but it wasn't compulsory and you and the Jumbly Girl agreed that the clothes she made you were far better. You had a tiered pinafore dress, a new section in a new Liberty print off-cut added when you grew. You had a raspberry-pink Clothkits dress with rows of blue tulips across the yoke, and lined pockets for your treasures. You had a soft Paisley blouse with velvet ribbons to fasten the neck.

You said you weren't allowed frills, you said there were no pleasures.

Some of your friends from playgroup were there, and the kids from your street. The boys zoomed around the playground with their arms spread, making aeroplane noises and dropping bombs. They were still bombing Cologne and Dresden, though most of their parents hadn't been born at the time. Sometimes they were on horseback with guns and lassoes, cowboys and Indians, which they must have learnt from television programmes.

Friends and enemies, people like us and outsiders.

Soft power and hard, imperialism of one kind and another.

The girls skipped or did handstands or played at fairies and princesses, role-play that rolled from week to week with you as narrator, director, storyteller. There was a fairy palace whose court politics were Tudor, ugly sisters, wicked step-mothers, curses spoken over cradles, witches and ghosts. You veered between balletic fantasy and a compulsive interest in the return of the repressed.

In both your clothes sense and your narrative tendencies, it could be said that not much has changed.

The stiff nylon uniform was optional, but school lunches, called dinners, were compulsory, and there were dinner ladies whose job was to compel. You had to finish what someone else put in front of you, which was a bizarre idea to a child otherwise encouraged to eat as lightly as possible. Plastic trays on plastic tables set out in the sports hall that did duty for lunch and assembly and music, the smell of sweaty feet blending with old fish and liver, substances presented for eating when they didn't look or smell like food. Spam fritters, rehydrated mashed potato, blancmange.

It was the days of BSE, cows fed on pellets made of cows' brains, children fed burgers made of cow-carcass slurry. Every dish was or resembled diseased organs. They were quite right, the Owl and the Jumbly Girl, to stick to the home-grown and home-made.

You could not, would not, sat there with sealed lips until the sights and smells and the revulsion of other children being forced to eat made you vomit. Sometimes you ran away, wriggled through the railings and scudded down the leaf-strewn pavements home, where the Owl was out at work and the Jumbly Girl made you a Marmite sandwich

on proper home-made bread and took you back for the afternoon.

The Jumbly Girl had an idea. If you would stay for two school dinners, she would take you out of school to the wholefood vegetarian café you both liked for lunch on the third day. The Angel Boy was not part of this complicity; she must have made an arrangement.

You took the bus into town, front seats, top floor. Real food, vegetables and nuts and pickles. Carrot and coriander soup! You'd thought you didn't like soup, floating lumps, but this was silky, aromatic. Butter on the bread, where the Owl allowed only margarine. She let you have dessert – flapjack, carrot cake – while she ordered coffee.

Then it was three school dinners, and then four. You learnt how to drop your Spam fritter on the floor, how to spread the blancmange around the grey-scratched white bowl, or slip it to Gareth who would eat anything. You'd eat some of Lulu's custard if she'd make your potato croquettes in their brown crumb carapace go away.

The deep-fried things were particularly appalling, something about the fresh hell of the innards. At least with custard there were no surprises.

The week before Christmas, the dinner ladies held Sharon down in her chair and forced liver and bacon into her mouth as she fought and wept and the rest of you watched. Sharon vomited and they pushed it back in. She cried so much she had to go home.

Sharon was Jewish.

In January, packed lunches were allowed. Words had been had. The Jumbly Girl made you sandwiches with home-made

bread and your grandmother's piccalilli – you have always loved pickles, the sharper the better – and the red-waxed Edam that betrayed your nursery taste, but she bought it anyway. Sometimes you had chopped herring on caraway-flecked rye bread from the Polish deli where the owner had numbers tattooed inside her wrist and liked to give you a handful of fudge with the cow on the wrapper. Lulu and Kay said urgh, raw fish, urgh no, she's eating it. Lulu and Kay had jam on white bread, Penguin bars, juice boxes. Friends and enemies, people like us and outsiders, but you stayed friends, they needed you to be the narrator.

bomb shelters

You couldn't read. Everyone else could read. Almost everyone else had been able to read for a whole year. *You're just not trying, are you, you just don't want to do it*, but you were trying and you did want to do it.

Hot shame, your stupidity unbearable, sirens going off in your head every time you tried, louder and louder. Fat and stupid, liar, not trying hard enough. You cried, hysterical, no self-control.

The Owl and the Jumbly Girl couldn't bear your dullness. She's not stupid, they insisted to your teacher, to Mrs Edwards, who had told them that you would probably never learn to read or write or do numbers, that you were *retarded*. They were clever, the Angel Boy was clever. Your stupidity was inadmissible. You were inadmissible. You cried, the Owl shouted, you cried more and he shouted more. You're clever, they said, very clever, as though they could invent their daughter's cleverness by insistence. How were they to know that it would have been better if they'd loved your stupidity?

Let's call up the wolf again, let's send her to say: you are lucky and one day you will be clever, it so happens that your brain can and will produce thoughts that other people, examiners, can quantify, but mostly clever is a word to make some people feel better than other people. It is important to some people to feel better than other people but it isn't

and won't be important to you. You can let go of that. It's not yours. You'll learn to read when it's safe for you to show weakness, and one day you'll read Virginia Woolf who will explain 'the enormous importance to a patriarch who has to conquer, who has to rule, of feeling that great numbers of people, half the human race indeed, are by nature inferior to himself.' Meanwhile, know that most people in most of time and the world didn't read or write and they weren't stupid or worthless, just doing other things, remembering and telling stories in other ways. Writing is a technology of memory but it's not the only technology of memory.

And it's used for lies, isn't it? You're not remembering, you're fabricating, literary flourishes, I suppose you'd claim, but other people know what it is. Truth matters, detail matters. If you believe this rubbish you're crazy and if you don't you're a liar and either way it's not nice for the rest of us.

The Owl read to you at bedtime, mostly the classics of his American childhood. *The Red Pony, The Mouse and his Child, Huckleberry Finn* with the racial politics carefully explained. He had been a Freedom Rider in 1960s Mississippi, but that history was hard to understand at a school where a white child could believe it when she was told there was no racial hierarchy. There was one Black child in your class, but he was a boy and interested in football, out of your orbit. Another class had a Black teacher whose clothes you remember admiring, understanding now and not then that as the only person of colour in the staffroom she had her reasons for dressing so carefully. When you all sang *The ink is black, the page is white, together we learn to read and*

write, the song made no more or less sense than many things the grown-ups required and it didn't occur to you that the white children were the pages and the Black children were the ink, or that the words were supposed to address a problem other than illiteracy. Checking now, your remembered dimness is inexplicable; the song, written to celebrate the desegregation of American schools, continues to hymn the 'beautiful sight' of Black and white children sharing a classroom and growing together 'to see the light.' British schools had never been segregated and you had heard of racial segregation only when the Jumbly Girl explained the Owl's boycott of grapes from apartheid South Africa. The curiosity you brought to stories and art and museums must have failed at school, or you were too absorbed in your imaginary life to pay attention to other people's realities.

Now you know more about the lives of people of colour in 1980s England, you wonder how and why you were able to remain oblivious to what was happening around you, in a city with a significant British Asian and Black British population. The Owl alerted you to the politics of race, at least, in an environment where it was taken for granted that nice people didn't mention skin colour, that it was rude to notice paler and darker skin but necessary to judge larger and smaller bodies, as if one form of supremacy could be separated from another. In your community, being Black or Asian was treated the same way as having toothpaste on your sweater or buttons undone; well-mannered people knew to ignore it, which meant, you see now, that it was well-mannered to pretend everyone was white, to silence and erase all other realities. The only vocabulary for race

was racism, which was a failure of manners as much as morals. No wonder your curiosity failed. The Owl didn't do that. He often didn't behave like a well-mannered person, didn't seem to understand what was unmentionable, which caused no surprise because he was American and bearded and professorial, exempt on several grounds.

You liked being read to, felt safe in the curve of his arm with his beard brushing against your hair and his American voice holding the upstairs ghosts at bay, but you had no purchase on the sweeping landscapes and the quests of boys who thought in another kind of English. It was as if he was trying to hold open a door to a room that was in another building.

The Jumbly Girl did not read to you, nor, so far as you knew, to herself. She did not tell stories. She did not play. When she couldn't get away from the house and from you, she was productive. She improved every golden minute. Shop-bought bread was white and nasty, so she made her own. She taught you to stir the yeast, like grey clay, into warm water with – don't tell the Owl – a teaspoonful of sugar to see it on its way. She taught you to knead the dough: push – pull – turn.

She didn't, she had the Kenwood mixer, she could never bear the feel of flour on her hands, you know that.

You used to stand on one of the stained pine chairs to peep under the damp tea towel and see the loaves rising in their metal tins. She dug a vegetable bed, edged it with bricks, grew onions and carrots, chard, salad greens more interesting than those in the shops. You had your own small trowel, but you were afraid of worms and especially of slugs

and preferred to skip with your wooden-handled skipping rope on the patio or practise walking on the wooden stilts the Owl had made for you with off-cuts from the bed he had also made for you.

See? How can you ever suggest they didn't love you?

They loved you. But there was a mismatch. They would have found another child, a less crazy child, less demanding and emotional, easier to love. They did find their other child easier to love.

Well, who wouldn't?

There was one set of books the Jumbly Girl would read occasionally, if you'd tidied up properly and not argued with her or each other and the bread was baked and the day's sewing done and the weather justified staying inside. Some of your Beatrix Potter books were from her childhood, the watercolour illustrations faded on yellowed pages; others, their paper bluish-white and glossy, were almost aggressively new in that house of the second-hand, reused, home-made. She and your grandmother quoted Beatrix Potter so often to you and to each other that her books became almost the basis of a private language. There was a flutterment and a scufflement, your grandmother said, describing someone making a fuss in the library or the bank. Pit pat paddle pat, you said, stamping in puddles on a women-and-children-only walk down the road, because the men came out only for moors and mountains, not exercising kids cooped up by weather. Best of all you liked Mrs Tiggy-winkle, the hedgehog laundress who turns out to have a little girl's lost handkerchiefs. *All through her gown and her cap, there were hairpins sticking wrong end out.* Your grandmother used

hairpins to secure her bun, and sometimes to pin your plaits across your head like Heidi. She would also paint your fingernails, though only a soft pink close to their natural colour, and give you a squirt of her perfume. Beatrix Potter's books were the Jumbly Girl's friends partly because they are set in the Lake District, where you went most weekends to camp and climb mountains, but their version of Cumberland is very different from the landscape of adventure that the Owl enjoyed.

Didn't you just say you did ballet on Saturday mornings? Which form of terrible suffering was it then, ballet lessons or hiking?

Their human and animal characters stay in the valleys, spend their time in gardens and villages, living in pretty stone cottages. The illustrations celebrate domesticity while the texts are frankly Gothic. There is Peter Rabbit, whose transgressions begin when his mother tells him he and his sisters *may go into the fields or down the lane, but don't go into Mr McGregor's garden. Your father had an accident there; he was put in a pie by Mrs McGregor.* And there is a watercolour of a Victorian farmer's wife bringing to the table a pie in a white dish, smiling, careful, an excited child in the background, an excited dog beside her and the meaty hands of Mr McGregor gripping his cutlery in the foreground. Then old Mrs Rabbit goes through the wood to the baker's, where she buys a loaf of brown bread and five currant buns. You wanted a picture of those buns. Were they small sponge cakes, which were what you knew as buns from birthday parties, or more like the Chelsea buns sometimes served as dessert in the school canteen, sticky

spirals with raisins? Was there icing? Why were the little rabbits not more excited? Flopsy, Mopsy and Cottontail, *being good little bunnies*, pick blackberries, but Peter runs away straight to Mr McGregor's garden, where of course his comeuppance awaits. He escapes in the end – even Beatrix Potter doesn't kill off her protagonists – but there are several near misses and Mr McGregor's murderous intentions are plain.

Almost all the books explore violence, and the hierarchies are those of the food chain. Old Brown Owl tries to kill Squirrel Nutkin, who escapes – after a picture whose caption is 'this looks like the end of the story, but it isn't' – only by breaking off his own tail and leaving it in Brown Owl's beak. Jemima Puddle-duck is seduced away from the safety of the farmyard by 'a foxy gentleman' who offers her for her nest a shed 'almost quite full of feathers – it was almost suffocating; but it was comfortable and very soft'. Jemima has just enough wit to be 'rather surprised to find such a vast quantity of feathers. But it was very comfortable; and she made a nest without any trouble at all.' The foxy gentleman was your first encounter with the Byronic hero. Reading to your own children, you would be reminded of Jane Eyre at Thornfield, also very comfortable beside her foxy gentleman as long as she can ignore the evidence of an earlier resident, although Jemima has left the farmyard not because, like Jane, she must find her own way in the world, but because the farmer's wife keeps taking her eggs to be incubated by hens, who are better than ducks at sitting still: 'Her sister-in-law, Mrs Rebeccah Puddle-duck, was perfectly willing to leave the hatching to someone else – 'I have not the patience

to sit on a nest for twenty-eight days; and no more have you, Jemima. You would let them go cold, you know you would!' (Did the Jumbly Girl, who had certainly not the patience to sit on a nest for twenty-eight days, ever reflect on Rebeccah's insight, ever think that you might all have been better served if she had taken paid work, as some of your friends' mothers did, and left you and the Angel Boy in the care of someone who did not resent the neediness and slow pace of small children?) Jemima's gentleman friend asks her to bring him 'Sage and thyme, and mint and two onions, and some parsley. I will provide lard for the stuff— lard for the omelette.' In case the listening child hasn't understood this recipe for roast duck, the next page – showing Jemima picking herbs with her beak – remarks that 'Jemima Puddle-duck was a simpleton: not even the mention of sage and onions made her suspicious.' Even then you thought that from the nesting duck's point of view, an omelette was only a little less worrying than a duck dinner.

You had a Peter Rabbit bowl, transfer-printed china where the other crockery was all hefty hand-thrown stoneware. The dish survived to be passed on to your children. You and they practised new reading skills on the rim, which read, *Round the end of the cucumber frame, whom should he meet but Mr McGregor, who jumped up and ran after Peter, waving a rake and calling out, 'Stop, thief, stop!'* (You learnt most of your grammar and punctuation from Beatrix Potter: the correct use of 'whom', semicolons and how to be judicious with exclamation marks.) It seems odd to give toddlers their lunch from a dish showing how a baby rabbit seeking cucumbers is hunted by a man wanting to eat a

rabbit pie, but it does not seem at all odd that the only books the Jumbly Girl could bear in those days cheerfully explored the violent undercurrents of pretty Victorian domesticity. She was no Jemima Puddle-duck, but she was finding out for herself the suffocations of nesting.

You don't know any of this, you have no right—

It was your grandmother who taught you to read for yourself. You went to stay there one half-term break, just you. As the Owl backed the car down the drive, muttering no doubt as always about how he wanted to run over your grandfather who stood in the road waving as if the Owl wasn't capable of reversing without help, your grandmother held out her hand and said right, lovey, shall we see to this reading business then, is it time now? She'd been a primary school teacher in a deprived part of Leeds for forty years, starting during the Blitz with a class of fifty kids who spent their nights in bomb shelters while their houses were blown apart. You sat beside her – her bones were too fragile for you to sit on her lap – with her arm around you and began to make your way past the cat on the mat towards the goat in a boat and by the end of the week you could match the letters to the words you knew: *maids heard the goblins cry, come buy, come buy.*

bounty

The Jumbly Girl took you and the Angel Boy to visit her friend in Wales at half-term. The Owl said he had too much work and couldn't come. Wouldn't come, the Jumbly Girl said. He was obsessed, she said.

The Owl was angry. He stayed up there, typewriter, didn't say goodbye.

The Jumbly Girl stopped at the petrol station only a few hundred metres from home, your side of the park, within the orbit of your playing out. She hated to use a petrol pump, was forever bringing the car home almost empty so the Owl had to waste his time filling it up when he could have been working. (You do the same now, but your husband doesn't mind. You drive so little it rarely arises. It's hard to take off the petrol cap – a lever in a place you forget, keys, something clockwise or anticlockwise, click, twist something the other way, or the same way – and you can't bear to stand there on the forecourt taking up space and being stupid, a silly cow who can't even stick the nozzle in the hole.)

When she came back from paying, she reached round and passed into the back seat a whole handful of chocolate bars, a crumbly Flake and a Marathon which must have been for the Angel Boy because girls weren't allowed nuts—

Aren't you about to say you ate peanut butter on your toast every day? Slipped up there, didn't you?

and a Dairy Milk in its Silk Cut purple foil, cigarettes and sugar both lethal in episcopal violet, and a KitKat in its red and silver livery, asking to be snapped into alluring fragments and eked out. You looked at each other and then at her. Whole bars, unrationed, unbroken? For you?

The Angel Boy devoured while he could. You squirrelled yours away, bounty never seen before and perhaps never to be seen again.

You did not need to be told not to tell the Owl.

daft tarts who didn't know any better

Other people had Barbie and Sindy dolls. You couldn't tell the difference, they were both blonde and blue-eyed and exquisitely thin, and they both came with beguiling wardrobes of sparkly sheer synthetic fabrics, ballgowns and evening dresses, tiny high-heeled shoes for their tiny high-heeled feet. They had hairbrushes, which had to be bigger than the shoes so you could brush their hair with your clumsy human fingers, and tiaras and sparkly hair-clips like ballet dancers. (You were sometimes taken to see the ballet, because it was art, especially with the orchestra playing nineteenth-century music, even though there were also pink silk shoes and sequinned tutus and the dancers' legs were bare right up to the top and they often wore strapless tops and danced *en pointe*, which ought to have been even worse than high heels if the objection was to women crippling themselves for beauty.)

You went to other people's houses to play with their Barbies and Sindies and with their dressing-up boxes which included their mothers' old handbags, patent leather and, let us hope, fake crocodile and snakeskin, with metal snaps you could twist and stiff silky linings that smelt of perfume and powder. You used to try on their mothers' old high-heeled shoes, a net curtain on your head being a veil though not usually bridal, just feminine, just pale and sheer and lacy,

and old party dresses from dancing days. The Jumbly Girl preferred backpacks, hands free for the pram or the shopping, never touched make-up, wouldn't have been seen dead behind a lace curtain and the thing is you're the same now, aren't you, you travel the world, show up at posh literary festivals, with a tatty hand-luggage-only backpack, won't use a wheelie suitcase because it slows you down, because how's that supposed to work when you need to sprint to make a tight connection at an airport or a station, or when you decide to spend a day hiking between hotels? You sometimes buy high heels but you never wear them, because who wants to be caught by shoes in which she can't run away, and you sometimes buy makeup but you don't wear it, not even on stage or for photos, and as for the lace curtains – so you can't say she was wrong, not unless you're wrong too.

You had a party for your sixth birthday.

Right, so don't try any more sob stories, if this is meant to be some kind of misery memoir it's not going well.

Before you started school, not long after the Angel Boy was born, you had moved down from Scotland to a large Victorian house in Manchester, the sort of house casually acquired by the Owl and the Jumbly Girl's generation that would be far beyond the dreams of their children and urgently resented by their grandchildren. They'd been characteristically ambitious, bought a doer-upper with the idea of doing it themselves, so for years the house remained unfinished, missing floorboards, offering exciting access to the subfloor where there were wires and pipes you weren't supposed to touch but who could help just brushing as you crawled past?

The little girls who came to your party hadn't seen a subfloor, didn't know their houses' bones and veins, though you all lived and went to school and the library and the shops in Victorian buildings; in some ways growing up in Manchester was growing up in the nineteenth century, amid the Thatcher-ruins of empire. The Jumbly Girl made healthy versions of party food – not that you wouldn't do the same, thirty years later, not that you wouldn't want to slap other people's children who picked apart your home-made low-sugar wholemeal apple muffins – but you hardly noticed because of the presents, because every little girl had brought you a gift wrapped in brand-new shiny paper. And their mothers didn't understand that most dolls were nasty plastic tools of oppression bought by daft tarts who didn't know any better, didn't bother to seek out the dark-haired dolls with soft childish bodies, much less the brown dolls who still came with shiny straight nylon hair, which meant that this year you unwrapped a thing you'd coveted and never thought to own: a pale-pink head and shoulders, cut off above the boobs like a marble bust, with long blonde hair and a dial between the shoulders that you could twist to make the hair longer or shorter, and she came, this decap-itation, with a set of hairbrushes and clips and ties and also a set of make-up, blue and green eyeshadow, a whole palette of lipsticks and blushers, brushes smaller than those in your watercolour set. You'd never even have bothered wanting such a thing, it would have been like wanting a swimming pool or an ice rink, a pointless thought, but here it was, yours to groom and play with. Only in the morning it was gone, and when you asked she said, *yes, we took it away, it*

was stupid, it was plastic and ugly and we won't have such a thing in the house.

The house, as it was finished, was painted in dull shades of brown and green. There was old furniture, fragile, not to be jumped on, some of it carved with what appeared to you to be grinning skulls. There were floor-length curtains at the original leaky sash windows, also in strong dull colours, patterns you would later recognize as William Morris, patterns you would later covet in brighter colours for your own smaller cold Victorian houses. There were hand-thrown mugs and bowls thickly glazed in shades of oatmeal, beige, sage. You thought it needed more pinkness and sheen, more lush nylon carpet like in other people's houses, maybe some china kittens and fairy pictures instead of the paintings of severe landscapes in severe weather. You could see that your present didn't fit and you still wanted it back, in the bedroom the Owl had papered with the pink butterfly pattern you'd chosen, under the ceiling he'd painted pink for you, because it's true that he did, always, understand the need for a room of one's own, always understood that a person might feel safest alone, behind a door that closed with a slippery handle, in a cloud of smoke above a flight of creaky stairs. You wanted to paint the plastic face and arrange and re-arrange the golden hair, and you knew it was you, really, who was stupid and ugly, you knew that wanting stupid and ugly things was the outward sign of your stupidity and ugliness, that taste was indistinguishable from morality and yours wasn't good enough.

Lulu's family did not have taste.

They're nice enough people but when you're older you'll understand.

Lulu did tap-dancing, not ballet. Her mum was a nurse and her dad worked in a biscuit factory and brought home an astonishing cornucopia of misshapen pink wafers and chocolate fingers and custard creams, refined flour and sugar and vegetable fat and artificial colours and preservatives casually supplied as if they wouldn't make you fat and rot your teeth and corrupt your soul, not that souls were really a thing there and then, not that anyone spoke of morals because all that had been displaced. It was fat that was bad, physical weakness was moral weakness, ill-health was either malingering or neurosis, goodness subsumed into correct taste and the control of the body. Strange, you think now, for feminism and anti-racism to co-exist with essentially fascist thinking about the body, especially as the Jumbly Girl began to work in disability rights. (Was it part of her rebellion, this tacit defence of the deviant body?) You understood that Lulu's family weren't as good as your family because they kept their small house so warm you didn't need a jumper, called their dinner 'tea' and ate it – processed muck from a box – on their laps in front of the gas fire and the television, another box producing processed muck.

You didn't say but Lulu's mum is kind, Lulu's mum tried to show me how to care for my chilblained hands and feet, Lulu's mum remembered that I loved the hot Ribena she gave us last time. You didn't say, I like going to Lulu's house because there's no shouting, because no one tells you you'll get fat like your mother if you eat those biscuits, because you and Lulu can put on Lulu's mum's lipstick and jump on

Lulu's bed and sing in your broadest Manchester accent and all Lulu's mum will say is, honestly, you girls, why don't you come down now and have your tea?

It's not, now, that you think they were wrong. It's not that you think it was a good idea to give little girls decapitated women to groom, to give them a toy girl who couldn't go anywhere or do anything, not even dance with Ken or clean its Barbie house with a Barbie vacuum cleaner, because its whole existence was for getting ready, because it had been invented for the sole purpose of display and didn't need to have arms or legs or anything but a pretty face to paint. But let's whistle up the wolf again, let's send her threading the years, slipping through war and climate change, booms and busts, the accelerating loss of the places a wolf might live and the creatures she might eat, along the streetlight-orange leaf-strewn pavements of your childhood suburb, rain needling the smoggy air, leaded petrol fumes spreading through her lungs, let's send her to say: it's fine to paint your face in pretty colours, it's fine to arrange your hair, but then out you go, you go into the world with your whole strong body, not just your painted face, and you meet everyone, you see as well as being seen, you touch and taste, you stride and rest, and that's why you shouldn't play a game where the getting ready never ends, where it's never done, where you never step into your red shoes and close the door behind you.

Let's send the wolf to say: beauty is a form of power, it's not boring. Maybe if someone had said that it would have been a form of power you could have explored, from which you would not have felt excluded, too ugly to think of it.

Let's send her to say: people have always adorned and modified their faces and bodies, the work of beauty can be creative, and also beauty is work, it's not that other people are born that way. Maybe there could have been pleasure there for you.

Let's send her to say: Lulu's mum works nights caring for people, Lulu's dad does what he needs to do to put food on the table. You already knew it wasn't about money, because some of the families to be despised were obviously wealthier than you and that could be despicable too, when people had costly cars and newly built houses and holidayed in hotels instead of camping and bought high fashion in synthetic material instead of making their own timeless clothes. Let's send her to say, Lulu's family's relationship with pleasure and amusement is different from yours and worthy of your consideration. Perhaps they have a happier time than you do. Perhaps they are kinder to each other and themselves even though society and culture are kinder to you.

gouge

Head clamped. Long, sharp fingernails, almond-shaped, pride and joy, forced into small ears. Scouring pink whorls, gouging deep in your head, as if to winkle out your thoughts, to unseat your mind.

It ended faster and with less pain if you didn't fight.

Just cleaning, there was ear-mess.

You couldn't see the ear-mess, couldn't reach it with your own soft fingers, couldn't do anything to forestall or prevent—

So? You're not claiming this was some kind of violation, are you? No one raped you. It was normal, ask anyone. What a fuss! You received affection, not like some.

Wolf, bite. Bite!

a fine needle against your cheek

You were free-range.

More kids had more freedom in those days, when there was less traffic and more tolerance of physical risk though also more accidents, a lot more accidents if the safety videos you watched in school, the TV wheeled in on its metal trolley, were any guide. This is why you shouldn't climb pylons. This is why you shouldn't play with fireworks. For the boys, this is why you shouldn't chase your football into the road. For the girls, this is why you shouldn't get into a strange man's car. They were fascinating, like an early version of hospital dramas or fly-on-the-wall documentaries about the emergency services. This is what it looks like, kids, when it all goes horribly wrong. Here's a comeuppance in Technicolor.

But you were the most free. You could do what you liked. It wasn't so much that you were allowed to go longer and further earlier than the other neighbourhood kids as that no one ever suggested there were limits to your range. In the most literal sense, there were no boundaries. They didn't say, you can go into the village and you don't have to come back before lunch, they just didn't ask where you'd been and there wasn't usually lunch anyway because the Owl and the Jumbly Girl had more important things to do. Plenty of meat on those bones, you won't starve to death. Pull yourself together.

What nonsense, you can't possibly remember all this, how far you were allowed to go when you were six. Anyway, they wanted you to be independent, self-reliant, no mollycoddling, and you survived, didn't you, learnt a thing or two?

You had one friend who could join your wandering. Kay lived two doors down. Kay's father's temper was worse than the Owl's, both of them professors who immured themselves in pipe smoke in the attics of their Victorian houses and regarded the interruptions of women and children with outrage. Her mother was a nurse, senior to Lulu's mum but still, shift work, *shh* on the stairs and landing, don't wake her in the afternoons. It would take you until you had your own children to connect Kay's family's fractures with the death of her brother, which had happened while Kay was too little to remember and therefore, as far as you were concerned, in prehistory. You and Kay went to the park, where you competed to swing highest on the big swings whose chains left your hands welted and smelling of iron. There were men in the bushes who liked to jump out and open their coats and you thought it was funny, mostly. My mam seen bigger 'n that down the hospital, Kay shouted from the peak of her swing. You loved to swing, loved the rhythm, the way you would later love to run and to knit, would always find comfort in walking. Up and down, in and out, iambic heartbeat. You and Kay sang and chanted as you swung, nonsense, skipping rhymes, songs you made up, the poems your grandmother recited to you.

You and Kay went into the village, careful at the big roads, wait for the green man or ask a nice lady, though at least once you were nearly run over forgetting that cars

might be turning right, brakes squealing and horns sounding. You went to the library, crossing the square with the war memorial and the pigeons. Carnegie, you would realize later, and a local government that took libraries seriously, laid a wide road from Children's Fiction into the adult world, no risk, in those days, of arrested development in YA. You went to the sweet shop, Kay with her pocket money and you with coins harvested from under the cushions of the creaky leather sofa, where the Owl sat in the evenings after dinner parties when there was no typewriter or sewing machine but talk and laughter, music – Fairport Convention, Simon and Garfunkel, Joni Mitchell – perfume and wine and sometimes a strange sweet smoke drifting up the chilly stairs. They were good party-givers, party-goers.

The sweets were priced in pennies and ha'pennies, handed over in soft white paper bags with twisted corners. You loved toffees and the sour chewy jellies, cola bottles, cherry lips, all the things that were worst for your teeth. Kay, who was naturally slim, whose mum thought it perfectly ordinary for children to eat sweets, found your desire and anguish around them weird. She liked the hard palate-grating fruit candy, rhubarb-and-custard, pear drops, things you could suck down to a fine needle against your cheek. Kay ate hers in the street, wandered home with the bag open in her hands, wanted to sample and swap but for you such openness was indecent, far worse than the men in the bushes. You hid your portion in your pockets or sometimes in your clothes, sneaked them into your bedroom. You had stolen an old margarine tub and hidden it beneath a loose floorboard in the coffin-sized space between your bed and

the wall, down there with the pipes and wires and spiders. When you were too sad or too hungry, you hid in that space and chose one sweet, eking them out over weeks, saving the best for last, deferring gratification so long that in summer sometimes they melted into a garish sticky puddle from which you took one careful mouthful at a time.

Oh no you didn't.

sleepwalking

You changed schools. They sent you to a school like the one the Jumbly Girl had attended, with a uniform and no boys. There was an entrance exam, about which you remember only that the Jumbly Girl gave you a secret packet of chocolate raisins to put on your desk in the big hall. The new school cost money, lots of money, so you'd better be grateful, don't think you can take it for granted, your special posh school. All the other kids on the street, who'd played your imaginary games for years, stayed at the school at the end of the road, so you weren't the narrator any more. In this new school you had the wrong accent. You had the wrong kind of uniform, second-hand, the first time you'd felt stiff nylon on your body, and the wrong kind of shoes because your feet were too wide for the correct ones. You didn't know what the other girls knew, times tables and the rules of tennis and thank-you letters. You, who had always been chatty, articulate, verbose, became very quiet. Sometimes you could go a whole day without a word in your mouth.

Oh, strike up the tiny violin. Don't be ridiculous. You're making a fool of yourself, you know that?

You had homework now, couldn't play out in the street with the other kids. You had piano lessons and flute lessons and a pottery class and ice skating as well as ballet and

hiking and camping at weekends. You were terrible at all of it. You were a very lucky little girl. You should have been very grateful.

You don't deserve any of it, you never did deserve any of it, everything lavished on you and you're still crazy and greedy and lying and lying and lying.

The deal was that the Owl took over at 6 p.m. (tu-whit tu-whoo, incoming), that the Jumbly Girl's shift ended when it was time to cook dinner. She'd had enough by then. You could feel the air changing as the hands on the clock edged towards their daily vertical, when she would tell you to go and tell the Owl it's six o'clock. He cycled home from work and went straight to his attic study, where he smoked a pipe with the door closed so that you and the Angel Boy were not exposed to the smoke.

It is only now you understand that this policy ensured that he and his work and his pipe smoke were not exposed to his children. Who was being defended from whom?

You went up two brown-carpeted flights, knocked on the door and turned the slippery round handle. Smoke curled out and you stood on the threshold looking in through a fog. She says it's six o'clock, you said every day, the window behind him your seasonal calendar, darker every day of the autumn. Tell her it's not, it's five to, he said, not looking up, smoking, typing. Often you were sent again every five minutes for the better part of an hour, the Jumbly Girl's movement around the kitchen louder, the likelihood of being smacked higher, with every passing minute. Overtime. Undefended.

Later, after the Owl had tumours in his mouth, they made a deal: the Jumbly Girl would lose weight if he would stop smoking. He did stop smoking and she did lose weight, but inevitably she put the weight back on and he needled her about it for decades, his superior willpower, her failure in self-discipline.

The Owl oversaw bathtime, toothbrushing, fluoride tablets so you didn't have horrible British teeth, bedtime reading, the curtain calls of your bad dreams.

You screamed in the night, deep in the night, after all the lights were turned off and the dark sounds had taken over, the creaking of floorboards where no one walked, the rattle of cold pipes, scuffling in the chimneys, birds, probably, old houses do make noises, talk to themselves. Sometimes you went sleepwalking, setting off the burglar alarm as you approached the front door, worn grey carpet under bare feet, outgrown purple nightdress with the white star pattern.

He always came, stumbling in a woollen dressing gown and sheepskin slippers. He always let you tell him what had made you scream, the dead woman in the spare room, the thing that crawled up the stairs, the mummy or skeleton in the coffin-space between your bed and the wall. He followed you back to your room, sat on your bed, told you how he too had been menaced at night, how wolves had slunk up the stairs in his 1950s American house and lurked under his bed, blood breath and shit stink, until someone – you want to make it his father, his father who overdosed long before you were born, of whom the Owl does not speak – told him, make friends with your wolves, let them protect you.

Oh, now you remember. You didn't invent the wolf. Not everything you inherited was terrible, do you ever think about that?

But you agreed, you damp with sweat and tears, throat sore from screaming, sitting up in your bed under the pink-flowered quilt the Jumbly Girl had made for you, he at your side decorously mindful to keep the dressing gown closed over his interestingly hairy legs, that your ghouls weren't friend material. She wasn't after companionship, the dead woman in the spare room, and the crawling thing had no protective instinct. You and he would simply have to turn on the big light and cool reason and wait until they went away.

But they weren't nightmares. You weren't sleepwalking. You hadn't gone to sleep, wouldn't learn how for another ten years. Until you left home you slept only in snatches, jumpy, vigilant, late to bed and early to rise and awake for a few hours in between, reading time. It was a shock to you, at university, when you started to sleep all night and realized how much time it takes. The Owl and the Jumbly Girl, even your grandmother, would have said you were pretending to sleepwalk, malingering, faking to get attention, and in some ways they would have been right, you knew exactly what you were doing, you decided to walk about and scream. But also you weren't faking at all, there was no pretence about the fear, you screamed and cried because pretence had broken down, because in the watches of the night you could no longer pretend that everything – anything – was all right. Later, you'd learn to hide from your demons in study, to starve them into submission and run them into the ground.

But back then you had no tricks. You were wide awake and so frightened you'd brave the darkness and the ghosts and the gritty carpet, set off the alarm to summon him, to test him, to see if he still loved you enough to come down the stairs. And he did. Every night.

It's just that by day he was angry, the man who loved you.

Some people are, aren't they? Good people.

Some kids wouldn't have been bothered.

Oversensitive, hysterical.

He probably couldn't help it.

Probably his father had been angry too.

You were just the wrong child for them, they did their best.

Probably it wasn't anyone's fault.

candlewick bedspread

You had a German au pair called Ingrid.

You didn't, you're lying again, there was Katrin and then there was Birgit, there was no Ingrid.

Ingrid cried and wasn't even ashamed, just went around brushing the floors and tidying the kitchen with tears dripping down her face. The Jumbly Girl was always angry with Ingrid, even more than with everyone else, because Ingrid had no common sense. Ingrid took the clothes out of the washing machine before the spin cycle had finished and hung them, also dripping, over the rack in the cellar. Ingrid boiled the vegetables instead of steaming or sautéing them. Ingrid believed the Angel Boy when he said he was allowed to go to bed without brushing his teeth.

Ingrid lived in the spare room, across the landing from your room. The renovation project hadn't reached the spare room – never would – so there was still embossed beige-and-green wallpaper, a gas fire hanging over the boarded-up Victorian fireplace, and nylon carpet, speckled yellow and orange, whose black rubber backing was disintegrating so that crumbs of it stuck to bare feet. There was a mirrored mahogany wardrobe for her clothes, a primrose-yellow candlewick bedspread from which it was tempting to pick strands, and ragged unlined curtains stirring in the draught through the rattling sash windows.

Until the Owl went to bed, the landing light was on. You could just about read by it and you had ample warning of anyone coming because the Jumbly Girl was running the sewing machine downstairs and the Owl was typing in the attic and both sets of stairs creaked; you knew how to go up and down silently but they didn't need to. If both machines were sounding, you could cross the landing and tap quietly at Ingrid's door and she, wearing checked pyjamas and a grey dressing gown, sometimes also a brown woolly hat, would let you in. You knew how to cross Ingrid's floor silently too, and she'd light her gas fire whose asbestos grate glowed an interesting shade of orange and you'd lean over her Walkman and listen to Madonna, Wham and the Pet Shop Boys on very low volume, the song about brawn and brains and lots of money. Manchester didn't look as if anyone was making lots of money. Maybe Stuttgart did, but Ingrid's English wasn't good enough to tell you.

Ingrid kept snacks in her room. She offered you ginger biscuits, which gave you ideas. What about treacle tart, you suggested, having read about it in E. Nesbit where the children were served a sweet pudding after lunch every day *and* cake for afternoon tea. Or Battenberg cake, which you'd encountered at a party and subsequently persuaded your grandmother to buy, pink and yellow squares, synthetic jam, grainy ersatz marzipan, transgressive delight. Ingrid obliged. You and she spent your evenings in silent communion, lulled by cheap sugar and the early stages of carbon monoxide poisoning.

This didn't happen, none of this happened, there wasn't an au pair called Ingrid, there were no midnight feasts, you never had a candlewick bedspread and what's candlewick anyway, you're making it all up, lying and lying and lying again.

lies and fabrication

You were to be weighed.

You hadn't met the school nurse before, hadn't realized that this kind of school had a nurse. The nurse saw a few girls each week, alphabetical order so you could see it coming. There was a letter home, telling the mothers to attend. Why they think, the Jumbly Girl said, mothers have nothing else to do, you'll notice they're not asking the fathers – but you hadn't noticed, partly because you were too upset about the weighing to notice anything and partly because it was silly to say that; like all fathers yours worked all day at his office and all evening at home too if he could get away with it, of course fathers didn't go into school.

You didn't want the Jumbly Girl to come to school. She might make them cross, or they might make her cross, and either way it would be your fault.

You felt sick when you thought about the weighing. The Owl weighed you sometimes and the number told him how bad you were, how many times you'd eaten cakes and sweets at a birthday party or taken a second helping of something you shouldn't even have tasted in the first place, how often your grandmother had baked Fattening Cake for you and you had eaten it. Weighing at school would be even worse because they were weighing everyone, it was a competition, like the marks for tests in maths and spelling and history which

the teacher read out in order, Simran or Claire at the top and you or Samantha at the bottom.

She told my mother to give me full-fat milk, said Anna Cather. She told mine to make sure I had a mid-morning snack, said Kirsty Doolin. You and Judith Liebeskind exchanged glances. No one was going to tell your mothers to give you creamy milk and extra snacks.

You met the Jumbly Girl outside the sickroom, off the Senior Cloakroom where you'd never been before, wouldn't have dared step because you were still afraid of the big girls, still surprised that a school could have seven-year-olds and eighteen-year-olds in the same place. The nurse is running late, she said, of course they've no respect for my time, you'd think they'd know better at a girls' school. Sorry, you said.

The nurse opened the door and told you to come in. The nurse had a paper doily kirby-gripped to her head and wore orange tights under a pale-blue dress. There was a metal-legged orange plastic chair, none too clean. The Jumbly Girl sat on its edge and you stood, rubbed one foot against the other calf. Don't do that, she said, stand properly.

We know she's fat, the Jumbly Girl said, you don't need to tell me that, we don't have sweets or cakes, we never eat puddings or refined flour, she gets plenty of vegetables, I don't know what more we could be doing.

The nurse eyed you, jerked her chin. Vest and pants, she said, hop on the scale, and your eyes were hot as you struggled out of your second-hand nylon pinafore and couldn't undo the maroon tie and didn't know whether to keep them waiting while you unbuttoned the too-big second-hand white blouse or just pull it over your head. It was hard to

take off the thick navy tights without sitting down. You stepped on the scale, closed your eyes for a few extra seconds of not knowing. Hop down, she said, let's check your height. You knew you were taller than you'd like. You'd have liked to be tiny, doll-like, fairy. You'd have liked to be so small you could hardly be seen. Samantha might have been almost as stupid as you but she was also a head shorter and had big blue eyes and a blonde plait longer than her spine.

She's not overweight, the nurse said, nothing to worry about there. Not, she said to you, that that means you can go eating sweeties and cake, not that you shouldn't be careful.

You stopped. Not overweight? Not fat?

It's as if she'd said you had blue eyes. Next she'd be saying you could do maths. Nonsense.

How, the nurse said, did she get that bruise?

It was a big one, on your leg.

The Jumbly Girl laughed. She's going to tell you, she said, that her father kicked her, but of course it's not true, she's always making up stories, can't tell fact from fiction.

Oh, the nurse said, did you get in his way when he was watching the game? That'll teach you.

No, you said, I wasn't fast enough coming down the mountain and he got cross.

See, the Jumbly Girl said, I told you, forever making things up.

He did lose his temper. Men were allowed to, in those days. Adults were allowed to. It certainly wasn't illegal, you could say it was almost encouraged, to hit your child. Corporal

punishment had just been banned in state schools but it was still happening, even at your primary school the head- mistress had kept a slipper on her desk, and people could still pay to send their children to schools where they'd be beaten. (Perhaps privilege is not invariably a blessing to a child; in England at least, socio-economic status has long sheltered institutional and family violence apparently invis- ible to a state eager to think the worst of working-class parents.) A little bourgeois boho neglect was nothing to worry about. You weren't the only one whose parents hit you when they felt like it. It wasn't reasonable to expect men to control rage, any more than you could expect men to control desire when presented with a woman in a short skirt or on a dark street or having taken a drink. What did you expect? The Jumbly Girl's simmering also boiled over most days, but that was different. You could see that she wasn't losing control but deciding that your behaviour now justified her steady desire to smack you. She told you why she was going to hit you and then she did it, which was what other people's parents also did, sometimes in public and without consequence, what was normal then and there, an occupational hazard of childhood. It was undignified and upsetting but not frightening the way the Owl's rages were frightening. And you wouldn't know, you've never lost your temper, most of the time can't even find your temper, but probably uncontrolled fury is frightening for the perpetrator as well as the victim. Toddlers, plainly, do not enjoy their tantrums. You wouldn't do it, he didn't do it, for fun. He'd probably have liked his wolves to tell him how to stop.

Later, back home, there was trouble. If you don't stop

telling people these stories, you'll be taken away, do you understand? If you keep saying things like that, social workers will come and take you away to an institution and there'll be no more books and no more dolls' house and no more grandma and grandpa and no more of that school, you'll be locked up with the other liars and that will be the end of you.

This is arrant nonsense, this whole story is lies and fabrication, it's typical of you, are you crazy or malicious or both, making up this rubbish?

You don't know, forty years later, what you made up and when. Did you invent the nurse? The scales? The mountain? We know you made up the wolf, we just saw you do it, you and your ravens. You're pretty sure you didn't invent the bruise because you remember your grandparents noticing it too, when you had a bath at their house, avocado bathroom furniture, white tiles criss-crossed with pink and green flowers, gas heater high on the wall, bath full to the brim with hot water and scented bubbles though maybe you're inventing that too, you and your novelistic imagination, perfectly capable of making up the kirby grips and the orange tights, doesn't prove a thing. Maybe there was no bruise or maybe you hurt yourself climbing a tree or falling off a swing and made up a more interesting story. They're not wrong, you did make up stories, only usually about fairy princesses and winged unicorns, or alternatively skeletons and the walking dead, but at least once you pretended to be sicker, more fragile than you were, exaggerated a sprained ankle and limped longer than necessary because it seemed so romantic, so balletic, to have sprained an ankle, even if

you did it chasing someone in the icy playground rather than falling off your twentieth pirouette. You liked the shape of the word 'sprain', the way it looked like the *squ* words whose tilt you enjoyed but wasn't quite one of them, the way the *p* almost invited the slip, the slither, the turned tendon of the *q*'s flick.

Did you invent him telling you what you'd invented? Or are you inventing it now, is your unconscious trying to blame him for the troubles you brought on yourself?

Are you crazy because of your childhood difficulties or was your childhood difficult because you're crazy? How far did you go, to get attention?

Just how much of an exhibitionist are you?

Isn't it convenient that you found a way to earn a living by making things up?

how to manage

You had had flu. The Jumbly Girl believed you in the end, because thermometers don't lie even in the mouths of girls who do. You, who were never absent, never took a sick day, had been out of school a whole week which meant you'd never make up what you'd missed, would be bottom of the class for the rest of term, but meanwhile you were up and dressing for the first time in a while and you put on your new red cord trousers, the first time in your life you'd chosen trousers, dresses all the way, usually, still is, but you'd seen some of the popular girls on Own Clothes Day and they had bright trousers so you thought maybe if you had something similar, and credit where it's due the Jumbly Girl went along with it, bought them for you. The red cords had been a little big before, no point buying new clothes to fit growing children, but now when you pulled them up and fastened the stiff zip and the button, they fell right down again, and when you held them up you could span your fingers between your belly and the trousers. She was out volunteering so he was the one in the kitchen and you went down to show him, look, I'm slimmer now. Good job, he said, well done. He had never said that to you before. You must have lost weight, he said, come up to the bathroom, let's see, and you closed your eyes stepping on the scale the way you always did but there was no disappointment or shouting this time.

Hey, look at you, that's my girl, now let's see if you can keep it off. I can, you said, really, I can and I will, and when she came home he told her look, see, if she can do it so can you, do you really want your nine-year-old showing more self-control than you?

None of this is true. He has no memory of it.

Self-control. Self-control meant not eating and not being hysterical. Being hysterical was crying or laughing too much or worrying about things that didn't worry anyone else and especially getting angry. Being hysterical was also cuckoo and acting like his mother and would land you in the loony bin if you didn't get it under control. You didn't get angry, or only with yourself. You still don't, only in the abstract, social injustice, destruction of environments, abuses of power, only on behalf of others. You did cry, quite a lot, which was because you were hysterical and neurotic, and sometimes you cried until you couldn't breathe, until your lungs closed down and your heart did strange jerks and jumps against your ribs and you had pins and needles in your hands and feet and needed to sit down, which was a hysterical fit, a fit of hysteria, something crazy women did on purpose to get attention and you were lying when you said you couldn't help it, you just needed to try a bit harder the way normal people did, exert some self-control.

They must have been very scared, the Owl and the Jumbly Girl, of your needs and appetites. You see now how it was your job to incarnate intolerable emotion, to perform what could not be countenanced. Fool, scapegoat. They must have believed it was only the most rigorous repression and

surveillance of you that kept their world to its axis, stopped their planet and all who sailed in it lurching and tumbling into the dark. Wolf, tell that little girl: those are just feelings. You can manage them. Cry if you need to, it'll pass. Paper bag for your panic attack, feels like an emergency but it isn't. Men have been telling women their emotion is madness since the Garden of Eden, and meanwhile men's emotion leaves bruises on your legs and broken crockery on the floor and that's your fault too, you drive them to it, your madness leaves them no choice. Wolf, foe to men, dig it up again, tell her she's not mad. Not mad, sweet ladies.

You knew how to go on a diet, to keep the weight off. You had never encountered an adult woman who was not on a diet, nor one who was thin enough to be allowed to eat what she wanted. It wasn't even an idea, a woman who could eat what she wanted. Being a woman was being on a diet. Your grandmother weighed herself weekly and halved her portions for the next week when the number went above a certain level, easy enough, she said, if only the Jumbly Girl would do the same. Your friend Milly's mum weighed everything she ate and wrote down the calories. In your friends' houses the fridges held special food for the mothers, fat-free yogurts and low-calorie cheese and bunches of celery to be eaten raw and unadorned when emptiness became intolerable, rumoured to use more calories in digestion than it contained. There were foods no one should ever eat, foods eaten by bad people, of whom you were secretly one, including but not limited to: sweets, butter, cream, white bread, white rice, shop-bought cakes and pastries,

processed food, which meant anything in a box or packet or tin except tinned tomatoes, they were all right, especially if the label was in Italian, as long as there was no sugar or salt added. Then there were foods that were allowed only to men and boys, the Owl and the Angel Boy who was not fat and therefore did not have to be weighed: anything fried, desserts and ice cream not previously excluded, nuts, jam, margarine, home-made baked goods (not, of course, that the men did the baking), steaks and other expensive cuts of meat, cheese. Women could have salad, grapefruit, crisp-breads and cottage cheese, at least during the day when the men were at work, though the less they ate, the better. In the evenings women served themselves miniature portions of the family meal, though often sneaked leftovers in the kitchen while clearing up. Oh, I really shouldn't, they said. A moment on the lips. Oh, I can't help myself.

You halved your breakfast, one piece of toast not two. Breakfast was tricky anyway, always toast and she said peanut butter was disgusting and American and especially revolting eaten the way he'd taught you with jam and he disapproved of Marmite, English and especially revolting eaten with margarine so whatever you did was wrong.

He never said any such thing, you're making it up again, he enjoys Marmite, always has, and didn't you say women didn't eat nuts?

As if disapproval and enjoyment were incompatible.

You'd always hated the school canteen, the noise and the smell of baked beans and viscous brown gravy and viscous yellow custard, not as bad as primary school because there were big windows and the room wasn't used for anything

else, but bad all the same. It turned out that if you simply didn't go in nobody noticed, that the surveillance systems weren't set up to catch people skipping lunch, or alternatively nobody minded if girls skipped lunch because wasn't there after all a 'salad bar' reserved for the older girls so they could eat lettuce and crispbread instead of the various forms of brown stodge available to the pre-pubescent? After school was the time you needed to exert self-control, no one around to police you in the kitchen but you made a rule, no more than two crispbreads with no more than one teaspoon of the Jumbly Girl's fat-free cottage cheese on each one. For someone whose approach to other people's rules has always been creative, you found it surprisingly easy to follow your own. You could resist. You could help yourself. At dinner, you said give me a smaller portion, please, no, less than that, I'm on a diet, and the Owl looked at the Jumbly Girl and said well done, that's my girl, and her mouth tightened. You took smaller portions and his approval, she took larger portions and his contempt, but she went on taking them, the portions and the contempt, rebellion of a kind.

You'd think at some point he might have noticed that if the object was to make her lose weight, contempt wasn't working.

You ate your salad without dressing. You drank only water.

Every woman had a calorie book that listed the number of calories per ounce in every food. There were fewer foods then. The books fitted in the women's handbags. Hers was yellow and had a picture of a tape-measure on the front,

24, 25, 26 waistline. You stole it, memorized the contents along with your times tables and the key dates in British history. Seven sevens, the Norman Conquest, calories in a large, small and medium apple. Engraved on your heart when you die. It was the time of Britain's slow conversion from imperial to metric measurements, yours the bilingual generation, imperial at home and metric at school, buy in metric and cook in imperial. You became very good at mental arithmetic, grams to ounces, kilos to stones, ingredients divided by portion, running tally. You didn't have a daily allocation, just as few as possible. Zero would have been ideal.

Such self-control, they said, her friends and your friends' mothers. What wouldn't you give! You'd always been greedy at other people's houses, where meals adapted for a child's palate were served at regular hours and without shouting, and especially at parties where there were shop-bought cakes and biscuits and crisps, Cadbury's Chocolate Fingers threaded through Hula Hoops presaging the trend for salted chocolate, Iced Gems and Fondant Fancies in alluring shades of pink, all set out for the children to help themselves, as much as they wanted. Waxed paper bowls to hold pink jelly, sometimes with tinned fruit salad suspended in it, eyeball grapes, velvet peaches, and yellow ice cream, which could be whizzed together into an intriguingly textured sweet slurry. Enough of all that. You were taking a higher path. No thank you, you said, I'm on a diet. No, really, I can't, I'm slimming. Well, said one mother, can I give you anything at all? You considered. You were very hungry and if she was offering, if this was an adult who actually wanted you to

eat something— It was fashionable to present a dish called a hedgehog, cubes of pale cheese and tinned pineapple on cocktail sticks stuck into half a grapefruit flat on the plate. Cheese was too high in calories and the pineapple might have been canned in syrup not juice, not for you. You inquired after the other half of the grapefruit. I suppose so, she said, if that's what you want. Yes please, you said, but I'll wait and eat it while the others are having jelly and ice cream.

Dieting, it turned out, was surprisingly easy for you, you for whom so many perfectly simple things were impossible. You decided not to eat and you didn't eat. You went hungry. The next time you were weighed, the number was even better.

What is this nonsense, they didn't weigh you, you're making him out to be some kind of monster here, sure you had scales in the bathroom but who doesn't and naturally he took an interest, he cared about your health.

See, he said to her, see? The red cords had to be put away. You were not Getting Like Your Mother, even if you were hysterical and crazy and neurotic like the Wicked Witch of the West.

Well, what's so wrong with that, he didn't want you to be fat or crazy, he cared about your health, is that a bad thing now?

When you went back to school after that summer of slimming, the bullying stopped. Of course it stopped, you were no longer fat. You had learnt your lesson. It was not exactly that the posh girls had ever called you fat, what they had said was poor and common and inner-city and working

mother and nose stuck in a book, they had said second-hand uniform, takes the public bus, walks all over town on her own; they, like you, understood your freedom as the symptom of your unimportance. What might happen to you didn't matter, nobody cared. If those glossy girls accidentally touched you or your bag or even your chair, they made a performance of wiping off the you-germs. If another girl spoke to you, they didn't speak to her for several days. You learnt to carry a book and read when they were chatting and playing. You might have rather they'd just beaten you up, but it wasn't that kind of place and anyway in a fair fight you might have won. The Cheshire girls were too cherished, too blonde and fragile and shiny, for the streets and buses of Manchester. Their mothers, who did not work, drove them to school and to the tennis club and to their riding lessons in gleaming cars whose interiors smelt of perfume, leather and dogs, and as often you were simultaneously envious of the care taken over them and scornful of their dependence. Whatever they said, you had always known what was wrong with you and now you had solved it and your alleged poverty and commonness and inner-city address no longer mattered.

You knew that you were not poor because you lived near and had previously gone to school with children who were. You and those children had seen perfectly clearly how their lives were different from yours. For the sleek daughters of provincial doctors and lawyers at your private school, poverty meant not having a second car and a third bathroom and a pony, meant getting years of wear from a winter coat bought with growing room. You could see the absurdity.

They didn't read, didn't go to art galleries or museums, spent their holidays skiing or at beach hotels rather than climbing mountains and exploring old churches and archaeological sites. They knew how to get high marks and teachers' approval but not how to look at a painting or knit a hat or use a map and compass. You didn't want to be like them, and your unspoken scorn probably made things worse. The bullies moved on to Kelly whose hair and clothes were rarely washed now her mother was in the cancer hospital and Lina who was unnaturally good at maths and had recently arrived from Egypt with a funny accent, a niqab-wearing mother and no father in sight.

It was not, you think now, your size that was ever the issue, and to that extent you were lucky. You have suffered the consequences of fatness only in your head and in your home, not in your career or on planes or in shops and restaurants. The bullies moved on when you lost weight because your weight loss had given you confidence. You had found something at which you excelled. For the first time in your life, you had been praised. And if they came for you again, you knew how to manage: hunger dulls pain and numbs fear. Some appetites are easy to control. The bell jar is a fine and private place.

better drowned

Your grandmother gave you *Swallowdale*, the second in the *Swallows and Amazons* series. Though you went on to read all of Arthur Ransome's books many times, to yourself and then to your own children, *Swallowdale* remained your favourite. Like Beatrix Potter (like Wordsworth, a later passion), Ransome sets most of his books in the Lake District, in north-west England, where a family of four children on holiday from the south meet two girls who live in a big house on the lake shore. The Walkers' father is a naval commander, almost always away at sea, but he has given permission by telegram for his children to sail a boat and camp wild without adult supervision: 'better drowned than duffers if not duffers wont drown.' Chuck them in: if they drown we didn't want them anyway. It was reassuring to you to recognize the Owl's and the Jumbly Girl's attitude to parenthood in a book: incompetent children are better dead, competent children won't die – not, you think now, unlike the medieval drowning test for witchcraft, though at least in this version it's the deserving who survive. For the Walkers as for you, the edict was simultaneously liberating and frightening. Do what you like, but don't expect help.

Mrs Walker, who grew up on a cattle station in Australia, riding horses alone in the desert and spending time with

people she calls 'natives', is more concerned than the Commander for her children's welfare, but also places great value on independence and survival skills. We might note the confluence of imperial and military family stories, the daughter of Australian settlers married to the naval commander, though Ransome himself was left-wing, progressive, and the books' gender politics are noticeably liberal for their time, not that there's any incompatibility between imperialism and a certain kind of feminism.

John and Susan, the two older children, take up approximately parental roles, John as captain of the *Swallow* and Susan as mate. Susan is responsible for her siblings' food, water, fire, hygiene and first aid. John commands the boat, leads hikes and assesses risk. Titty daydreams, draws, writes stories and poems and makes up the role-play games that take over the summer. Roger, the youngest, eats a lot and makes jokes that aren't funny. Titty (Titania, you always hoped, though none of the books gives her full name) was your obvious companion, writer, dreamer, narrator of fantasy play, but you could never quite live up to her disembodiment, her absolute lack of interest in food and physical comfort, even as you envied her permission to outsource all such concern to her big sister. Titty's absorption in her creative and fantasy life seemed both enviable and dangerous, like someone walking along a clifftop reading, though Susan is always there to comfort Titty when her dark imaginings get out of hand and to feed her and remind her to brush her teeth and go to bed. Poor Susan, you could never quite stop thinking, though she was clearly meant to be the boring housekeeper/mother substitute. Maybe if someone else had

prepared the occasional meal, Susan could have had a dream of her own.

The Walkers meet Nancy and Peggy Blackett, whose father died in 'the war' (World War I; the next one is over the horizon, coming for the children as they reach their twenties), and who have grown up in the care of a mother and peripatetic uncle who embrace adventure and activity in rebellion against their own stultifying Edwardian childhoods. The sisters wear boys' clothes and sail under a pirate flag. Nancy's status as heroine turns on her refusal of the domestic roles accepted by Susan and Peggy. She, like John, takes the title of Captain and expects to command. She set a standard to which you could not rise; like *Little Women*'s Jo March, Nancy likes boys' clothes and has no patience for feminine weakness. Unlike Jo, her family and community support her gender expression. You were pretty sure neither heroine would have liked you.

Your copy of *Swallowdale* is so well worn that the pages are falling out, the glue made brittle by time and many relocations, the damp of old houses in England and the dryness of the underfloor heating in Iceland, where you sat between your children's mattresses on the floor and read aloud, nights when it had been dark since lunchtime and nights when daylight would continue for hours after they went to sleep. You have lost the title page on which careful printing in blue biro said 'To Sarah with love from Grandma, Christmas 1982.'

Your children liked *Swallowdale* less than the other books, because quite early on John fucks up. Trying too hard to prove himself, to be worthy of that inaccessible

Daddy, he smashes their borrowed sailing boat into a rock and sinks with all hands on board. It's a warm summer day, they can all swim, no real harm done, but John is certain that he has betrayed the trust of his parents and the *Swallow*'s owner and the siblings who call him Captain and everyone who has ever thought well of him. The adults, so negligent by modern standards in attending to health and safety, rally when emotional competence is required. Nancy and Peggy's uncle Jim, the first grown-up on the scene, steps ashore and sees the wreck. ' "Lost a mast? Holed her too? Well, these things will happen." He congratulates John on managing the mishap as well as possible, helps him patch up the boat while recounting a larger-scale disaster of his own making and escorts him to tell his mother what has happened. Meanwhile, 'what with all the swimming and diving that had been done that day, Mate Susan was thinking that it would be a good thing if the captain and the rest of the crew had something solid to eat. She opened a pemmican tin, and made pemmican sandwiches, good thick ones with one of the loaves she had brought across from the island.' Food figures as simple sustenance, fuel for active bodies, *and also* through food the colonial and class dimensions of these books are uncomfortably clear. *And*, not *but*: a book can be, perhaps most books are, simultaneously liberating for some readers and in collusion with the oppression of others (think – always – of *Jane Eyre*). No food without culture, no aesthetics without politics. As you would later say to generations of students, what you don't get is what gets you, and if as an eight-year-old you did not get the racial and class politics of what you read, that's because

those politics got you. The books were good art and in some ways freeing, partly for their recognition of the exhilaration and fear of children cast off, thrown in, and learning after all to cope. The Swallows and Amazons managed. You managed, survived, grew up, although you had to borrow from their pages wise Uncle Jim and the farmers' wives providing daily essentials. In the absence or withdrawal of parents, John and Susan find substitutes, get by, and care for their siblings well enough for everyone to have adventures. You had no John, no Susan, no uncle or Cook, but you had your grandparents and some of your friends' parents and later some of your teachers to show kindness. You went hungry but/and you had adventures.

You learnt the assumptions of whiteness without noticing them as you learnt to read. (What you don't get is what gets you. The page is white.) The Swallows' and Amazons' freedom is real, intoxicating, and also inseparable from the labour of local women and colonized people far away. You did not see this as a child because you were not meant to see it, because the dependence of one person's freedom on another person's oppression was taken for granted, though you did know enough to wonder at farmers' wives casually moved to press upon the children food that you knew took days to prepare. In *Swallows and Amazons*, Mrs Dixon offers John 'a big bag of brown toffee' when he rows across the lake to collect the morning's milk. "I'd nothing to do last night so I fettled you up a baking," she says. You knew toffee isn't baked. You had made it with your grandmother, wandering off to read while she guarded the big pan of boiling sugar for chapters at a time, entertained later by the

exertion required to hammer or saw it into pieces, less entertained by the cleaning up. Later, Mrs Dixon gives the children one of her prize-winning pork pies. You had seen the Jumbly Girl make the hot-water pastry and the spiced meat filling, boil up bones and soak gelatine to make the jelly for raised pies reviled but still eaten by the Owl. You knew how much women's work went into each dish, and you could see that the Swallows and Amazons did not know and did not think.

The 'pemmican' in Susan's sandwiches is canned corned beef, renamed by the children to erase the contribution of industrialized life from fantasy games rooted in ideas of noble savagery. They are playing at being explorers, discoverers, with the working inhabitants of the Lake District cast as 'natives' (you think now of the Owl and the Jumbly Girl's insistence on solitude and hardship in those same landscapes which were still dwellings and workplaces for other people). As for many explorers and discoverers, the feeling of wild adventure is founded on the provisions of industrial manufacture and so the sense of wilderness depends on the denial of dependence. 'Pemmican' was an anglicized version of the Cree term for meat pounded and preserved with fat and dried fruit, energy-dense and easily transported on long journeys, the kind of food that would have made a big difference to your mountain days. Settlers adopted the preparation and the word, which still appears on American prepper websites although usually in a commercially manufactured form because preppers are usually more interested in stockpiling industrially produced food than the obviously more sustainable practice of

learning to grow and cook their own. Food, even in children's books, especially in children's books, is never 'simple sustenance'. We can't go back to Eden.

Susan knows to prepare different sandwiches for her mother's visit to the camp in the aftermath of the shipwreck (you think of heads of state inspecting sites of disaster):

Susan had had everything nearly ready before ever Nancy had sighted the rowing boat . . . Now the kettle had boiled, tea had been made, and while the others were talking shipwreck . . . Susan had folded the old ground-sheet in two . . . for a table-cloth, so that when they came back . . . they found a tea worth looking at, with the lids of biscuit tins piled high with slices of fried seed cake (it had been dried by Peggy and it really did seem to taste all right) and sandwiches of bunloaf, marmalade and butter. Usually on the island it had been found best to carve one very thick slice of bread for each explorer and to put the butter on at the last minute . . . But today, thin, buttered slices, and small sandwiches neatly arranged in pyramids, suggested an orderly quiet world in which nothing could ever go wrong.

And Susan's tea saves the day, convinces Mother that as long as the local farmer's wife is willing to supply the children daily with milk, eggs and bread, they may camp at the site of the wreck rather than being required to return to the rooms she is renting for herself, infant Bridget and Bridget's nanny.

Unlike many writers of this period – Virginia Woolf, for example – Ransome never elides or erases the dependence of the middle class on other people's physical work. It is explicit that the children's summers of play are contingent on the readiness of servants, housekeepers and farmers' wives to provide support more concrete than that of the nuclear family, keeping the children supplied with meat and apple pies, fruit cakes, bread and cheese, eggs and milk. You were fascinated by the Swallows' interactions with these sonsy women, all so eager to feed, so generous with labour-intensive food. Imagine it, a kitchen where you can walk in tired and hungry and someone will give you rest and food, without resentment, without shame! Imagine taking such a thing for granted! Susan can and does cook, clean and administer first aid as required, but without the constant backup of these working women she would have few supplies and no time to do anything but cook for her siblings and friends. You would have liked that, someone who knew what you needed and gave it to you, someone to whom the practice of austerity was intolerable.

This is a difficult summer for the Amazons' mother and uncle, because their aunt, Nancy and Peggy's Great Aunt, is visiting. In a way you recognized from the Jumbly Girl's reversion to fearful and defiant adolescence in the presence of your grandparents, Mother and Uncle Jim are too scared of the Aunt's anger to oppose her explicitly but too resentful of her power to require compliance of the children. Nancy and Peggy are required to dress in white frocks and behave submissively at afternoon tea and formal dinner but allowed to escape in shorts and play at pirates when the

Great Aunt can be distracted. Cook, who simply sells her labour to the family, is free from this torturous psychodrama. After a particularly difficult morning, she hands the girls 'the big fishing basket' as they sneak away to join the Swallows:

> John and Susan saw at once that one person at least at Beckfoot had nothing against the goings-on of Captain Nancy and her mate. Cook had given them a fat beef roll, like a bigger and better kind of sausage. There were enough apple dumplings to go round. There were lettuces and radishes and salt in a little tin box. There was a lot of cut brown bread and butter. There was a hunk, the sort of hunk that really is a hunk, a hunk big enough for twelve indoor people and just right for six sailors, of the blackest and juiciest and stickiest fruit cake.

Most of that food probably comes from local farms, the salad from the garden at Beckfoot, though July seems early for Cumbrian apples, but the raisins and spices in the cake are the fruits of empire and we all know where sugar comes from. Cook, sometimes lovingly called 'Cookie' by the girls, has no name and even less life story than the other adults in these books, but you observed also ways in which she has more freedom than her employer. Cook, as Mrs Blackett very well knows and fears, can always give notice. Being a good cook, she can go. Her professional competence buys her independence from family drama. Note from your eight-year-old self: paid work offers a woman more in-

dependence than bourgeois domesticity. You notice also that there's no hierarchy of food, no sense that children might be disappointed by or not know what to do with lettuces and radishes and salt. There are six active, hungry, growing bodies here, and there is enough nourishing food for all of them. There is no interest in who eats more or less, no politics in the distribution. They share the meal and feel good.

You read all the time, but especially when you were hungry. Stories provided distraction and escape from your body's impossible demands. No wonder you read *Swallowdale* until it fell apart.

pink syrup

When you went to birthday parties, you were given a party bag at the end. Party bags contained a couple of small toys, which were cheap plastic rubbish, and a slice of birthday cake, icing fusing with the paper napkin in which it was invariably wrapped, sometimes a fragment of the child's name or new age in harder icing, or a smattering of rainbow sprinkles whose dye leaked into vanilla buttercream. If he saw it, the Owl cut off the icing, *sugar mashed into fat, revolting, only the English would do it.* There was always a small hoard of sweets, usually in a tiny pink-striped paper bag, actual sweets with artificial colourings and flavourings and glorious textures: rubbery foam jellies; marshmallows at once spongy and elastic; cola bottles fizzy and chewy, sometimes covered in abrasive sugar; glottal toffees that replaced the words in your mouth with a surge of sweetness; hard acid drops exploring the point between pleasure and pain; a miniature roll of Parma violets, chalky musk, which looked enough like the fluoride tablets you were given every night that it was hard to believe they were dangerous. Sometimes you ate the cake, a last mouthful of sugar and refined flour before the next party, but the sweets were taken away and put into the sweet jar, a curved stoneware vessel whose lid had a hole for a spoon, maybe designed as a large salt cellar. The sweet jar lived at the top of the corner

cupboard in the kitchen, out of reach even if you stood on a chair or climbed onto the counter, and what went in never came out.

But in the cupboard over the basin in the bathroom, there was a bottle of pink paracetamol syrup, sticky and years old because it was very rarely allowed, only to the Angel Boy when he had chickenpox. It tasted like the strawberry-flavoured ice lollies your grandparents sometimes bought for you from ice-cream vans, only with an interesting bitter back note, and because you could lock the bathroom door you could take the time to climb onto the side of the bath and up onto the counter around the sink, from which you could reach, you discovered, even to the back of cupboard, so for a while, until the level in the bottle fell low enough that you were worried someone would notice, when things were bad you allowed yourself a swig or two of pink syrup.

knowing that they could and didn't want to

Whenever they could, most weekends, the Owl and the Jumbly Girl collected you and the Angel Boy from your schools on Friday afternoons and drove straight to the Lake District, some three hours up the motorway. If you were quick, you could climb for a few hours and pitch the tents high on the mountain before dark to maximize the high-level hiking hours the next day. In winter, when it was already dark by the time school ended, they woke you hours before dawn on Saturday to be on the hills by sunrise, stopping at a service station where you were expected to eat a breakfast that would see you through until the next day. You were carsick and vomited again at the smell of baked beans and sulphurous eggs and the cigarette smoke that still fogged most public places. You had always been revolted by fried food *and that was your own silly fault and you paid for it with hunger. Well, you weren't going to waste away by Monday, were you?*

You and the Angel Boy carried your own kit: sleeping bags, wet weather gear, enamel bowls and mugs, thick plastic water bottles, while the adults took the tent and primus stove. Camping equipment was heavier then and the Owl and the Jumbly Girl, always inclined towards asceticism, minimized food. It was only, after all, a couple of days. *You'd had a huge breakfast and if you hadn't it was your own doing.*

You ate dried fruit boiled in water from the nearest stream for camping breakfasts. You liked the varied textures, the toughness of apple rings even after cooking, the furriness on one side of an apricot and sourness on the other, the graininess of dried pears, the vanilla smoothness of prunes, but once you set off into the hills you were soon hungry again and there was, as usual at weekends, no lunch. It was too much fuss, to stop whatever needed doing and make food. Hunger was weakness. You shouldn't need anything anyway after all that breakfast. You had learnt not to ask.

So? I hope you're not claiming that being taken hiking consti-tuted suffering. Do you have any idea, even now, what a lucky girl you were? Have you forgotten the food collections for the families of striking miners another two junctions up the motorway, have you forgotten how skinny some of the kids at your first school were?

Answer me this: would it be better to know that your parents wanted to feed you and couldn't, or to know that they could and didn't want to?
Seriously?

By the time you were ten your grandmother had given you her wartime copy of *Palgrave's Golden Treasury of Verse*, printed on almost see-through utility paper, and, inspired by Jane Eyre and Anne of Green Gables and Laura Ingalls Wilder, you had memorized a lot of Wordsworth and Keats and Tennyson and Matthew Arnold, mimicking your Vic-torian heroines with a self-administered Victorian education.

Following the Owl up mountains in all weathers and usually hungry, you recited to yourself. Behold her single in the field, yon solitary highland lass, reaping and singing by herself, stop here or gently pass. Men looking at women, but not the way the flashers looked at you and Kay. Alone she cuts and binds the grain, and sings the melancholy strain. O listen, for the vale profound is overflowing with the sound. You knew about fields and vales. Books taught you ways of looking at them, how to read a vale profound or a peak in Darien or the motherly moor that shelters Jane Eyre when she flees Rochester. You loved the gloomy lines, which gave you the same thrill as some of the more dour Christmas carols. Sorrowing, sighing, bleeding, dying, sealed in the stone cold tomb. Remember O thou Man, thy time is spent. Songs and poetry overlap, but it was the rhythm of the spoken word that was your metronome, not music. Old yew, which graspest at the stones, That name the underlying dead, Thy fibres net the dreamless head, Thy roots are wrapped about the bones. Tennyson, mourning his friend and lover Arthur Hallam, but you were impatient with adult passions, even Jane Eyre's. You loved the words. *Thy fibres net the dreamless head.* The footsteps of the English canon, dead, white and mostly male but beautiful for all that, walked beside you. You told no one what you read and learnt, kept the voices close, called them when you needed them.

You spent your days climbing mountains, the routes plotted by the Owl to maximize the achievement of miles, summits, ascents and technical challenges without much regard for the limits of children.

So? You rose to the challenges. You never had to call mountain rescue, did you?

But still there is photographic evidence – evidence is important here – of you, aged seven, rock-climbing with your arm in plaster—

sitting on a rock, you're exaggerating again, trying to make them look bad—

It's true that you sat for the photo but you remember climbing up to that seat, the discovery that the plaster cast helped to bear your weight as you reached and hauled, not that there's evidence for the climbing, so you're probably lying again, who wins, anyway, an argument about what happened before a photo was taken? But there is photographic evidence of you, aged eight, huddled on the back seat of a car below a mountain blue-lipped and white-faced on the edge of hypothermia.

Well, the arm healed fine, didn't it, in the allotted time, and you're forever turning blue-lipped and white-faced for no good reason, you do it to this day, sitting in a library or at your own table with a cup of tea, and you survived, didn't you, learnt to be tough, to push on.

Learnt to ignore your own distress of mind and body, and yes that learning has been useful to you, how else did you get this far, it's not that you're not in some ways grateful, but maybe one wears out, in the end, maybe there are after all limits to be reached, maybe sooner or later we reach them. In the evenings, the grown-ups sitting outside the tent drinking from a half-sized bottle of whisky that they had bothered to carry up the mountain where food was too heavy – *tea! It was tea, made with boiled water from the*

stream – cooking noodle soup with dried vegetables like bits in vomit, you and the Angel Boy played on the hillsides and in the high tarns. You knew how to amuse yourselves in that landscape, how to climb and descend, how to stay alive. You weren't duffers and you didn't drown, did you?

Let's whistle up the wolf. She can take food, this time, to the hungry child on the mountain. She can take a beef roll and a fruit cake and some apple dumplings. She can take ginger beer and chocolate, bunloaf with marmalade and butter, and the child can eat all she wants. She can eat her fill. Let's send her permission.

a friend called Keith

The Jumbly Girl had a friend called Keith.

Sometimes she went away with Keith, just a few days, every so often, maybe a week. For work, or something.

Keith came to stay.

Keith took you out for a walk in the village. You showed him the war memorial and the library. Keith asked you to choose a gift. Anything that will make you happy, he said.

The Owl did not like Keith.

He said Keith was limp-wristed.

Will it be a secret, you asked. If you want it to be, said Keith. You looked at him, made your assessment. Could I have a chocolate eclair, you asked.

You had never possessed a chocolate eclair. Sometimes they were in the bakery window, glossy and foamy. You thought whipped cream was ladylike, pale and airy. The Owl knew it was dirt and fat and sin. Cream was too bad to eat, ever.

Your eclair came in a box, hard to smuggle into the house but you managed. You put your eclair in your secret plastic tub and saved it. When you needed it, the tub smelt bad and the cream had turned green.

It is not easy to dispose of a mouldy secret eclair when you are seven.

getaway plan

You read Laura Ingalls Wilder, in the same voracious way as Arthur Ransome, over and again until the paperbacks began to disintegrate. The Owl, approving of the books' Americanism, soft power in the transatlantic war of your childhood, bought you the whole Little House series, one or two at a time, over the spring and summer of 1983, in the same Puffin editions as Swallows and Amazons, and you kept them through a dozen relocations, read them like Ransome to your own kids. Beginning in the Wisconsin woods in the 1870s, Ma and Pa and Mary and Laura and Baby Carrie leave their big wooden house near the big wooden houses of their aunts and uncles and cousins and grandparents. Pa trades the possessions of settled life for a covered wagon and horses to pull it, and the family sets off across the prairies in search of a new life – or, in the event, a sequence of new lives – in the west. Pa always wants to move on, Ma always wants to settle somewhere with a school for the girls and a church for regular attendance. Pa believes in independence, manifest destiny and white supremacy with the conviction of any manic Republican, but he's not very good at pioneering. His crops fail. He takes out loans he can't repay. He is perpetually surprised by weather and insects. On your second or third round of reading the series to your own sons, they would develop a

theory that Pa had held up a bank in the east and was in flight from the authorities, successive moves caused not as Laura claims by natural disasters or misunderstandings of property law but by the approach of the police (what police, on the prairies in the 1870s? The utter lawlessness of the place is one of many repressions in these books). Ma, the boys decided, had not been involved, because Ma would have known how to hold up a bank properly and would have had a better getaway plan.

You liked the Laura books partly because of all the moving. You like moving. You can't settle, don't feel safe. You like to learn a new place, a new light, a new sky. For both feminist and personal reasons, you remain distrustful of 'home'. Homes are places where vulnerable people are subject to bullying, violence and humiliation behind closed doors. Homes are places where a woman's work is never done and she is always guilty. It's better outside, fresh air, witnesses, community. Outside, you can run away.

Like her Pa, Laura likes to run away. She's another daughter hoping to grow up to become her father rather than her mother, to hunt the land and till the fields and keep moving. She doesn't like to cook or sew or clean, is delighted when Pa allows her to labour in the fields, substituting for the son who is needed and doesn't exist. Like Captain Nancy the Amazon pirate and Jo March in *Little Women*, Laura has a hard time with femininity, and like them, she made you feel inadequate because you did like to knit and sew and cook, still do, and you would have liked a frilled sunbonnet and a lacy petticoat under a pretty dress. You enjoyed Laura's less rebellious sisters, virtuous blonde

Mary, further sanctified by blindness as a consequence of scarlet fever, and especially Carrie, characterized mostly by shyness and physical fragility. You liked the fantasy of a Ma who was wedded to domestic routine and feminine propriety, though in real life you found rules and restrictions threatening and were proud of your liberty.

There were details of clothes and sewing that delighted you: overskirts, shirring, puffs, ruffles and pleats, all hand-sewn by Ma in her determination not to let her environment influence her daughters' dress. Laura and her sisters graduate to hoop-skirts and corsets at puberty, in the way that the girls in ballet books graduated to pointe shoes. In one scene, as Mary tries on her new dress in preparation for going to college, Ma and the girls admire her hair 'silkier and more golden than the golden threads in the plaid', 'her eyes bluer than the blue in it' and her 'stylish figure.' You wriggled with envious pleasure, but this admiration is preceded by a scene in which the trying-on stops because the dress is too tight. Mary has to hold her breath while Laura unbuttons her, until she breathes 'outbursting from the open bodice.' 'That bodice fitted well enough last week,' Ma says, and it's Laura who realizes that Mary's corset strings must have stretched in the summer heat. Laura tightens them and all is well, but she reflects that her own recently acquired corsets, 'were a sad affliction to her, from the time she put them on in the morning until she took them off at night.' Mary and Ma wear theirs all night too, and Ma worries about Laura's figure: '"When I was married, your Pa could span my waist with his two hands."' '"He can't now,"' Laura says, '"And he seems to like you."' Aged

nine, you were on Ma's side. If there was a way to control your figure, who in her right mind would let a little thing like 'the torment of the steels that would not let her draw a deep breath' get in the way? The idea of outsourcing the minimization of your waist measurement to a physical restraint seemed delightful. How much easier to tighten a corset than keep watch over every mouthful and never satiate hunger! You started to fasten the belt of your school uniform as tightly as you could around your waist every night, under your nightdress, but clearly an actual corset was required because all that happened was chafing around your undiminished belly.

The covered wagon offered the dual pleasures of mobility and domesticity, adventure always contained by order and routine. As Susan regulates and nourishes her siblings and friends, so Ma manages and feeds her children. There may be tornadoes, wolves howling around a tent at night, flooded rivers to ford and barely frozen lakes to cross, but there will be breakfast at sunrise, lunch at noon, dinner at sunset. Ma and her girls will wash on Monday, iron on Tuesday, mend on Wednesday whether the washing happens in a creek or a wooden washtub in a kitchen, whether the iron is heated on a campfire or at the stove. In the first few days of their long journey to 'Indian Territory', while they still have provisions from settled life, Mary and Laura wake in their small shared bed in the back of the wagon to hear Pa feeding the horses and smell the breakfast Ma is cooking. 'They washed their hands and faces in the tin wash-basin on the wagon-step. Ma combed every tangle out of their hair, while Pa brought fresh water from the creek. Then they sat on the

clean grass and ate pancakes and bacon and molasses from the tin plates on their laps.'

Pancakes and bacon and molasses! On the rare Sundays when you were at home, the Owl cooked what were called American pancakes, to distinguish them from the thin English (French?) ones that never came out right on Shrove Tuesday and, presumably for that reason, were never attempted at any other time of year. The Jumbly Girl claimed to detest America and Americans and disapproved of the pancakes. But you did not eat bacon with pancakes and you were not sure what molasses was.

You had maple syrup. Maple syrup!

Let the record show that there was maple syrup, that the maple syrup was hard to source in 1980s Manchester, doubtless expensive and preferable to molasses on pancakes. You weren't complaining, all you meant was that the molasses seemed exotic.

'In all the weed-tops tiny birds were swinging and singing in tiny voices.' Laura calls to the birds and Ma reproves her. 'You must mind your manners even if we are a hundred miles from anywhere.' Maybe forty miles, Pa says, to Independence. 'There was only the enormous, empty prairie, with grasses blowing in waves of shadow and light across it, and the great blue sky above it, and birds flying up from it and singing with joy because the sun was rising. And on the whole enormous prairie there was no sign that any other human had ever been there.'

Hold on. Stop there. Reading as a nine-year-old, you loved this *terra nullius* as Laura did, though like her you were vaguely aware that there was something not quite right

about the 'nature writing', an awareness possible only because the books hold their own undermining, their own discomfort. Other humans had of course been there for millennia and were still there, fighting for their own lands, defending ways of life sustained over generations and centuries. The 'Indian Territory' for which the Ingalls family is so misguidedly heading is part of a cynical deal done with the intention of replacing the original population with a white European one, hunting Native American people off their own lands so that all the Pas and Mas can have farms of their own, bringing deforestation and the extinction of flora and fauna in the wake of genocide. You knew almost none of the story as a child; even though you studied the Pilgrim Fathers in history when you were nine, an adventurous departure from the standard English curriculum on the part of a teacher who'd lived and worked in the US earlier in her career, Native American people appeared only as the emergency services for starving and disease-ridden colonists. But the trauma is there, seeping through books ostensibly about individualist triumph over adversity, manifest destiny and the civilizing of the Wild West. When the Ingalls family (temporarily) settle and build a house, they are near enough to an Osage settlement to hear music and singing and to entertain occasional visitors. "'I thought that trail was an old one they didn't use any more," Pa said, "I wouldn't have built the house so close to it if I'd known it was a high road." But only two pages later, after Ma has served Pa and a visiting 'Indian' a meal and they have shared a pipe, Pa says, "'Well, it's his path. An Indian trail, long before we came." Laura worries about the obvious distress

of the 'Indians', their 'jamborees' and 'war cries' and he explains, "'When white settlers come into a country, the Indians have to move on. The government is going to move these Indians further west any time now. That's why we're here, Laura." "But Pa," Laura says, "I thought this was Indian Territory. Won't it make the Indians mad to have to —" "No more questions, Laura," Pa said firmly. "Go to sleep."'

It's there, a thorn in the foot of the obvious racism, of the casual acceptance of genocide and forced migration. These books do not and cannot acknowledge the real history of America, but they don't entirely repress or erase it either. When the 'Indians' leave their settlement, the Ingalls family stand on their doorstep watching a procession that goes on for days, warriors and farmers and families riding away from their own lands. 'Ponies' manes and tails blew in the wind, beads glittered, fringes flapped, eagle feathers were waving on all the naked heads. Rifles lying on the ponies' shoulders bristled all along the line.' Women and children come, also riding. 'The ponies did not have to wear bridles or saddles, and the little Indians did not have to wear clothes. All their skin was out in the fresh air and sunshine. Their straight black hair blew in the wind and their black eyes sparkled with joy.' Laura, tied and buttoned into her drawers and petticoat and dress and apron, blinkered by her long-sided sunbonnet, her hair tangle-free and braided so it catches on the buttons of her dress, struggling to internalize nineteenth-century codes of conduct for young ladies that make even less sense on the prairies than in Boston and New York, is envious. 'She only wanted to be bare naked in the wind and the sunshine, and riding one of those gay little ponies.'

There it is, noble savagery, the idea famously articulated by Rousseau and still alive and well in surprisingly many surprisingly serious publications appealing to 'primitive tribes' and 'our ancestors' for evidence of how everyone everywhere ought to live, and especially how everyone everywhere ought to eat. With an understanding of the world already forming around the nineteenth-century poetry you learnt with your grandmother, inflected by the Owl's hippy puritanism, the idea that 'primitive tribes' lived in some kind of ideological purity seemed plausible enough to you. Shouldn't everyone, after all, consume minimally, scorn the fruits of late capitalism and overcome pain and sickness by willpower alone? It would take you another fifteen years to recognize the white supremacy underlying this fetish, on which you would write part of your PhD. Laura's envy of the Native American children is outrageous, perhaps more than the Swallows' and Amazons' soft-focus fantasy games. Because of Europeans' cold-blooded violence towards children as well as adults, European diseases and the indirect effects of the genocide destroying their families, communities, languages, arts and sciences, most of them will not survive to adulthood. Those who do survive will continue to be subject to violence, oppression, deprivation of all kinds, disease and the systematic destruction of their cultures. Laura will indeed have to wear a corset, marry as a teenager, lose a baby. She will be denied the freedoms a boy in her situation would enjoy, but she will live to a ripe old age in her own house and make a comfortable living as a writer. She would, in this moment, like to be naked and astride a naked pony, but she would not like to be on the

path those children are following. The family watch until the end:

'It was dinner-time, and no one thought of dinner. Indian ponies were still going by, carrying bundles of skins and tent-poles and dangling baskets and cooking pots. There were a few more women and a few more naked Indian children. Then the very last pony went by. But Pa and Ma and Laura and Mary still stayed in the doorway, looking, till that long line of Indians slowly pulled itself over the western edge of the world. And nothing was left but silence and emptiness. All the world seemed very quiet and lonely . . . Laura . . . sat a long time on the doorstep, looking into the empty west where the Indians had gone. She seemed still to see waving feathers and black eyes and to hear the sound of the ponies' feet.'

There is a haunting here, a space in the text for what is gone. *Little House on the Prairie* falls far short of what twenty-first-century readers could reasonably expect of a twenty-first-century book, but the effort to repress the trauma of American history is partial and ambivalent. You explained to your children along the way: these are myths of origin, and like most myths of origin they are founded in and elaborated on violence. *And*, not *but*: the liberation this time and place offers to Laura and by proxy to her readers is real and founded on genocide. This white writing has a visible shadow. Perhaps your kids would have realized without instruction, as you did, that while history is written by the victors, what is repressed returns in fiction.

We might wonder now why you, such a quiet child, in love with the forbidden trappings of femininity, took so

much pleasure in books where girls run wild, or long to run wild. The Owl and the Jumbly Girl wanted you to be wild, would have been delighted to see you riding a horse or sailing a boat dressed like a boy instead of lying about reading in the prettiest clothes you were allowed. When you were ten a new girl started in your class, a girl with beguiling green eyes, wholesome English colouring and fascinating hip-length hair, hair like Laura's and Jo's and Anne Shirley's, because her mother wouldn't let her cut it. Yours was shorter because the Owl didn't notice things like hair, thought it feminine weakness to think about appearances, and the Jumbly Girl didn't mind about experiments in hairdressing as long as you took care of it yourself. As so often, you prized your independence while finding other children's restrictions exotic. You'd read in a women's magazine to which the Jumbly Girl had an ambivalent subscription that shorter hair was better for fat faces, so you cut it and you didn't look thinner and the shorter hair annoyed you. Wendy didn't read or write unless she had to, wasn't interested in craft, art or design, couldn't see most of the problems that troubled you, more or less shared the Owl and the Jumbly Girl's view of you as neurotic and unnecessarily complicated and so, perhaps, brought the consolations of familiarity. You hoped Wendy's robustness, common sense and physical confidence might somehow rub off on you but now can't imagine what benefit you brought to her other than the pleasure of patronizing someone whom she believed to deserve it. You were convinced Wendy would have been a better daughter for

your family, that they would have swapped immediately given half a chance, not that her no-nonsense parents would have wanted you. She was Nancy Blackett, Laura Ingalls, maybe even Jo March. She rode horses bareback, played with large slobbery dogs, excelled at netball, changed into jodhpurs or jeans as soon as she got home. Given the choice between shorts and a flounced frock, naked bareback riding and a long dress with petticoats, you'd have gone femme every time.

Like other heroines, Laura is expected to internalize feminine discipline. Don't run, Ma is always telling her. Tidy your hair (but don't think you have anything to be vain about). Tighten your corsets (don't flaunt your body). Don't express opinions, contradict or raise your voice (don't be sullen or sulky). Unlike the March sisters and Jane Eyre, Laura never really accepts these rules, never pays them more than lip-service, partly because her environment doesn't support them. These are Ma's ideas, from the East and twenty years earlier, ill-adapted to prairie life. Laura works the fields with Pa, her skirts kilted up out of the way. She cuts her own hair the way she wants it, Ma watching disapprovingly. She supports herself and the family by working as the town schoolteacher from the age of fifteen. There's no explicit rebellion and plenty of respect for her elders, but the codes of femininity drafted in the cities of the East aren't really relevant: in a way that begins to disclose some of the enmeshed histories of feminism and colonialism, pioneer life grants Laura some space that Ma was never allowed to occupy. These books offered you both

physical and moral imaginary space, neither as easy as it first appears. Those prairies are the site of both liberation and security for Laura and her readers *and* must be inhabited and haunted by the dispossessed. Ma's reassuring rules don't hold. Good fiction holds conflicting stories, invites us despite itself to read against the grain.

your way around the garden

You knew your way around the garden. Near the back door was the herb bed, bushes of frondy fennel, shoulder height. Tasted of aniseed, which you didn't much like but found interesting all the same. Twiggy rosemary, watch out for slugs, bitter but fragrant. Soft mint leaves, lemon and pepper, furry and a little fibrous on the tongue but pleasant, a leaf or two in the mouth as you swung on the swing. In summer, strawberries by the pond, not many, lots of slugs, not really for helping yourself, and autumn raspberries – prickles! – against the high brick wall along which you liked to balance, though first you had to climb up the rope of the tree-swing and out along a branch. It probably wasn't as high as you remember.

Ivy grew over the back of the house, around the coal cellar and the back door, and there were foxgloves into whose speckled pink flowers you liked to poke your finger, and deadly nightshade which looked like a potato plant but wasn't. Don't ever eat those, the Jumbly Girl said, and don't ever let the Angel Boy eat them either. You thought of them sometimes, just in case, kept them like a spy's box of cyanide pills at the back of your mind, and one day when you were nine, when the bullying was at a crescendo, you picked a handful of ivy leaves and took them up to your room and ate them. Bitter and hard, what you deserved, shiny against

your soft tongue. That night you lay awake, waiting, wanting to meet your end open-eyed, but what came in the end was a sleep from which you awoke as usual and probably you didn't really mean it, not with any conviction, or you'd have eaten the deadly nightshade and the foxgloves as well, wouldn't you?

.

poor Keith

The Jumbly Girl took you and the Angel Boy to stay with Keith. Keith lived south of London, a whole day on the train. You didn't know there was anything past London.

Keith turned out to have a wife, called Flora. Flora had floofy hair and wore make-up and thin tights and the sort of shoes in which you can't run away. Poor Keith, married to a silly woman.

Flora and Keith had two children, who were also silly. One of them was a girl, but she didn't read or sew.

Flora said she was cooking. She took a box of fish fingers and a bag of oven chips from the freezer and put them in the oven. She emptied a bag of frozen peas into a pan of boiling water and boiled them for a long, long time.

Flora did not like the Jumbly Girl.

conquer themselves so beautifully

Your copy of *Little Women* is a hardback, dust jacket long since lost, red boards sun-bleached, steamed and water-marked from being read in the bath. You remember red dye on your knees in the bathroom with jungle wallpaper, green tiles and a brown bathroom suite.

Oh no you don't, that wallpaper was in the kitchen. Caught you!

The lock on the door was easily reached, at the height of the door handle, and you used it to feel safe, one room where footsteps on the stairs would not turn into judgement and scolding and shame: how can you lie about reading on a day like this, in a mess like that, when there's so much to do? The Owl gave you books, but he was working when you read them and for the Jumbly Girl, reading was self-indulgence, indolence, consumption not production, which was also how both of them saw eating. Eating was not an animal necessity but a lapse of willpower, to be deferred and resisted as long as possible. You learnt to read and eat secretly, in shame, in shameful pleasure. Reading was best done in the bathroom, with the door locked, and indeed you spent hours sitting on the toilet, knickers round your knees, book on your lap. If you were near the end of a book, you took two with you when going to pee. At the time you thought you were reading on the loo because you couldn't

bear to stop, because any time spent sitting down not reading was wasted, but now you see that the bolt on the door, the convention of leaving people in peace in the bathroom respected even in your house, promised security you felt nowhere else. You think about your adult preference for reading and writing in cafés, on trains and at airports, places where you can disappear in a crowd, run away any minute and there is no one to accuse or accost. (That's some nice white-lady privilege right there, says your friend T, you know some of us don't get to disappear, you know some of us know we'd get shot if we ran at an airport. Thank you, you say. He's right. It can be hard to see your own invisibility.)

The endpapers of Abbey Classics show exactly the kind of reading for which you might have longed. A young white man in a suit, or maybe a school uniform, sits on mown, daisied grass, leaning against a tree trunk, intent on the book resting on his raised knees. On the other side of the tree, a girl in a short-sleeved, collared dress, wavy hair cut in a bob, lies propped on her elbows reading a book. The sky behind the boy is filled with lightly drawn images of adventure: shipwreck, ice floes, someone who might be an eighteenth-century highwayman about to kiss a long-haired girl, a Native American man striding beside a white boy, a little girl riding a galloping reindeer. The girl's side of the tree shows a little girl in an embroidered blouse hugging a goat – *Heidi*, which you had in the same edition – a knight on horseback, an older couple in a moment of (clothed) passion. The young people under the tree are at ease, at leisure, healthfully and unashamedly outdoors – is it an

apple tree, is there a snake? – and simultaneously roaming these wide worlds.

Over the page, someone – some dead hand – has written in blue fountain pen, 'Christmas 1956, Uncle Reg, Auntie Kath & Ann'. A pocket-money, jumble-sale purchase. The one-paragraph introduction promises 'one of the most lovable books ever written. The Marchs [sic] were a typical American family of the last generation and the many ups and downs of their life makes [sic] delightful reading.' *Little Women*, you think now, *Little House, Little Town on the Prairie*, the diminutive arts of girlhood. Don't get big now.

You did not and do not find *Little Women* lovable, although you did reread it repeatedly as you reread everything between the ages of six and sixteen. Even to the extent that there has ever been a 'typical American family', the Marches were definitely and defiantly not it; their counter-cultural status, if not as marked as that of the Boston Puritan Alcott family, is part of the book's queasy appeal, especially to you as you grew up in a household defining itself against the mainstream. We meet the four March sisters 'knitting away in the twilight, while the December snow fell quietly without, and the fire crackled cheerfully within.' The setting bespeaks high thinking and plain living: a faded carpet, 'very plain' furniture but 'a good picture or two hung on the walls' and 'books filled the recesses.' The reader, it is assumed, knows 'a good picture' from a bad one; as you had already been taught, moral goodness is identical to good taste. Carpets and furniture are unimportant, or at least offer opportunities to display a taste for simplicity, but scant resources are well directed towards paintings and books.

The girls are discussing Christmas as they knit socks for soldiers: the opening line is Jo's 'grumble': 'Christmas won't be Christmas without any presents.' Even Laura Ingalls, grateful recipient of a stick of candy one year and a tin mug the next, would agree, but Meg reminds her sisters that their mother has asked them to give up Christmas presents 'because it's going to be a hard winter for everyone; and she thinks we ought not to spend money for pleasure, when our men are suffering so in the army. We can't do much, but we can make our little sacrifices, and ought to do it gladly. But I am afraid I don't.' The men are suffering in the American Civil War, fighting of course for the North and against slavery.

Meg, aged sixteen, 'very pretty, being plump and fair' (imagine it being pretty to be plump!), and Jo, fifteen 'very tall, thin and brown' (it's the naturally skinny heroine again), work full time, Meg as a governess and Jo as a paid companion to a 'nervous, fussy old lady', although 'I can't get over my disappointment in not being a boy, and it's worse than ever now, for I'm dying to go and fight with papa.' Amy is at school with girls who bully her because of the family's poverty, and Beth, 'a rosy, smooth-haired, bright-eyed girl of thirteen' is too shy for school and 'seemed to live in a happy world of her own, venturing out to meet the few whom she trusted and loved.' (You fight the urge to concoct amateur and anachronistic labels for Jo and Beth.) Mrs March returns with a letter from their father, away serving as a chaplain in the Civil War, and after a modest supper they gather around the fire to hear her read it aloud. 'I know,' it concludes, 'they will be loving children

to you, will do their duty faithfully, fight their bosom enemies bravely, and conquer themselves so beautifully that when I come back to them I may be fonder and prouder than ever of my little women.' The girls know that these 'bosom enemies' are themselves, their own failings. Men's enemies are other men, women must not only 'conquer themselves' but do so 'beautifully.' Again, self-control is the cardinal feminine virtue. Amy 'sobbed out', "I am a selfish pig! But I'll try truly to be better, that he mayn't be disappointed in me by and by." "I think too much of my looks, and hate to work, but won't any more, if I can help it," Meg cries. "I'll try to be what he loves to call me, 'a little woman', and not be rough and wild; but do my duty here instead of wanting to be somewhere else," Jo says. Beth does not speak, but 'resolved in her quiet little soul to be all that father hoped to find her.' The distinguishing characteristics by which the reader has been introduced to the girls – Meg pretty, Jo energetic, Amy strong-willed, Beth shy – are what they must overcome to avoid disappointing their father. As fictional characters, their quest is to erase themselves, and so like *Little House on the Prairie* the book is knotted, depends on what it claims to destroy.

The next morning the girls find that Marmee has given them each a copy of *Pilgrim's Progress*, which she calls their 'guide book' to lead them 'through many troubles and mistakes to the peace which is a true Celestial City.' *Pilgrim's Progress* is a spiritual autobiography – an account of coming to salvation – by the English Nonconformist preacher John Bunyan, written while he was in prison for sedition in the 1680s. It is a foundational narrative of Puritan Christianity

in which the everyman narrator achieves perfection by self-erasure. The battle for self-control ends in death, because the reward for victory is Heaven. Ups and downs of life indeed. There are children's editions of *Pilgrim's Progress*, which was acceptable Sunday reading in otherwise book-free Protestant households for three centuries, and so it was easy for you, following up the references as always, to find a second-hand copy for a few pence in the local bookshop. It's a recipe for striving, with the constantly deferred promise of eternal rest. Work harder than seems possible now to earn leisure after death; the logic strikes you as not unlike that of starving now to earn eventual eating. Get thin enough and you can have cake, save hard enough and you can be rich, hate yourself enough and you will be loved. You'll be thin enough, you'll have done enough self-deprivation, when you're dead. Where there's life there's inadequacy, and where there's inadequacy there must be striving. As an undergraduate, you would match *Pilgrim's Progress* to Max Weber's *The Protestant Ethic and the Spirit of Capitalism* and see the Yorkshire upwardly mobile working-class elements of your upbringing in a new historical light. Is it God or the market that wants you hungry and hard-working? Who, exactly, is served or saved by your self-control? As a ten-year-old, *Little Women* made you feel resentful and inadequate at the same time as it seduced you with domesticity and loving family life.

When the girls go downstairs on Christmas morning, the servant Hannah has set out a modestly celebratory breakfast. But Marmee, who has already been out to help 'some poor creetur who came a-begging', comes in just as

they sit down. She tells them that 'Not far away from here lies a poor woman with a little new-born baby. Six children are huddled into one bed to keep them from freezing, for they have no fire. There is nothing to eat over there; and the eldest boy came to tell me they were suffering hunger and cold.' The March women process across the city carrying their bread, pancakes, muffins and cream, to find a room 'with broken windows, no fire, ragged bedclothes, a sick mother, wailing baby, and a group of pale, hungry children.' No good pictures or recesses full of books here. The poor family, German-speaking recent immigrants (Jewish?), call the girls angels. The Marches return home to eat bread and milk, the narrator informing us that 'when they went away, leaving comfort behind, I think there was not in all the city four merrier people than the hungry little girls who gave away their breakfasts.'

There's the same narrative problem with the Hummels as with the starving poor in many nineteenth-century novels. They exist solely for the heroines to prove virtue, and have no moral qualities of their own. Austen knows this; in *Emma*, where power, love and moral standing come in culinary form, one of the ways we know that Emma has more integrity than Harriet is that Emma recognizes the subjectivity and agency of local families facing hunger while for Harriet, taking baskets of food to peasant households is a way to display her own marriageable qualities. The girls in *Little Women* are constantly battling their own desires, repressing appetites of one kind and another. Meg must learn not to enjoy clothes. Jo must repress her taste for Gothic fiction and mannish outfits, what we would now call

her queerness. Amy needs to recognize the moral failings of her peer group, cease to pay attention to her appearance and set her mind on higher things. Beth, having already achieved self-abnegation, is famously too good for this fallen world by her mid-teens. It was all painfully familiar to you, and you were ambivalent about the novel's collusion with the girls' self-destructive quests. Here, at least, was a book that did not ask you to be Nancy Blackett, but it did not really give permission to be anyone else, or to be at all: imperfection is intolerable and perfection is death.

Laurie, the boy in the big house next door, possesses and represents pleasure and comfort. His grandfather's house has flowers, music, fruit and ice cream, what the Jumbly Girl would have called – not without longing – 'flummeries', meaning transient, unnecessary and often extravagant objects of desire, but it does not, inevitably, have love or the moral superiority of the Marches' plain living and high thinking. You thought of your grandparents' house, where the heating was always on and there were plush velvet armchairs and gold-rimmed flowered china and several kinds of cake in the tin, and apparently no comeuppance. Laurie – otherwise not much like Jane Eyre's Rochester – will have to know loss and learn humility before he can have the happy ending of marriage to a virtuous woman (Amy, reformed), and even then the pleasures of prosperity are marred by infertility.

Little Women is uncompromising and narrow in its vision of the good life. Marmee tells her girls, 'To be loved and chosen by a good man is the best and sweetest thing that can happen to a woman . . . It is natural to think of

it, Meg; right to hope and wait for it, and wise to prepare for it; so that, when the happy times come, you may feel ready for the duties, and worthy of the joy.' 'Poverty seldom daunts a sincere lover. Some of the best and most honoured women I know were poor girls, but so love-worthy that they were not allowed to be old maids. Leave these things to time . . .' If you are 'love-worthy', devote your time to hoping, waiting and preparation for duty and you may be 'chosen by a good man.' The context of this lecture is Meg's confession on her return from a fortnight's visit to a wealthy friend, made possible by her employer's children catching measles. The sisters pooled their best ribbons, petticoats and accessories to help Meg keep up with her friends. Marmee opened 'a certain cedar chest' in which she 'kept a few relics of past splendour, as gifts for her girls when the proper time came.' But the proper time has not come and the 'old fashioned pearl set' is withheld: 'mother said real flowers were the prettiest ornament for a young girl.' Meg asks Beth to sew ribbons on her nightcaps to match those of Annie Moffat but Jo contradicts her: 'the smart caps won't match the plain gowns, without any trimmings on them. Poor folks shouldn't rig.'

Marmee has reservations about allowing Meg's holiday, but the Moffats are 'kindly people in spite of the frivolous life they led' and Meg has good enough instincts to feel 'without understanding why, that they were not particularly cultivated or intelligent people, and that all their gilding could not quite conceal the ordinary material of which they were made.' (You remembered the Jumbly Girl assuring you or herself that you would understand the difference between

your family's austerity and Lulu's warm lounge and fast fashion when you were older.) Even so, Meg is self-conscious about her clothes and 'the more she saw of Annie Moffat's pretty things, the more she envied her, and sighed to be rich.' (Even so, you envied Lulu's Barbie.) When Laurie sends her flowers as promised, to wear instead of jewellery, Meg shares them around the assembled girls and feels better for the opportunity to be generous, but she overhears the mothers supervising a party remarking that 'Mrs M has laid her plans, I daresay, and will play her cards well' in marrying Meg or one of her sisters to Laurie, thereby securing the family's fortunes. This is, of course, exactly what happens a few years later. Laurie wants Jo but has to be satisfied with Amy, partly because Jo can't see herself as a rich man's wife. Alcott, like Austen, has to write romance, has no happy ending other than marriage available, and like Austen resists and undermines the romance form at every step. Austen's heroines are also repeatedly presented with silly, clothes-obsessed women who cynically devote their intelligence to maximizing their return on the marriage market rather than building the cultural capital and moral fortitude that, in the fantasy world of romantic fiction, net the biggest fish. In this puritan version of romance, the reward for not trying to be attractive is that you deserve – but may or may not get – the most attractive man. (Work hard here below for eternal rest in the hereafter, refuse food now and you'll earn the right to eat later, don't spend your money and you'll be rich in years to come. Strive, save, discipline mind and body and whether you are eventually rewarded or not, you will have the satisfaction of knowing that you deserve to inherit

the earth and marry the hero. Most of all, take all this for universal truth, don't notice that it's the gospel of white European Protestants.)

On the last night of Meg's visit, the Moffats give a dance. Meg, forced to admit that she has only one plain, old-fashioned party dress, allows Annie's older sister Belle and her French maid to conduct a make-over. 'They crimped and curled her hair, they polished her neck and arms with some fragrant powder, touched her lips with coral-line salve, to make them redder . . . They laced her into a sky-blue dress, which was so tight she could hardly breathe, and so low in the neck that modest Meg blushed at herself in the mirror.' They lend her jewellery, a fan, high-heeled boots – the whole dressing-up box - and teach her 'the management of her skirt' and how to walk in heels. Meg 'very soon discovered that there is a charm about fine clothes which attract a certain class of people', and spends her evening dancing, flirting and even drinking champagne. But Laurie has been invited, and is frank about his dismay at her appearance and behaviour. 'Please don't tell them at home about my dress tonight,' Meg begs, promising that she will ''fess to mother how silly I've been.'

Sent by parents who disdained worldliness, frivolity and unnecessary expenditure to a school where social status depended on the display of wealth and conformity to codes of behaviour you did not recognize, much of the ethos of *Little Women* and its sequels was familiar to you. The second-wave feminism that had liberated the Jumbly Girl from aspects of her 1950s provincial upbringing had much in common with Louisa Alcott's Boston puritanism. The

Owl and the Jumbly Girl valued the 'natural' body, as long as that body was 'naturally' slim and strong. They did not use deodorant or remove body hair. The Jumbly Girl did not wear make-up. You didn't like being so different from your peers at the time, but you live your adult life in a broadly similar way, because – because it seems obviously better.

They weren't wrong. Intensively farmed, highly processed fast and cheap food and clothes do us and our habitat no good. (Privilege again, yes. Not everyone can grow their own salad. Not everyone can buy organic fairly traded raw ingredients, or clothes made to last by people paid a living wage. But you do not see how anyone is well served when people who can afford to make these decisions choose not to do so. Better, perhaps, to buy chips and doughnuts and give the money to the food bank, but then who supports the small-scale farmers working their land in sustainable ways?) The Jumbly Girl was and is good at making clothes. They were good clothes, and she and you are still wearing some of them thirty years later. But good taste was, like Marmee's, rooted in moral superiority. People who wore high heels or lipstick, who drove expensive cars and laid soft carpets in their houses, who stayed in hotels instead of camping and lay on the beach instead of climbing mountains, went to restaurants instead of fasting until there could be a home-cooked meal, might have had more money than you did but they were morally and intellectually inferior.

You went to restaurants, have you forgotten, you went to the Indian restaurants in Rusholme at least once a month, a decade before it was called Curry Mile, and to Chinatown,

you knew how to use chopsticks before you were four! You said, just a few pages ago, you said there was carpet, you actually wrote about how it felt to walk on.

Asceticism was its own justification. Not having things was better than having them. In particular, women who 'did themselves up' were 'tarty' (in dresses so low that modest Meg blushed at herself in the mirror), which now strikes you as an odd line for a feminist of any generation but has strong antecedents. Wollstonecraft herself scorned women who were interested in dress, who displayed their bodies or attempted to attract men. High heels were tarty. Short skirts and/or close-fitting tops were tarty. Perms – it was the 1980s – were tarty. You and the Jumbly Girl, in your hand-made loose-fitting Liberty dresses, in your cord trousers and hand-knitted jumpers, in sensible shoes with your natural hair and skin and smell, were better than that, the way Meg is better than her corseted, bejewelled, rouged friends, the way Jane Eyre in her 'Quakerish' plain black dresses and firmly plaited hair is better than the aristocratic husband-hunting girls in their bright silks and ringlets.

You still knit and sew your own clothes, though the materials are more expensive than finished clothes in shops before you even think about valuing your time. You buy sensible shoes and boots and look after them so they last for years, for embarrassingly long, so that in photos of your now-adult kids as small children you're wearing the same beloved boots with the orange laces. Your hair started to go grey in your thirties and you don't dye it. You've never owned a hairdryer, don't like the noise.

You mean to put sunscreen on your face every day

between the equinoxes – the switch between taking Vitamin D in the winter and using sunscreen in the summer the last vestige of equinoctial rites of passage – but often you forget, as you also forget the vitamins. You've never used moisturizer or lotions of any kind, though when the skin on your hands and feet cracks and bleeds in the winter you sometimes look for the hand creams your husband gives you every year or two. You were not raised to think your body worth much care. People might, if they ever think about it, think you older than you are but you can't see why it would matter.

Still, you want to stand up for the Moffat sisters, for Blanche Ingram in *Jane Eyre*, for Lydia and Kitty in *Pride and Prejudice*, for the silly girls whose minds are full of frills and ribbons, who can't even dance properly in their high heels and corsets, much less climb a stile or cross a muddy field, partly because they are right. As Austen repeatedly points out, only in novels does being plain and clever, poor and quiet, get you the handsome young man with the big house and plenty of servants. If it's a marriage market, you'd better get out there and sell your wares, even if part of what you're selling is that idea that you're not for sale. Romantic fiction is a double bluff. The fantasy is that you might win by refusing to play the game and despising those who play to win, except that for many nineteenth-century women it's not a game at all but a means of survival.

a friend called Hugh

The Jumbly Girl had a friend called Hugh.

Sometimes she went to visit Hugh, just for a few days.

She took you and the Angel Boy on the train to stay with Hugh, in a white house with bay windows on the Isle of Wight which was even further south than Plymouth, practically in France.

Hugh's wife wasn't there any more. He had a daughter called Patience. Patience had long mousy hair and liked to read school stories.

Hugh did not buy you eclairs.

The Owl did not like Hugh.

famished great girls

You read *Jane Eyre* far too early, as many girls do. You still have that book, though in your office you keep more recent scholarly editions for teaching. Your home copy, for reading in a different way, has lost its cover. It's the Penguin English Classics edition, first published with an introduction and notes by Queenie Leavis in 1966, reprinted in 1977 when the Jumbly Girl bought it because she was teaching an evening class on nineteenth-century art and culture. The title page informs readers that 'Q. D. Leavis is the wife of the distinguished literary critic, Dr F. R. Leavis, and has taught in Cambridge for many years.' You don't know whether to hope she wrote that note herself or that she fumed over it until her dying day. You didn't pay much attention to the title page, anyway, though you did recognize that the novel's teasing subtitle, 'an autobiography', is part of its fiction, that the inventing has started before the claim to truth. *Jane Eyre* is an autobiography to the extent that all first-person fiction is autobiographical. It's a life story, just a fictional one.

Oh yes, nudge nudge, wink wink. You're not Charlotte Brontë. Not that she got away with it either, wasn't there a campaign to ban that book, didn't the vicar threaten to sue?

You didn't read this or any other introduction or endnotes, didn't notice or imagine the idea of literary criticism, until you were applying to university and first learnt that understanding literature is not the same thing as loving books, that there are good and fruitful relationships between readers and books that are not about passion. Even so, most readers' relationships with both Jane Eyre and *Jane Eyre* are exactly about passion.

We read Jane Eyre too young because it's a school story, beginning like many children's classics with a heroine in exile from the nuclear family. Jane is orphaned in infancy, taken in by an uncle and left after his death in the care of an aunt who dislikes and distrusts her. We meet her reading a book borrowed from her cousins' library, sitting 'cross-legged, like a Turk' (hello again, feminist racism) in a window seat, the curtain drawn to make a hiding place from which she can see out into the November garden and enjoy the comfort of indoor reading on a rainy afternoon. She's not eating, but apart from that is in the state to which women and girls are said to tend if left to our own devices, secretly curled up with a book, consuming stories, doing nothing useful and very probably filling our heads with romance, fantasy and other misguided notions.

Women, unreliable narrators the lot of you.

He never said that, when did he ever say that, he was taking female PhD students years before it was fashionable, there were two female post-docs in his team before the millennium changed.

Jane's cousin John is home from boarding school where he fell ill because 'he gorged himself habitually at table,

which made him bilious . . . Mr Miles, the master, affirmed that he would do very well if he had fewer cakes and sweet-meats sent him from home.' John finds Jane reading, accuses her of 'rummaging my bookshelves' and attacks her, ending by throwing the books one by one at her head. Jane, shocked and bleeding, rage following terror, shouts "You are like a murderer – you are like a slave-driver – you are like the Roman emperors!" 'I had read Goldsmith's History of Rome, and had formed my opinion of Nero, Caligula, &c.' the older, narrating Jane tells the reader. You had not, at the age of nine or in fact since, read Goldsmith's *History of Rome*.

You're pretty sure this was your first introduction to Nero, Caligula, &c., and also to that rendition of et cetera. Like many readers – you suspect many nineteenth-century as well as later readers – you developed a knowledge of Classical and biblical history and literature by inference from fiction. For you at nine, Nero and Caligula must be like John Reed. Four decades later, despite studying Latin for six years and reaching – briefly – the point where you could read Virgil, your knowledge of Roman history is still filtered by Victorian fiction. You know Greek myths from Romantic revisiting of them. Without Virginia Woolf's justi-fication for the lack, you have the ghost of a classical education.

The Reeds send Jane away to Lowood, a spartan boarding school where the girls are cold, hungry and without access to sanitation, but also thoroughly educated because the school is for fatherless middle-class girls who will have to support themselves. There are many nineteenth-century novels about women in this position, the 'middling sort'

who interested Mary Wollstonecraft, too respectable for manual labour in factories, fields and private houses but without male relatives to keep them in genteel security. By taking manual work, or even working in a shop or business, middle-class girls would lose all remaining social status and become unmarriageable, but without paid work and in the absence of a secure and supportive family, they are at risk of ending up on the streets. Frances Burney's novels explore the lives of middle-class girls who fall through the net of the eighteenth-century family – perhaps that's why they are less popular than Austen's – and half a century later Charlotte Brontë skirts the possibility.

Jane suffers at Lowood. Mr Brocklehurst, the school's director, finds it his duty as well as his pleasure to humiliate the girls by dressing them in a bizarre, uncomfortable and inadequate uniform, punishing the pretty ones by cutting off their hair, requiring them to walk miles without food through rain and snow, in flimsy shoes and without gloves or warm coats, to attend two church services every Sunday. Their food is horribly scant: 'with the keen appetites of growing children, we had scarcely sufficient to keep alive a delicate invalid. From this deficiency of nourishment resulted an abuse which pressed hardly on the younger pupils: whenever the famished great girls had opportunity they would coax or menace the little ones out of their portion.' But Jane is loved, and educated. She befriends Helen Burns, a saintly scholar a few years older and wiser. The kind headmistress, Miss Temple, notices and encourages Jane's intelligence. Inviting Jane and Helen to her study after Jane has been publicly scolded by Mr Brocklehurst,

Miss Temple takes a seed cake from a locked drawer and 'cut slices with a generous hand.' Adequately fuelled for one evening, Helen translates Virgil, discusses French literature, displays a breadth of knowledge that Jane finds dazzling and wonderful. Poetry, literature and history books open new worlds to a hungry and unwanted child. Jane begins to apply herself energetically to her studies and 'my success was proportionate to my efforts . . . exercise sharpened my wits.' Hard work is rewarded. Exertion makes you better. Jane's French improves, she commits to memory the facts that constituted the learning of history and geography at that time and she learns to draw, replacing night-time fantasies of 'hot roast potatoes, or white bread and new milk' with those of being able to sketch 'picturesque rocks and ruins.' Rise above your bodily desires, find safety in the life of the mind. Spring comes, and summer. Jane finds 'a great pleasure, an enjoyment which only the horizon bounded' in 'the prospect of noble summits girdling a great hill-hollow, rich in verdure and shadow; in a bright beck, full of dark stones and sparkling edges.' She learns to enjoy landscape, to be uplifted by 'unnumbered varieties of moss' and 'a strange ground-sunshine' made by 'the wealth of [Lowood's] wild primrose plants.'

You knew Jane's landscape. Except for Charlotte's *Villette*, set in a boarding school in Brussels where a Protestant narrator starves herself and feels morally superior to pretty Catholic girls who eat cake, the Brontës are Yorkshire writers of Yorkshire books. Your grandmother, ardent plant-lover and lifelong explorer of Yorkshire's hills and fields, had taught you to look at mosses and primroses, to notice the

outdoor world on a small scale, while the poems she gave you taught you words for the wonder of mountains and sky. Your grandparents knew how to play but also how to leave a person in peace, and you had plenty of moments of solitary aesthetic joy. At Jane's age, you saw yourself in her: independent by necessity, hungry, outside the mainstream by circumstance and inclination, in secret but life-saving rebellion. You were wrong, of course; your day and generation gave you access to forms of capital available only in fantasy, which the novel's ending provides, to a Victorian orphan girl.

In *Jane Eyre*, food, shelter and warmth are never taken for granted. While Jane is still living with the Reed family at Gateshead, the nurse Bessie shows her the sympathy she cannot voice by giving her a seat by the fire and bringing her a 'circlet of delicate pastry.' There is Miss Temple's seed cake, and when Jane leaves Lowood for her post as governess to Mr Rochester's illegitimate daughter Adele at Thornfield, her welcome to a warm fireside and 'a little hot negus and . . . a sandwich or two' assures us of a safe landing, assurance that is in the end false but needed in the moment. She may be misled at Thornfield but she is always warm and well nourished. When Jane discovers the existence of Bertha, Rochester's mad first wife who lives locked in the attic, she runs away and immediately becomes indigent, sleeping rough and begging for scraps of pig food.

Rescued from imminent hypothermia and starvation on a moor by a family of scholarly, plain-living and high-thinking young people, Jane is almost literally mothered: 'Diana broke some bread, dipped it in milk, and put it to

my lips. Her face was near mine: I saw there was pity in it, and I felt sympathy in her hurried breathing. In her simple words too, the same balm-like emotion spoke: 'Try to eat.'

Jane Eyre is only intermittently a realist novel, the plot turning on supernatural sights and sounds and wild coincidence. As Queenie Leavis points out, none of the dates add up, with characters reading books unwritten and unpublished in the years suggested elsewhere. Its final fantasy is that of most feminist romance, that the plain, clever heroine might win the marriage game by not playing, and that there is a way to retain the erotic charge of power in a heterosexual relationship without the accompanying social and economic inequality, in this case by amputating the hand of the Byronic hero, blinding him, burning down his house and providing a string of coincidences to give our poor orphan heroine a whole lot of money and a ready-made family. (It would surely be easier if she just got together with Diana.) But one of the novel's minor hopes – you will not call them fantasies because you share this hope – is that the world will provide, that there is a sufficiency for all of us, that we will not die on the roadside of cold and hunger. There is faith in civilization.

In early readings, you were bored by the ending of *Jane Eyre*. Helen the interesting best friend was dead and Jane, your imaginary companion in reading, rebellion and outdoor life, lost to the dull world of romance. Your instinct, you think now, was correct; the marriage plot is inevitable for Brontë but the book is more excited about female friendship and the life of the female mind. The happily-ever-after rings hollow because the sisterly relationships that have sustained

Jane through her tribulations become peripheral to marriage to a man who has lost whatever questionable Byronic appeal he ever had. *Jane Eyre* works best, you intuited then and can see now, as a book about the fellowship of motherless and scholarly women.

Your friend A says the unmothered often find each other, and you think of your other friends. Not all of them, but most. You think that often the unmothered have learnt to look to the wider world for nourishment of one kind and another, and have found what was needed. The unmothered are excellent foragers.

blood

It was surprising to everyone that you passed the Senior School entrance exam. You muddled through the first year, bottom of the class but somebody had to be, last to be picked in every PE lesson when two popular girls were made team captains and took turns choosing who was on each side at hockey and netball and lacrosse, one of few to fail auditions for the choir, embarrassingly bad at everything that mattered and barely passable in some less important undertakings such as French and Art.

Your school didn't have a pool so you were taken on buses to the boys' school, where boys climbed onto the roof to see into the changing rooms through the high-level windows. The PE teacher went along the bench snatching towels from girls who were trying to hide their bodies. We're all women together here, she shouted, stop being so silly, though she kept her tracksuit on and commanded from the side of the pool. After the first couple of weeks most of you wore your swimming costumes under your clothes and kept them on wet afterwards, white blouses clinging under scratchy nylon jumpers for the rest of the day.

By the second year, bodies were changing, a new hierarchy emerging, and everyone was on a diet. It was the era of heroin chic. You and your contemporaries had known nothing else, didn't recall the curvier shapes of 1980s su-

permodels, much less the hourglass figures celebrated in your mothers' 1950s childhoods. Beautiful bodies were thin, thin bodies were beautiful, the more thin the more beautiful, the more beautiful the more thin. The photos in the teen magazines you passed around showed hipbones jutting under tanned white skin, ribs you could count, collarbones around which fingers could almost meet, knees and elbows the widest points on arms and legs. The magazines gave the weights and heights of the models and singers you were to emulate, all of them, you see now, approaching the red zone on the BMI charts with which you became familiar. It was as though if you could achieve your heroine's weight, you would achieve her fame, her success, her American teeth and wavy hair, as though weight control was the girlish route to power. Kirsty could touch her thumb and middle finger around her upper arms. The best girls could encircle a thigh with their hands all the way up to the crotch. See this, said one of the Claires, lifting her shirt to show a ridged torso tanned from her summer holiday, this isn't even bone, it's pure muscle, but pure muscle was not in fashion. Most girls couldn't or wouldn't commit to the level of self-destruction required to meet the cultural ideal. They began to sound like their mothers: I really shouldn't but oh I can't resist, just this once. I can't help myself when I see chocolate.

You could resist. You could help yourself. No one had ever suggested that your hunger was an excuse for eating, you were used to it.

School held weekly cake sales in the morning break, when each class chose a charity – cute animals were popular,

human rights were not – and each mother baked a cake which was sold slice by slice for less than the cost of the ingredients, never mind the mothers' time. The Jumbly Girl did not bake cakes, had never baked anything but bread. After her response to the first letter you took home, you knew not to ask, and it's not, you think again now, that she was wrong; if she'd wanted to give ten quid to a donkey charity – she didn't – she could have done it without also having to give her labour. She was right, a girls' school with an ostensibly feminist ethos treated mothers' time as worthless. Many of your teachers had entered the profession in the decades when married middle-class women didn't work. They'd chosen intellectual and professional life rather than marriage and maternity and had little interest in or respect for those who'd gone the other way. If you didn't want to spend your days baking Victoria sponge cakes to subsidize retirement paddocks for overworked horses, you shouldn't have had children. Don't ever learn to type, your maths teacher told her classes, and don't ever learn to make a cup of tea, that way you can't end up as someone's secretary. Domestic competence was the enemy of promise.

As well as the weekly cakes, there was a daily 'tuck shop' where girls who had skipped breakfast to lose weight could compensate with Mars bars and Hedgehog crisps. For tenpence, you could buy a packet of ten Chewits and make them last all day, two hundred calories of sugary comfort instead of the BSE burgers and mushy peas, the gravy and custard, offered in the canteen, though you seemed to be the only one to whom it occurred to skip lunch as well as breakfast, the only one who could choose not to eat cake

however good it looked and however hungry you were. Being hungry was hard, choosing to stay that way wasn't. You were getting what you deserved, and you were getting it first, before anyone else could tell you.

You went to pee one day at school, in a stall in the dark hallway off the Lower Fourth's cloakroom. You wonder now what the cleaners, who were the only adults to see those toilets, thought of the graffiti on the walls. Someone had drawn a small girl being held down by a stick figure while an erect penis bigger than the child approached her spread legs. Someone had written 'I want to die' over and over again, like the lines you sometimes had to write as punishment. Someone had carved the outline of a phallus deep into the door, a job that must have taken a long time, and though it had been painted over you would have had to replace the door to get rid of it. You sat there, looking at these and other things, and saw a wet rusty stain on your white knickers.

You knew what it was. You'd been dreading it for months. You'd been told you could go to the school office if you were ever caught short, but you would no more have done that than paraded naked down the street waving that bloody underwear. You rolled up scratchy school toilet paper, went on your way feeling sick and ashamed, as though you could have stopped this filthy thing happening to you. The cramps came, sharp enough to make you whimper and gasp, and you spent the afternoon hunched over arms folded across your middle. Back home, you stole a pad from the Jumbly Girl's wardrobe, tried to wash out the stain but you didn't know to use cold water so you rolled up the knickers to

push into a bin on the street on your way to school the next day. The blood was dark and clotted and there was a revolting smell. Your budding breasts hurt and you wanted none of it.

You're not sure you knew that periods begin as you cross a certain weight, or that forcing your weight back below that number can make them stop, but you did know that you were good at dieting, that you knew how to control at least some aspect of your appalling body, and you did know that it was good to be thin. You knew that you didn't want to keep going this way, to be a woman, and you knew how to stay small.

Send in the wolf. Hope the wolf knows what to say because the truth is that you never did come to terms with it, the mess always seemed a failure of control, you were always ashamed. Pills and coils did their tricks and thirty-five years later it's all over but what help is that, to a thirteen-year-old?

never happened

There were tender swellings on your chest. You could see what was coming and you did not want it.

Someone else saw it too. Hands, cold like yours, pushed up under your thermal vest and your school shirt and your navy jumper. Paddling at the sore nubs. There were code words, a private language.

Let it feel the buds, let it feel, someone said, but you had no choice, to let or not.

And? You do know some kids get raped, right? You're not claiming that hands up your top makes you some kind of lifelong victim. I hope you're not suggesting that any of this constitutes trauma.

One day, ten years later, weeping, you told the Owl what had been done. There was a long silence before he said: I believe you. You were somehow surprised both that he should think you would expect not to be believed and that he did believe you.

That never happened, you never made this absurd allegation before and if you had he would certainly not have believed you.

Girls' bodies were fair game. You all knew which were the gropey dads, whose brother would try to get you into his bedroom when you went round to play, whom you shouldn't visit when her grandfather was there. You protected each other, didn't leave a friend undefended, because you knew the adults didn't want to know. The system failed once, at a Bonfire Night party when you were fifteen. You and Suzanne hurried to tell her dad, come quick, Jen's dad's got Cathy in the spare room and we can't get in. Be quiet, Suzy's dad said, the man's a doctor, you could ruin his career saying things like that.

batterie de cuisine

This time you went about things more scientifically, with the resources of a teenager. You bought a book about how to lose weight, which came with recommended calorie limits and weight charts. It did not seem relevant that your weight was already below the 'healthy' section on the chart; probably what was healthy for the imagined adult female readership was overweight for a thirteen-year-old, and anyway everyone knew that you were fat. The book gave daily limits for a man – all men were apparently the same as far as metabolism was concerned – a tall, active woman, who was allowed about two-thirds of the man's ration, and a small or particularly fat woman, who had a half or a third of what permitted to the man, about the same as inmates of the Warsaw ghetto in 1940. You were just tall enough for adult women's clothes, just graduating from Mothercare to British Home Stores, and you felt particularly fat.

The Jumbly Girl had at last worked her way through volunteering and part-time teaching into full-time professional life, and was commuting weekly to another city. You had started to cook dinner on the nights she was away, because if you didn't the Owl took you and the Angel Boy to restaurants

you said you didn't go to restaurants!

and then the Jumbly Girl raged at your extravagance

when she came home. The diet book included recipes, but they required a way of cooking that you didn't know, weights and measurements and timings where you'd learnt from the Jumbly Girl and your grandmother to use whatever was in season in whatever quantities came to hand, to sear the meat, cook the onions and garlic until they were mostly cooked and then add the herbs and spices and faster-cooking vegetables, to steam a handful of rice per person or boil as much spaghetti as you could hold in the overlapping circle of your thumb and index finger. The diet book thought of steaks and chops, potatoes and bread and butter, apple crumble that could be made without fat and served in small portions, fruit jelly. It was easier just to eat less, to leave for school without breakfast, to avoid the canteen again, to explain at dinner time that you'd skipped revolting school lunch and had an afternoon snack so large that you were now too full for dinner.

The book said you would be hungry but you would get used to it, that as your body shrank your energy requirement would fall and your appetite would align to your new figure. There is an extent to which this is true – hunger is hardest to endure for the first few days and then your metabolism slows down and cognitive impairment blunts the worst of it – but you were never not hungry, not even just after you'd eaten the two crispbreads and cottage cheese you sometimes couldn't help yourself taking when you came home from school. You continued to read and study, but as the weeks passed and your weight fell, food occupied more and more of your thoughts.

In the Jumbly Girl's absence, the Owl began to express

nostalgia for the cakes and desserts of his childhood, his regime slackening without the stimulus of battle. In the kitchen there was a battered copy of Irma Rombauer's American classic *Joy of Cooking*, reviled by the Jumbly Girl, alongside her heroines Elizabeth David, Jane Grigson and Claudia Roden. There was a glass jug with cup measurements among the objects that the Owl had brought from America before you were born, before you could remember, so you began to experiment. He wanted something called a chocolate brownie. Brownies, as far as you knew, were junior Girl Guides, an organization including some of the friends from your old state school but no one at the private one. They swore allegiance to Queen and country and went around in brown dresses doing good deeds, being awarded badges for making beds and pots of tea. Sexist rubbish, the Jumbly Girl said, and though you weren't worried about the sexism the excitement about uniforms and rule-following was distasteful to you. You read the recipes for brownies, which were clearly a kind of chocolate cake made by an unfamiliar method and using very large quantities of sugar. You didn't mind, you weren't going to eat them anyway. You couldn't get unsweetened chocolate or indeed, in provincial England in the 1980s, anything better than Bournville, and you didn't know to compensate by reducing the sugar so they must have been sickeningly sweet, but the Owl seemed to like them. You progressed, taught yourself to make pastry for the apple pies he remembered, and then lemon curd and meringue. Pound cake, which was Victoria sponge by another name, but in *Joy of Cooking* came with exotic flavourings and fillings, caramel custards and coffee creams.

Pinwheel cookies, requiring lengthy rolling and unrolling of butter doughs. Cream pies and cheesecakes made with ingredients that the Owl would have called disgusting and dangerous when the Jumbly Girl was around. Gaining confidence, you moved on to the copy of Constance Spry's cordon bleu cookery textbook that some sadist had given the Jumbly Girl as a wedding present, leading her, then a twenty-five-year-old PhD student, to believe that the labour and skills described were the baseline for the bourgeois life on which she was embarking, that to join middle-class femininity she was required to pluck game, joint rabbits, serve four-course meals using a batterie de cuisine that she did not have, did not want and did not have room to store. She still has that hardback pink book and still regards it with fear and loathing, and now you see how neatly targeted was your adolescent aggression. You read through the chapters on pastry, baking and desserts and then set to. You made choux pastry and crème pâtissière, soufflés and roulades. You tried the laminated yeast doughs, croissants and Viennoiserie, but with margarine in place of butter they didn't come out well.

You made spun sugar by burning sugar to the point where it would set brittle as it fell and then flicking the molten caramel over a buttered rolling pin with two forks held back to back. You still have some of the burn marks, but you were used to burning yourself. Stick it under the cold tap, get on with things. The burns blistered, turned black, eventually healed, though more slowly as you lost weight. Occasionally in the middle of these long and often late-night baking sessions you would be overwhelmed by

your desire for the butter and sugar, for the pans of double cream you heated slowly with chocolate and then egg yolks, for the biscuits you crushed, the nuts you toasted, the cinnamon and nutmeg and vanilla, and then you would shove the whole lot into the bin and hide it under real rubbish, waste all those expensive ingredients, quick before you couldn't help putting them in your mouth. Mostly you resisted. Mostly you set out trays of cookies and shortbreads and pies and cakes for the people who deserved them, the people who didn't get fat, weren't battling their ravening greed from dawn to dusk. The Owl seemed to like your baking, occasionally expressed pleasure when you produced something he recognized from the childhood he'd fled.

No he didn't, what are you talking about, this is rubbish, all of it, you must have learnt to bake some other time, in some other place.

You didn't bake when the Jumbly Girl was around because however diligently you cleaned the kitchen afterwards she hated the mess, resented your showing off, couldn't stand you to use up food even when you did the shopping yourself. But she couldn't help herself eating what you made. She couldn't help the Owl calling her fat.

lucky girl

By your early teens you had friends, one of whom remains a friend. You met when you both took nineteenth-century novels to someone's birthday party: *Villette* for you, *Bleak House* for Judith, and discovered that despite coming from opposite ends of that school's not-very-wide social spectrum, you also shared interests in current affairs, languages and cynicism. You spent a lot of time at Judith's house, where there was a mother who was usually there, rarely angry, never violent, and who provided not only meals at mealtimes but food in between if anyone expressed a wish for it. You did not express your wish, but you often found yourself eating more at Judith's house than at home. Judith and her sister did their homework at the kitchen table, where Monica kept an eye on progress and offered support while she cooked. She was an accomplished cook, had grown up in a Lebanese household in Paris, but she kept things simple for weeknight meals while Judith's father was away for work. It was food prepared with benevolence but no strong feelings and you could eat it without the guilt and anguish that followed eating elsewhere, to the point where you started to avoid Judith's house because you knew that when you were there your reasons for not eating seemed less convincing than at home.

It was Judith who noticed that your dieting was going

beyond the norm. You thought you were all at it, but now you realize that you don't remember Judith ever trying to lose weight, not then and not in the thirty years since. There were a few of you in your year group, girls who avoided lunch, never took sweets when they were offered around, never went to the tuck shop, hid in oversized versions of the school uniform and behind curtains of thinning hair. One of them spent her lunch hour running lap after lap of the track, skeletal limbs moved by muscle that didn't seem to be there. You were always cold. You were quiet. You observed each other competitively – whose parents had noticed, who had a diagnosis, who was too weak to come to school at all some days – but you did not speak of it, and nor did the adults. Judith was upset that when your neighbour Caroline went into hospital, it was her friends who had to explain her weeks of deterioration and eventual crisis to teachers wondering why she'd been absent all week. They should take more responsibility, Judith said, this shouldn't be up to fourteen-year-olds. You had no idea what she was talking about, why she imagined adults should feel responsible for you.

You had only another two or three periods, not enough to learn how to manage or accept them. Bones emerged comfortingly, hips, clavicle, shoulders and then ribs. Even the popular girls, whose mothers greeted their puberty by taking them for 'facials' (you still have only the vaguest idea of what this might entail) and manicures, envied your bones as they had never envied and would never envy anything else about you. You began to get tired on the two-mile walk across the city to school, to get a bit dizzy sometimes on

the stairs, and you greeted it all with relief. Here was safety. Here was something you could do. Here was the antidote to distress. You went about the business of schoolwork and housework feeling pleasantly numb, edges dulled. Your grades, which apart from occasional episodes of brilliance in English had never been more than mediocre, slipped, but since your parents were not interested in grades and teachers' expectations of you were at the low end anyway, nobody bothered you about it.

The Owl and the Jumbly Girl were giving up hiking because there were now too many hikers in the Lake District and the Pennines. They disliked other people, wanted the mountains to themselves. Trails and paths were for people who didn't know how to read a map, the way campsites were for people who were too soft to camp wild, but they didn't like it when there were other people camping wild. The sight of another tent across the valley ruined the weekend. The best that could be said of a day's walking was that you hadn't seen another human being all day, and those days, even in winter, even in heavy rain, were becoming rarer.

So they took up sailing, because it's relatively easy to have the horizon to yourself at sea, and in those days, before satellite navigation, you couldn't put to sea unless you could not only read a chart but use a sextant to calculate latitude and longitude to find your place on the chart in the absence of landmarks. In the absence of landmarks was where they wanted to be. You went to Weymouth to spend a week learning how to sail the kind of low-tech wooden boat they intended eventually to own. You were to sail as you hiked,

the hard, old-fashioned way, ropes hauled by arms, sails gathered by standing on a pitching wooden deck, navigation accomplished with a sextant, protractor, compass and pencil.

What, so it was the wrong kind of yacht? You must be sick in the head, complaining about this stuff, ballet and sailing and private school.

You were ambivalent, of course. You liked the sea, liked being so close to it so far from land. You liked it especially at night, when although it was very dark it was never fully dark, waves pale in the faintest light from the moon and stars, the sky above as big as the sea below, steering a matter of keeping an occasional eye on the compass but mostly, because lighting the compass made it impossible to see for a few minutes afterwards, a matter of feeling the wind on your face and listening to its sound in the rigging. You liked the danger of sailing a small boat in the dark, the knowledge that your lives were in your hands, which is how you continued to like holidays until well into your forties. You did not like sharing the very small space of a boat with your family and the instructor, who didn't wash, not even his hands between using the appalling bathroom and handling food. You did not like having no time or place to read, being forbidden to use up the battery providing electricity for light in bed. You did not like the extent of your dieting being visible when you were all together all of every day and night, but the Owl and the Jumbly Girl said what they used to say when you skipped meals as a younger child: well, you'll hardly waste away, plenty of meat on those bones.

They certainly did not say that. Earlier, of course, but not then, anyone could see you were too thin.

You're still too fat, you heard. It would be good if you wasted away.

You applied yourself to the task.

You turned out to be good at steering an old-fashioned sailing boat. You could feel in the pull and thrum of the wooden tiller when the sails were optimally set, and you liked being the one to give the instructions as you turned the boat and the others moved the sails. Ready about, jibe. You weren't strong enough now to be much use on the ropes so you steered a lot, and, standing still in the cockpit with spray and rain blowing over you and the wind as strong and cold as you'd expect out of sight of land in the North Sea, you were cold. You had hiking kit but not sailing kit, and when you are hiking you are moving, it's usually much less windy than at sea, and it's usually possible to take shelter, if only in the lee of a rock, when you stop moving.

This is utter nonsense, they bought you a very expensive oilskin jacket.

But you know the jacket in question – indeed a good one which you wore for ten years – and you remember its purchase, on half-price sale in a chandler in Bangor two years later when the Owl and the Jumbly Girl had their own boat.

You were up to your old tricks, turning blue in the face and fingers, and while steering, your arms extended and hands on the tiller, your hands went blue and then white and stayed that way. It didn't seem to matter, you could still control the boat. Your fingers were stiff afterwards but they

didn't hurt until later, in your sleeping bag, when your eyes watered with pain as the blood tried to return. Over a few days the pain stopped and your fingers turned deep purple, puffed up and developed open sores that didn't bleed or hurt even in salt water. They look revolting, said the Jumbly Girl, and took you ashore to buy gloves in Woolworths to cover them up. You wouldn't usually go to Woolworths, purveyor of cheap sugar and plastic tat, and you eyed the pick 'n' mix the way you would in adult life eye the windows of bakeries: disgust, envy, desire.

This never happened. This whole episode is fabricated for your own obscure purposes.

Back home, the Owl and the Jumbly Girl's Yachtmaster certificates earned, you returned to school, still wearing the gloves because your fingers had now turned black. You could write in gloves – you can still write, and knit, in the gloves you wear much of the year – but you took them off to use the bathroom and wash your hands, and that's when your classmates saw them. There was the kind of reaction you'd expect from delicately reared teenaged girls presented with disintegrating human flesh. Frankly, Sarah, said Frances, who lived near you and had known you since you moved from Scotland, you look disgusting. Your fingers are falling off, your hair is falling out of your head and growing on your face. I know you think the bones look good but they're actually weird and getting to be revolting. My fingers aren't falling off, you said, I can move them again, they're getting better. But you went home and said you'd like to see the doctor about your fingers, please, and for the last time the Jumbly Girl made a doctor's appointment for you.

She didn't. You're inventing all this, shame on you.

You didn't often bother the doctor and you hadn't seen this one before. Middle-aged white guy, moustache, brown tie. He turned your hands over and asked you to wiggle your fingers. He pulled a curtain so you could take off your navy school tights and show him your toes, which had purple patches but weren't blackened.

Trying to convince with your novelistic detail, everyone knows you're a professional liar.

Severe cold injury to both hands, the doctor said. Frostbite. We usually see it only in rough sleepers, you're lucky not to be losing your fingers. You don't look as if you've been sleeping rough but I'm concerned about how thin you are, that might be partly why you got so cold. Oh, said the Jumbly Girl, she's been on a diet. For the first of many times, the doctor checked your blood pressure, and then checked it again. He listened to your heart. Let's weigh you, he said, and you thought bring it on, mate, I'm not scared, you'll see. He asked a shaming question about your periods, and then about how much weight you had lost and whether you intended to lose more, and then he prescribed antibiotics to prevent infection from the dying tissue on your hands, diagnosed you with anorexia and referred you to a psychiatrist. But we're about to spend a month hiking in the Picos de Europa, the Jumbly Girl said, we can't be taking her to a psychiatrist. The doctor turned to you. Aren't you a lucky girl, he said. He asked you to promise to eat a certain number of calories, the number prescribed for the small fat woman in the diet book, or the citizens of Amsterdam at the beginning of the wartime siege. You'd

still lose weight but you'll be safe enough for a month, he said. You're not thinking we'd cancel the holiday, the Jumbly Girl said, she'll have to manage.

Lies and more lies. There was no frostbite, no severe cold injury. It was the Owl, not the Jumbly Girl, who contacted the doctor, and the first doctor tried to brush him off and he had to insist, threaten, to get the specialist referral.

The Owl does a lot of insisting and threatening. All his life, many people have been unreasonable to him. You find yourself wanting to embark on the doubtless tedious and difficult process of obtaining medical records from long ago and in another country, as if you might win. Instead you ask Judith: do you remember when I had frostbite? Yes, she says, your fingers turned black, though to be honest I was more worried that I'd known for months you weren't eating and the adults didn't seem to notice or care.

You managed. You did not, of course, eat your calorie allowance. Aspects of wild camping were easier when fasting. You'd stopped sweating, so worried less about trying to wash yourself and your clothes in mountain streams. You didn't pee much and rarely needed to move your bowels. Sleeping on the ground was more uncomfortable than usual and you couldn't sit on the stones arranged around the campfire, but there was little temptation in your camping food so the constant battle against your appetite was less work than at home. You forced yourself out of your sleeping bag and into action at the same time as the others every morning. The Owl always liked to walk faster than the Jumbly Girl in the mountains, leaving her trailing breathless and resentful. In younger years you and the Angel Boy had

walked with her but as you grew bigger you competed to keep up with the Owl, who would pause every so often to drink some water and sometimes eat a piece of dried fruit while the Jumbly Girl caught up, and then set off again as she approached, her slowness punished by denying her such a moment's rest. That summer you kept up with, sometimes ahead of, the Owl. Bring it on. Watch me, thinner and faster, thinner and faster, higher and higher.

Wolf, walk beside that fading girl. Tell her: what you love can hurt you. The voices drive you, your parasite chorus. They taught you to override fatigue and weakness and pain. You can climb mountains in all weathers, you can run without eating, you can cook without shopping. Later you'll find you can succeed, pass exams and job interviews and promotions. You can stay up all night, night after night, with a very sick child and still give lectures in the morning. You can endure, that's not your challenge. It's easy to die in the mountains, harder to know when to turn back; easy to require yourself to make all the food from raw ingredients including what many people believe to be raw ingredients, bread and yogurt, pickles and jams, harder to know when to buy some biscuits and calm down. It's more comfortable for you to keep running than to rest even when everything hurts and you're far from home, because hurt and distance are your old familiars and rest is strange. You're good in a crisis, best in a crisis, unfamiliar with peacetime. Practise it now: befriend what you love, don't let it chase you and become monstrous. Sometimes the best thing to do with a mountain is admire it from a place that's safe for the body you're in that day.

shards of their wineglasses

You read Sylvia Plath. Of course you read Sylvia Plath. Your copy of *The Bell Jar*, published in 1990 when you were fourteen, is neatly intact where the works of Arthur Ransome and Laura Ingalls Wilder are falling apart, but the difference is caused by your sons, who are not Plath readers, and to whom even you knew not to read Plath by way of bedtime stories.

You didn't bond with *The Bell Jar* as much as you wanted to. Esther's world was exotic to you, in some ways more so than Laura's or the March girls'. You didn't understand the social importance of clothes and make-up, why she keeps telling the reader what shape of dress and colour of lipstick she chooses for each outing. You could see but not read the codes of her pyjamas, shoes, evening gowns, and the apparent connections between the appearance and status of clever women with professional lives puzzled you. As far as you knew, one was required to be clever *or* attractive to men, not both. Blonde, fragile Mary Ingalls and Meg March were attractive, dark-haired, strong Laura and Jo were clever; within whiteness, there was a hierarchy.

Cleverness was unattractive and paying attention to your appearance was stupid. Obviously decent women valued mind over body, intellect over sexuality. By the age of sixteen, you had renounced sexuality for the life of the mind

and announced your renunciation with your thinness, not
that malnutrition entirely protected you from embarrassing
desires and encounters with boys. Poetry was safe and the
female body, with its appetites and tides, was dangerous.
Books were clean and women's bodies the dirty sites of fat
and blood and bad smells. *The Bell Jar* was confusing, with
its clever heroine who goes out with a different boy every
week and still studies hard enough to keep her prestigious
scholarship. Why did Esther want to go on dates anyway,
why didn't she have more self-respect than to wear 'a black
shantung sheath . . . cut so queerly I couldn't wear any sort
of a bra under it'? She can wear whatever she likes, of course,
because 'I was skinny as a boy and barely rippled', out
partying with the ill-fated Doreen who 'was wearing a strap-
less white lace dress zipped up over a snug corset affair that
curved her in at the middle and bulged her out again spec-
tacularly above and below'. Doreen parties too much and
drinks too much. Doreen disgraces herself. Doreen loses
her scholarship and disappears. (You are reminded of Jane
Eyre, also skinny as a boy and dressed in black, watching
curvaceous Blanche Ingram flirting in a flounced ballgown.
You are reminded, in some ways, of the curvaceous Jumbly
Girl, who liked parties and drinking and got stuck at home
for years despite her PhD. Call yourself Jane. Call yourself
Esther. Call yourself Virginia Woolf or starving-herself-to-
death Simone Weil or emaciated Simone de Beauvoir. You'll
be the skeleton at the feast, the clever one in black.) And
Esther can do what she likes, because 'I love food more
than just about anything else. However much I eat, I never
put on weight . . . My favourite dishes are full of butter and

cheese and sour cream.' Taken out for lunch on expense accounts, she 'picked the richest, most expensive dishes and ordered a string of them . . . I made a point of eating so fast I never kept the other people waiting who generally ordered only chef's salad and grapefruit juice because they were trying to reduce. Almost everybody I met in New York was trying to reduce.' Oh, the metabolic superiority of the literary heroine yet again: she might be profoundly, chronically miserable but at least she's thin, and by divine election, without the indignity of 'reducing.' And she can't cook. You have always been ambivalent about your cooking and knitting and sewing, your bread-baking and patchwork and crochet, outward signs of a mind only pretending to be serious and naturally inclined towards frivolity, towards frills and embroidery, energies wasted on domesticity at the expense of politics and public life. It's not really fair, is it, to blame the patriarchy for your woes and then sit at your kitchen table knitting while the bread bakes? Esther remembers Jody, 'my best and only girl-friend at college in my freshman year, making me scrambled eggs . . . They tasted unusual, and when I asked her if she had put in anything extra, she said cheese and garlic salt. I asked who told her to do that and she said nobody, she just thought it up. But then she was practical and a sociology major.' At sixteen, lying on your bed on the patchwork quilt you'd made the previous year, you stopped reading as if you'd been shoved, gazed up at your flowery wallpaper. Guilty of being practical, of devoting intellectual energy to scrambled eggs. You wouldn't add cheese, whose texture doesn't strike you as a good partner for scrambled egg, nor garlic, unless maybe

you roasted some last time you baked bread, but chives, certainly, whatever soft herbs might be in the garden. Chopped roast peppers, if there are any around. Esther is too busy being clever for such ephemera. Other people do the cooking. You didn't like her.

And yet. It seemed to you that her reservations about the lives of married women applied almost as much to Manchester in the 1990s as New England in the 1950s: 'This seemed a dreary and wasted life for a girl with fifteen years of straight A's, but I knew that's what marriage was like, because cook and clean and wash was just what Buddy Willard's mother did from morning till night, and she was the wife of a university professor and had been a private school teacher herself . . . I also remembered Buddy Willard saying in a sinister, knowing way that after I had children I would feel differently, I wouldn't want to write poems any more. So I began to think maybe it was true that when you were married and had children it was like being brain-washed, and afterwards you went about numb as a slave in some private, totalitarian state.' It is obligatory to acknowledge that this is a middle-class problem, since for many working-class women when there has been a choice between staying home and going out to work, it has been a choice between paid and unpaid manual labour and for several centuries almost everyone did both. Even so, Esther's background is not middle-class. The Jumbly Girl's background was not middle-class. The twentieth century's bait-and-switch exercise of educating some women like elite men and then at best requiring them to choose between mind and body and more often denying them access to the jobs

for which they were educated is class-specific only to the extent that education is class-specific, and that depends on who you vote for. Looking at the Jumbly Girl's generation, at her friends and your friends' mothers though she herself got out, you shared Esther's outrage and horror. Few of them combined careers with family life, and those who did were said disapprovingly to be 'having it all' or more often 'trying to have it all', as if a woman's need or desire for paid as well as reproductive labour was a form of greed, of bingeing, of taking more space than was allowed. No one ever said that fathers with paid work were 'having it all'. You read the fiction of the post-war generation of women and observed their lives, tale after tale of clever girls who had got away to university and then perhaps worked a little, in a way that didn't threaten the kind of man they hoped for, before marriage and maternity enclosed and enraged them. That was not going to be you, stuck at home with years of education eating at your mind, condemned to *Kinder und Küche* after being allowed to develop a taste for scholarship. And at the same time, guiltily, you quite liked *Kinder und Küche*. 'How easy having babies seemed to the women around me!' Esther says. 'Why was I so unmaternal and apart? Why couldn't I dream of devoting myself to baby after fat puling baby like Dodo Conway? If I had to wait on a baby all day, I would go mad.' In practice, when you had to wait on a baby all day, you did go a little mad. Less than some, but more than most. Even so, despite your horror at periods, you were always fascinated by pregnancy and birth. You always wanted children. You always liked babies and toddlers, admired all that unmediated desire and rage and

joy. Like you, the Jumbly Girl had her children younger than most of her friends, so you were around babies as an older child and a teenager and you enjoyed them and looked forward to having your own. Bad scholar, bad writer, bad clever girl.

And yet. The flatness of Esther's affect, the way the voice and the sentences convey her increasing dissociation, were disturbingly familiar. She attempts suicide, more seriously than you ever did, and is admitted to a sequence of hospitals, first for medical care for her injuries, then the state psychiatric ward where she has a brutal experience of electro-convulsive therapy and then – intellectual superiority to the rescue again – the philanthropist who provides her college scholarship extends her patronage to cover a private hospital, where Esther is kindly treated by a female psychiatrist who combines compassion with expertise: 'I didn't think they had woman psychiatrists. This woman was a cross between Myrna Loy and my mother. She wore a white blouse and a full skirt gathered at the waist by a wide leather belt, and stylish, crescent-shaped spectacles.' Dr Nolan is the fantasy healer, the combination of one's mother and a film star, nurturing and incisive, and the new expensive hospital is not far off the fantasy institution with its leisure facilities, good food and friendly nurses. Maybe your frustration came from your alienation from a time and place in which crescent-shaped glasses could be described as stylish, but you had no trouble with the sartorial codes of Victorian fiction. You couldn't see why a clever girl like Esther should care so much about the shape of the doctor's skirt, or what it told the reader.

You remember sitting in the chemistry laboratory that hungry year and looking at the bell jars, thinking about the central metaphor, the way madness cuts you off, and thinking about writing from within the bell jar, how it rarely happens because we tend to write retrospectively of madness, to put together sentences from a position of safety. Esther says towards the end, released from the asylum and returning to university although never to live with her mother, 'To the person in the bell jar, blank and stopped as a dead baby, the world itself is the bad dream. A bad dream. I remembered everything.' More babies. They litter this novel. Emotion recollected in tranquillity, Wordsworth murmurs at the back of your mind, but you remain suspicious of tranquillity, maybe still can't quite tell or trust the difference between calmness and stupidity. 'Maybe forgetfulness, like a kind snow, should numb and cover [my memories],' Esther says. 'But they were part of me. They were my landscape.' Maybe sometimes we should write from and not to that landscape?

You reread the writing from your own recent worst moments, the latest relapse; from hospital three years ago and the teetering weeks after, and think that the rawness of your distress is indecent, that to publish such words is like bleeding in public, like the skeleton at the feast stripping off her black dress and displaying the spectacle of her ribs and spine, the drape of skin over bone where her buttocks used to be, climbing onto the table where the curvaceous ladies sit and trampling the grapes and the flowers, stamping shards of their wineglasses into her bony feet, shimmying her pelvic bones and hollow belly. Your writing about

anorexia, your friend says, is really fucking disturbing. Good, you say, eating disorders are really fucking disturbing. Then she proves your point by adding that what worries her most about an essay you published is that you didn't explain that you were slim when you first decided to lose weight, that people might think you'd 'needed' the intermittent fasting that roused your half-sleeping dogs. As though the madness lay in behaving like a fat person when you weren't fat rather than in the way fat people are expected to behave, as if self-starvation is fine as long as the scale shows a big number. Nobody needs to fast, you say, hunger drives everybody mad. There are reasons why many of us might want to lose weight, mostly to do with the social consequences of not being thin, but nobody must. It's not a moral issue, it's not the law.

glass of milk

The psychiatrist said she would work on the eating with you, but you could stay out of hospital for now if you would drink four large glasses of full-fat milk every day. She said it would at least protect your growing bones.

You said you would try.

You could not do it, all those calories, all that fat, the nauseating smell and mouth-film.

The Jumbly Girl picked up your glass of milk and poured it over your head.

You sat there, victorious.

They made you sit a while, dripping at the table while they ate dinner, before you were allowed to take a shower.

And? Even if this is true you were maddening, you drove them to it, you brought it on yourself.

hard to match at the seams

But you remember this too: in the lowest weeks of your illness, when you had to sit and rest halfway up the stairs to your classroom and gave up on homework because you couldn't carry the books in your schoolbag, the Jumbly Girl took you to the haberdasher where over the years she'd taught you to judge the quality, weight and value of cloth. She asked you to choose fabric and patterns for two dresses.

For weeks you'd worn a soft, smock-waisted skirt discarded by your grandmother that reached the top of your Doc Martens boots, and a heavy-knit man's sweater that didn't match the skirt. For months your words for the Jumbly Girl and hers for you had been broken glass and acid, unforgivable sentences spoken over and again in hate and rage; it was not possible that both of you would survive the war of your adolescence and you were damned if she was going to win. (You were damned either way, actually, the pair of you.)

You chose a black fine-woven wool mix with a pattern of birds and flowers, nearly but not quite William Morris, and a crisp cotton tartan, navy and green, hard to match at the seams. She cut and pieced dresses that fitted your desiccated body, French double seams as she had taught you, proper linings finished as neatly as the visible side, zips sewn invisibly into the centre back seam. You tried them

on, cold in the cold house, bony neck goose-pimpled, and she crawled around you pinning the hems. Lace trim on the black, a filmy collar saved from a jumble-sale purchase on the tartan. You didn't wear them much – teenaged anorexics don't go to the kinds of parties at which exquisite tailoring is worn – and she can't have expected that you would, but you remember now that she made them. You remember that you accepted them from her.

a pre-dawn change

You liked your consultant, who seemed to you to be in the category of clever-not-domestic women, and treated you as an intelligent human being. I'd like, she said, to keep you out of hospital, because you are a clever girl who could do well at school and if you do that, you can have a life beyond your illness when you finish.

You were not clever. You did not do well at school. But it was beginning to occur to you that the approaching exams offered a way out into the world, and although in some ways you craved hospital, longed for someone to take you away and take over, feed you, loss of control was also your greatest fear. The deal in your family, you'd always thought, was that the parents preferred freedom to responsibility which meant that the children were given freedom instead of care and this liberated all of you from the conventional obligations of family life. No one checked your homework, signed a permission slip or showed interest in your grades. Bills went unpaid, more through disorganization than shortage of money. Birthdays were sometimes forgotten, there were holes in your shoes. Low-level stuff, but different from your peers. At fifteen as at six, you could go where you wanted and do what you liked. You were not expected to come home at any particular time, nor to tell anyone where you were going or with whom and when you intended to be

back. Most of the time there was no one to tell, because the Owl and the Jumbly Girl had now bought their old wooden boat and spent every weekend and all university vacations sailing it, first out of Liverpool around the Irish Sea and later from Wales, sometimes north to the Hebrides and sometimes south across the Channel and the Bay of Biscay. In the days before mobile phones and satellite communication, someone at sea in a small boat was uncontactable unless you knew which shipping area they were in and called the coastguard to request that a public message go out on Channel 16 of the VHF radio, but even then no response was possible until the recipient of the message reached land and a call box. The system was used sometimes to recall fishermen and sailors in the event of a family death, but as far as you knew anything else would have to wait. You couldn't even send a letter.

Not true, they could patch through a telephone call.

They, presumably, being the coastguard. It's probably true but you didn't know.

Oh yes you did.

The Owl and the Jumbly Girl required you to make a reasoned case for every penny you wanted. Handle the post will you, the Owl said as he left, leaving you to open overdue bills you had no means of paying, to read letters whose threats you could not assuage. You learnt to make calls coaxing the telephone and gas and electricity suppliers not to cut you off, learnt when to sound girlish and when womanly desperation would do the job. Asking the Owl to leave money for food while they were away felt like preparing for a court appearance, cross-examination. You say you want

to make sandwiches, but there is bread in the freezer, what do you really want the money for? You don't need eggs, there's cheese already there. Cut the mouldy bits off. Of course there's enough jam, you haven't scraped the jar and no one needs jam anyway, it's all sugar. The price of food was begging, and anorexia brought you blissful relief. You needed nothing, asked for nothing, received nothing. The Angel Boy did as you had done, ate at other people's houses, and later developed sources of money into which you had the sense not to enquire.

Wolf, patch through a call to one of the Swallows and Amazons' farmers' wives, would you, to Mrs Dixon who fettles up toffee? If it doesn't work, send out a message on Channel 16: tell her the children will be calling every morning for bread and milk and eggs. Tell her if she's feeling generous with the apple pie and sausages, there are children running short.

But with parental absence came a liberation you fiercely prized, though you now realize that you made little use of it and that what you enjoyed was the freedom from shame and criticism. Apart from the self-starvation, you did nothing that more conventional parents feared from or for unsupervised teenagers. You went alone into the city centre, which your friends were not allowed to do, but once there you went to subtitled films at the art house cinema, which were almost free if you were under sixteen. (Not much later, you'd be clubbing at the Hacienda on a fake ID with an older boyfriend, but even then you spent most of the time reading Keats in the loo where the light was adequate and waiting for the noise to be over, and the best thing about

the older boyfriend was that he lived with kind parents who liked you.) You spent many afternoons at the Manchester City Art Gallery, which had free entry and a spectacular collection of Victorian paintings which would later give you the structure of one of your novels, and at the Whitworth Museum, in what was then an alarming part of town, but which had changing exhibitions of contemporary art as well as permanent collections of costume and textile art that inspired your own embroidery, knitting and sewing. You discovered that the Royal Exchange Theatre sold last-minute tickets to students for about the cost of the bus fare, and all of this was a far more exciting use of what money came to your hands than buying food. You worked your way through the school library, discovered the public library in the city centre as well as the local one which you had almost outgrown, found second-hand bookshops selling classic novels for tenpence and spent hours reading in the original branch of Waterstones on Deansgate.

Upstairs in that shop, you found a whole room of French literature, which you read at first hesitantly, like a child, skipping and guessing, and then with growing confidence; bookcases of German and Italian fiction which were harder going but not entirely out of reach. You didn't feel like a 'clever girl', had low marks for most subjects at school, but these new worlds were, most of the time, just about, worth staying out of hospital. You kept your weight and health balanced on the cusp of collapse: thin, dizzy on the stairs, hair falling out of your head and growing on your arms and back, never entering deep sleep but struggling to wake up every morning. Medical checks were limited to weight, pulse

and blood pressure, none of the scans and blood tests that would cause alarm thirty years later, and sometimes your consultant would tell you that one or all of these things was so low that you should be admitted to hospital. Give me until next week, you'd say, and the next week you'd allow yourself fractionally more food and drink a litre of water before being weighed.

Meanwhile your consultant prescribed a phase of weekly family therapy. The Owl sat forward in the low chair to which he was directed, knees wide, alert, scenting battle.

Let's start, he would say, by discussing Patricia's time management. Do you realize you kept us waiting nearly half an hour? The Owl and the Jumbly Girl's time was valuable, not to be wasted. Like food and money, you had to make a case for receiving it, and Patricia's case was not convincing.

More lies, he was very patient, sometimes Patricia just looked out of the window for a moment or two and he let her do it.

It was obvious that you were anorexic because you were crazy, had always been crazy, hadn't your fits of hysteria started before you were two? Hadn't you screamed for hours, day and night, as a newborn? Hadn't you upset the Jumbly Girl by being difficult at the breast? And wasn't it part of your craziness, your neurosis, to destroy yourself to get attention? He said you were sick because the Jumbly Girl was fat and greedy. She said you were sick because the Owl policed your food. But you were causing trouble, making everyone's life difficult, and it was a mistake to reward the attention-seeking. After a while the family therapy was abandoned and you saw a series of psychologists on your

own, travelling to the hospital by three buses including a pre-dawn change at the scary bus station because the Owl and the Jumbly Girl had spent enough time ferrying you about.

Really, you're complaining? You do remember how long that drive could take? And you remember that the psychologists came in early, started their working days before 8 a.m. so that you didn't miss school? People were bending over backwards to accommodate you, young lady, and after you'd brought it all on yourself.

father and son

You read the big dicks of American and British liter-
ature. You had the vague, catastrophic idea that they would
teach you to see the world as men see it, as if you didn't
already know. You still thought that if you tried hard enough
you might somehow emulate them, avoid the ghastly fate
of womanhood, that if you were only thin enough and
controlled enough and rational enough and man enough,
you might just about pass. Looking back, you wouldn't
ban books, but you would forbid teenagers from reading
some before others. Read Atwood before Updike. De Beau-
voir before Roth.

It was not that you wanted to be in a male body or to
behave in masculine ways, whatever they are, you just
wanted to be respected like a man, to be ambitious like a
man, to be paid like a man. I take exams like a boy, you
said, by which you meant that you did not experience
premenstrual symptoms – partly because you continued to
suppress menstruation by restricted eating – and you were
stimulated rather than frightened by the formal arrange-
ments of traditional examinations, in which indeed you
began to perform well. Compared to your fights with the
Owl and the Jumbly Girl, exams were easy, the boundaries
clear, the demands consistent and within your reach. Exams
did not expect you to pay household bills with money you

did not have, to cook a meal without ingredients, to climb a mountain in the rain without food or waterproof clothing. You simply had to answer questions on predictable topics to the best of your ability in the time allowed, and during that time you would be warm and safe and uninterrupted.

You read Updike, admired his sentences.

Pynchon, Roth.

David Lodge.

Amis, father and son.

It did you no good, learning to see women and the world through the eyes of upper-class white men, misogyny and good writing apparently inseparable.

cuckoo

You won't eat your dinner.

The Owl shouts at you. Crazy, cuckoo, bound for the loony bin, is that what you want?

He picks up your stoneware plate and throws it at the wall.

It breaks into surprisingly neat halves.

Casserole runs down the Jumbly Girl's rag-rolled peach and cream paint, onto the back of the armchair she reupholstered in black and green chevrons.

When everyone else has finished eating, you clean it up.

You bring it on yourself, you drive him to it.

lipstick and intelligence

You liked the psychologists, kind young women all. There was Katie who became pregnant with twins and grew from month to month, her belly and fertility fascinating you. You made two rag dolls, worried that maybe she wouldn't or couldn't accept gifts from patients. You embroidered their faces so there were no button eyes to get into baby mouths, and you double-stitched their yarn hair so there was no risk of baby tangling or choking. You made them clothes with elastic waists and necks, sewed individual fingers and toes, made hinge joints for elbows and knees but padded wooden spines with wadded cotton so their necks would stay strong. Katie received them beautifully, wrote to you later to say that they had become her babies' favourite toys. Then you saw Tracie, who had glossy wavy hair and wore the kind of make-up the Jumbly Girl considered tarty, above-the-knee skirts and shoes in which she couldn't run away, but was still thoughtful and kind and clever. Note to self: lipstick and intelligence not invariably incompatible. You remember very few of those conversations but they kept you going, helped you to survive, to wait out the diminishing months of living with the Owl and the Jumbly Girl and to stay well enough to do well enough to leave for university. There must have been guid-

ance, insights: you remember telling Frances, a churchgoer who believed in self-abnegation at least for girls, that a person who refused to take care of herself implicitly required other people to do it for her.

change the world

And then at seventeen you read *The Beauty Myth*, by Naomi Wolf. You went with Judith to hear Wolf speak at Waterstones on Deansgate, where you also heard Margaret Atwood and A. S. Byatt, and for the first time you had a book signed and dedicated to you. Naomi Wolf has since written questionable work and espoused surprising points of view, but her first book, published when she was twenty-eight and you were fourteen, changed your world. It was unselfconsciously and unapologetically writing by, for and about young, bourgeoise white women. Thirty years later, its feminism is obviously myopic and even at the time it was criticized for its limited awareness of class if not race. Still, you were a young, bourgeoise white woman and you needed help and *The Beauty Myth* provided it by showing you exactly how in your own particular case the personal was political. Women's preoccupation with the failure of our bodies to conform to aesthetic ideals distracts us from political activism. The personal replaces the political. A person whose intellect is devoted to ways and means of shrinking her body and reducing the numbers on a scale is a person who has limited attention or energy for social justice, whose capital of every kind is channelled towards the self-defeating project of restriction and weight loss. Wolf was not the first and certainly not the last person to make this observation

but she was the first person to make it to you and to your peers, the first person to suggest that your eating disorder made you a slave of patriarchy, capitalism and what you were learning to call the military-industrial complex. It's obvious to you now, and was then, that social justice and liberation do not begin or end with the comfort of wealthy white girls, and wealthy white girls can't think about social justice or liberation while they are starving. Whoever you are, whatever privilege you hold, self-destruction makes you useless. Wolf was the first person to make you wonder what other uses you might find for the energies you'd spent on eight years of self-starvation, and how those energies might change the world rather than your body.

You joined Youth CND, were elected to the managing committee. You joined a collective sending medical supplies to refugee camps in the Balkan states, just emerging from civil war. You joined the Labour Party, though you were too young to vote. You entered and won poetry and public speaking competitions. You ate more or less enough, more or less enough of the time.

It was always, remains still, difficult to eat at your parents' house, easier in their long absences. As you neared the end of school and home, books, films, theatre and eventually studying took up more of your attention. There was no one at home to eat cakes and desserts, so you stopped baking. You were expected to have a good meal on the table for the Owl and the Jumbly Girl and any friends they brought when they returned from weekends and holidays on the boat. You were not given ingredients or the money to buy them, but there was a garden and a freezer and you were by now a

skilled cook used to improvising. The Owl and the Jumbly Girl were out or away most of the time so you didn't have to cook for anyone except yourself and the friends who often enjoyed a house with no parents and no rules. You had never liked preparing or eating meat and now you could stop, though you didn't know or care enough about nutrition to make good the loss of protein and lived mostly on vegetables, pasta and chocolate. You found an abandoned bicycle in the shed and began to use it to save bus money, quickly coming to enjoy the speed and independence.

Of course you took it for granted then, but now you see how the welfare state made good, or at least made adequate, the deficits of family life, because naturally all your medical, psychiatric and psychological care was free, the same way the libraries and galleries were free, and when you went to university that was also free. You could leave. At the end of your first year, you won a scholarship that gave you free housing during university vacations. You stopped going home.

II

Logical conclusion: remembering

the run of herself

It had started again where so many of the crises in women's lives start, in the bathroom. Someone should make an art installation about how women's lives change in bathrooms, says her friend S.

Undress distress. Knickerless annunciations.

Blood, welcome or feared; lines on a stick.

Puking, morning or self-induced, one way or another.

Stickiness on your thighs, welcome or feared.

Number on the scale, achieved and lost, welcome or feared.

The number was horrifying, higher than it had ever been except in late pregnancy. She should have known. She should have caught it earlier. She should never have let things go so far. She had lost control, without noticing. She had become a person who loses control and it was an emergency, it was like losing control of a car, it was like skidding and rolling and bouncing off the mountain.

She caught her own gaze in the mirror, above her newly vile body, and looked away. *You should be ashamed.* There was not enough shame for her, the total supply was inadequate to her situation. It would be necessary to make or mine or extract more shame, to find new sources of shame.

She had not even noticed, had needed the scale to tell

her that she was no longer herself, that sometime in the last few months she had misplaced herself so thoroughly she had not recognized the change. Lost the run of yourself, they say here in Ireland. Lost your mind. Lost your body.

How could she not have noticed?

She had misplaced herself. She had misplaced her family, moved everyone across the sea in the middle of a pandemic, under lockdown, when the journey of emigration may or may not have been legal. She had misplaced her friends, her husband's job, her sons' school and all their friends. She had misplaced a comfortable suburban house with a garage and a garden, a gravel drive and a utility room. She had hated that house, *ungrateful bitch, snob*. She had misplaced a highly sensitive cat, who had howled all the way across the country, across the sea, across the new country, as if it were the cat's calling to cry out what others contained, as if the cat were the household keener, the Greek chorus, the Fool.

She had disposed of two-thirds of her books, almost all her clothes, her grandmother's green velvet chaise longue, her husband's grandparents' dining chairs, the marital bed, wedding present. She had burnt her teenaged diaries and poetry. She had disposed of some things she would later regret, things she had already moved many times between houses and countries, but how can you tell, when it's time to dispose, what your future self might want? Past performance is no guide, especially under lockdown. She had disposed of the professorship it had taken twenty years to achieve, jumped off the ladder, was starting again at the beginning.

She had not known what to do with her own books, the books she had written. She had copies in many languages and editions. Her books didn't earn their place on the smaller bookshelves of the smaller house, it was not as if anyone in the family wanted to read them. There was no attic or cellar, no repository for what you do not want to have and do not want to lose. (After emigration, is there no space for the repressed?) She could not sell them, because there were no literary events at which they might be sold, the postal service had all but broken down and in any case she did not believe that anyone wanted them. She could not give them away because she saw no one and the charity shops, not being Essential, were closed. She began to see that she would have to dispose of her books, that she would have to load up the rucksack that she used to take on her adventures and carry the books she had written down to the recycling centre, where she would have to feed them one by one into the bin. Hardbacks, paperbacks, translations into languages she does not read, into alphabets whose sounds she cannot make. Large print, a collected edition of which she had been secretly proud. We could burn them instead, suggested her sons, in the fireplace, it's cold in this house, and when they saw her face, Mum, we can do it for you, we can take them away, if it's too much.

She had begun to run more. It had been her rule not to run every day, because she knew herself well enough to under-stand that a daily run would soon become necessary, even Essential, that she would soon be unable to do anything on a day when she had not run. But in lockdown, there was

no need to be flexible, to be able to accommodate travel or lie-ins, and there was more to run away from. She ran ten kilometres every morning, sometimes twelve or fifteen, use the childhood reckoning, ten miles. Ten miles every morning, sometimes twelve or fifteen. Twenty adult kilometres every morning— And to do this on middle-aged knees, she needed better core strength, and since there was no travel and no commuting and no social life there was no reason not to work on her core strength too, and so she became very strong, unnecessarily strong, and she ran with her nineteen-year-old son who was also becoming very strong, up hills, sometimes faster than him up hills, and she became very hungry, and since for many years she had eaten when she was very hungry and her weight had not changed, even when much of what she ate was chocolate and home-made cake, she ate, and when her body changed she thought well, you would expect a body to change, wouldn't you, when it's running a hundred kilometres a week and doing daily strength training with a strong young man? She had looked in the mirror and seen someone less provisional, more solidly present, a woman who in midlife occupied space more certainly than she once had. Her clothes fitted, but differently. The new physical state had seemed, inasmuch as she cared, mildly interesting.

She had climbed a mountain with her son and eaten a cereal bar just to keep him company, when she wasn't even hungry, for no reason.

She had gone into the good Austrian bakery to buy croissants as a treat for her sons and had bought herself a pain au chocolat and taken it down to the pier for a private pleasure,

for no reason. She had not eaten such a thing for years, had taught herself that she didn't like pastries, that they were too bland and greasy, not worth the calories. She liked her pain au chocolat. She had another one a few days later.

And here it was, her comeuppance, here was the consequence.

Here was the number.

She knew where women who had lost control needed to go. She turned to the men of science, voices of reason and cold hard fact. She did her research: obesity, diabetes, prevention and cure, liver function and insulin, the latest findings on weight control and blood sugar control and self-control. She invited the experts, all men, summoned them from America and India and South Africa and England, to join her parasite chorus, to conduct it, to know the score. She offered them her voice and her mind on a plate, anything to be thin again. She strove to obey, to be the experts' best girl. As she ran, she pushed their voices into her ears, pressed play on podcasts that lasted an hour, two hours, exhaustive, and as she ran they told her what she must do. She must fast two days in seven, and should that not be enough to achieve a more acceptable number, every other day. Or she could fast for sixteen hours in twenty-four, or better yet for eighteen or if she had unusually strong willpower or turned out to be unusually good at fasting, for twenty hours. There were no excuses. *You should consult your healthcare professional*, the disclaimers said, *before beginning any diet or fitness regime*, but it never crossed her mind that anyone did so; she could well have

imagined the response of a doctor to the time-wasting of a fit middle-aged woman who needed to lose some weight. *Any advice given is general in nature and not meant as a substitute for care by your usual health professional.* She'd never lived in a country where a person had a usual health professional, and certainly not one who would offer care to someone whose only problem was a lapse in self-discipline. The men of reason themselves had no difficulty exercising while fasting. It was good to run while fasting because it would teach her body to burn fat. It was good to go to bed hungry because she could lose weight while she slept. Any sensation of weakness or fatigue, headache or dizziness, should be transient and was, she understood, imaginary or due to some other feminine weakness but in any case was it not worth a little suffering, to be in control again? The men of reason did not experience hunger. Their concentration improved. They became even better scientists and experts. Their fasting was not a diet, to be followed for a certain purpose and discontinued when a goal was reached, but a permanent state of grace, a life sentence.

She did as they said. She was, it turned out, still good at fasting. She made the rules her own. It was a nonsense, she thought, to write off the suffering of fasting days with the indulgence of feasting days, either she was worthy of food or she was not, the situation did not change twice a week. Better just to get the job done, fast by the clock. Eight, six, four, two; her 'eating window' shrank week by week. Her world dimmed.

◆ ◆ ◆

Unfortunately she could not write fiction while fasting. That part of her brain, it seemed, was the first to go when fuel was scarce. She was not good enough, not strong enough, she was weak in will and competence and expertise, still in thrall to her ravening body. The voices of reason did not concern themselves with the making of art, they cared that she should be under control. What does a woman's mind matter, as long as her body is small, who cares, anyway, for women's inventions? There isn't a shortage, is there, of the stories of middle-aged women?

By autumn, her weight was entering the red zone on the charts she now consulted weekly, as if they might change, as if one day there might be a section of the graph that said she was good enough, that she could eat now. The men of reason set no lower limit; their rules were to be followed, she understood, to death.

One day she had to stop while she was running because her legs wouldn't go. She stood at the top of stone steps leading down to the sea – alone, early morning – and felt the first pulse of fear. While she waited for her muscles to obey her brain she emailed her doctor from her phone. All food has become frightening, she wrote. I'm lying to my husband and my friends about what I eat. In a few weeks I will be unable to work and take care of my family. I'm sorry to bother you but if I wait even a few minutes I won't think this is a problem.

Meanwhile, she travelled to England to launch her new book at a literary festival. She thought her hand luggage was too heavy for the airline's rules but it turned out to weigh

six kilos. She had to rest on the stairs at the airport, and later on the sweeping staircase of the grand hotel. She stayed with a friend who said, you're gaunt, you look terrible, and also you're speaking slowly and you keep spacing out, it's as if you can hardly think. I mean this with love, said her friend, you're not funny any more. Another friend said, I'm sorry but it's too sad for me to see you like this, it's like talking to someone in your third language, there's no point trying to say anything that's not both urgent and simple, it makes me want to cry. She thought these friends were being silly. She kept losing her voice, which was inconvenient, but apart from that she felt fine. Her thinking seemed normal to her and she was the one doing it. Your voice, said her opera-singer friend, is a muscle, and when your body is not fed it will eventually convert your voice into energy along with all your other muscles. Until, her friend did not say, it gets to your heart.

She had to suck a throat sweet before going on stage, to help her voice work. The experts did not allow such things. *Blood sugar, spikes and crashes, straight to your liver, obesity and diabetes.* To prove that she could stop at one, she ate nothing else that day. Audiences seemed happy enough with her performances. You still come alive on stage, her publicist said, as if she were not alive the rest of the time.

She found she could still run. Not ten miles now, but ten kilometres, same number in a different currency and it was the numbers that mattered. Country lanes before dawn, head torch. Promise me you won't, said her friend, what if you die out there, no one would know where you were. If I die, she said, it won't matter where I am, will it?

She must have flown home. She did not remember it.

She taught at the university all of the next day, which was her birthday. She did not remember it.

She forgot her laptop in her office when she cycled home and her husband had to drive her back to collect it later for the night's work, because neither of them believed she had the cognitive capacity to drive. She would remember that.

The next morning she put on the layers of clothes she now wore to run. She laced up her shoes – dizzy standing up – and set out, but after a few steps the dizziness came again even though she was already up, and her chest hurt. She recalled the words of one of the experts on fasting: *Training on an empty stomach turns out to be beneficial on multiple levels . . . if you're burning fat, don't forget, you're not storing it.* She knew his voice: light, English, posh. He was often on the radio, telling you one thing you should do to be healthy, to be in control, but of course it wasn't one thing because there was another one every week, an accumulation of restrictions and obligations. She tried to keep going but the pain came again, stabbing, and her legs were folding. She leant against a wall, working at breathing, and then walked home. You shouldn't be running, said next door's builder, you're in no state, do you need help, is your husband in?

It's time to go to A & E, said her husband. Her doctor had written to the Emergency Department weeks ago, telling them to expect her. They'll just send me away, she said, I haven't had an accident and it's not an emergency. She had already been weeks on the waiting list to see the Eating Disorders team. I need to lose more weight, she said, to get

help. Phone the doctor, her husband said, and we'll do what she says.

She biked to the hospital, because it didn't occur to her to find an alternative form of transport. It was raining, the road slick with run-over brown leaves, rush-hour traffic splashing past.

She locked her bike outside a Portakabin, put on her mask, sanitized her hands and told the masked receptionist behind the glass panel that her doctor had told her to come. Fill in this form, said the receptionist, and take a seat, but the seats had been rearranged at two-metre intervals so there were not enough of them for the people suffering from accidents and emergencies. Had they not been told that there was a pandemic on, that they should stop indulging in such things, that now was not the time for accidents and emergencies? She leant on the wall, and then slid down it to sit on the floor. It was hard to stand up again to return the form.

She sat again, on her coat, legs crossed, made herself small, and took out a book she was reviewing for an American newspaper.

She was halfway through it when a nurse called her name. The nurse took her through several sets of hospital double doors and directed her to a chair set in the middle of a room. The nurse checked her blood pressure, pricked her finger from which blood was slow to appear. Your blood pressure is too low, the nurse said. She put the slip of bloodied paper in a machine which beeped. Your blood sugar is in the danger zone, the nurse said, you must take dextrose tablets now. No, she said, I don't want them. *Spikes*

and crashes, said one of the experts in her head, *sweet blood causes inflammation, if you have one you'll want another and then another, diabetes and obesity.* You have to, said the nurse, you'll go into a coma. *Empty calories*, said the Expert, *pure sugar.* I don't have to, she said. The nurse sighed. *Fat and stupid, middle-aged woman acting like a teenager, taking up our time when there are real people with real problems in here.* Orange juice, then, the nurse said. No, she said. You must, the nurse said, it's dangerous. Why the fuck, she did not say, do you think I am here if not because my situation is dangerous?

She went back to her corner on the floor of the waiting room. Outside, rain fell. She finished reading her book, made some notes in her notebook because she had not brought her computer, and began to read the novel she would teach after the October break. The person behind the glass screen went and a new person came. She began to think fondly of her bike waiting outside, to fret that it was time to cook dinner and her husband would not know the correct order for the vegetables from the weekly box, that he would cook the peppers now and let the spinach wilt.

A masked man came pushing a trolley, crying his wares. Tea, coffee, sandwiches, biscuits, like being on a train or plane. Ah go on now, he said, there won't be anything else until morning, it's all free you know. No thank you, she said. Are you sure now, he said, not a small little sandwich even? She was sure.

It was dark, still raining, when they called her name again. Her heart, they said, was showing signs of failure, also her liver and her kidneys. If she would not take a

dextrose tablet they wanted to set up an intravenous drip. If there's sugar in the drip, she said, I don't want it, thank you. Would you eat something, they said, anything? No thank you, she said, and in her head the men of reason murmured approvingly, as if she were coming close to passing their test, as if it might after all be possible to fulfil their requirements.

A nurse led her to a small room. There was a bed made up on a trolley, on which she sat, and she had read only another chapter when a pleasant young man wearing scrubs came in and introduced himself. He was a psychiatric nurse, which surprised her because she was not mad, not in that way. I think, she said, I want to go home. I think this was a mistake, coming here. I'm needed at home and at work. He sat beside her, at the other end of the trolley. This is the best place for you just now, he said, we can look after you here. But I am just sitting, she said, in the waiting room, I would be more useful at home, cooking the dinner. It is time to cook the dinner. Yes, he said, but your physical state is precarious. There are early signs of organ failure. In our experience people in your condition are on the edge of a precipice. They deteriorate suddenly. Sometimes the damage is irreversible. We would rather you stayed here. I feel fine, she said, I cycled here. He winced. And do you think, he said, that was a good idea? She shrugged. I got here, she said, it would have been a long wet walk and everyone knows you can't park at hospitals. Let us find you a bed, he said, you're here now, you might as well get some of the help you've been waiting for.

The idea of help, of care, of someone – even someone

masked and gloved and irritated – to pat her shoulder and tuck her in was almost irresistible. She was so very tired. She offered the question to the obesity experts, to the Owl and the Jumbly Girl in her head, to her jury and judges. The hospital, after all, had its own experts, its own evidence-based authorities; since she appeared to be coming to the end of the road down which the voices of reason had harried her, could she be allowed just a night or two to rest, not to board a plane or go for a run or teach a class, not to fit a shift of voluntary work between a day of meetings and an evening spent doing an online literary event in another time zone while the week's bread and the family's dinner baked in the oven, as if she could neutralize privilege with exhaustion? Aren't there other people, she said, who need the bed and the monitors and the nursing, people who are really ill? *People who didn't bring it on themselves, real people who aren't just hysterical and attention-seeking and malingering?* There are many people who need our care, he said, and you are among them. Later she would realize that he must pronounce that sentence many times every day, that he must have it off pat, the way vets learn to say sometimes bad things happen to good people when you accept their offer to euthanize your suffering cat, the way healthcare providers learn to say I'm sorry that happened to you when you have to tell them something that was done to you in childhood. Rote, they don't have to mean it. At that moment it seemed the kindest thing anyone had ever said to her.

They put a band around her arm, one that gave her the wrong title and a misspelling of her name, and they led her to a cupboard, or at least a very small room with no windows,

where there was a washbasin and another trolley, so she washed her hands and sat cross-legged on the trolley, reading. She finished the book, made her notes, and began the next book. It was *War and Peace*, which she had last read in a Cretan village twenty-five years earlier, on a holiday where she had casually enjoyed seafood and local cheese and baklava, had swum in the sea with pleasure in the waves and her body's strength and little thought for its size and shape. After a few chapters a nurse came and said that while she waited for a bed on a ward the doctors wanted her to be on a heart monitor, and wanted a cannula in her arm in case they needed venous access in a hurry. They won't, she said. Do you want to use the bathroom before I hook you up, asked the nurse. She did not, realized that she had felt no need for at least a day or two.

She found peace of a kind in her cupboard. There were very clean white sheets over a plastic mattress, like too-thin icing on a cake. The heart monitor kept ringing alarms until the nurse came and sighed and muted the sound, which was annoying everyone. Her phone ran out of battery. It was, she thought, the first time in years, possibly decades, that no one was asking or expecting her to be anywhere or do anything, and her troublesome body was at last subsiding, ceasing to demand. There was no more hunger or thirst. The body ran slower and slower, quieter and quieter, and the voices in her mind began to calm. She had almost placated them, almost achieved their requirements. This, she thought, must be the state enjoyed and promised by the Owl and the obesity experts and the men of reason, greed at last disciplined, hunger silenced, weight under

control, the mind all but liberated from the mess and need of the body. This must be how true scholars, true scientists, live their lives, optimized, almost free from the distractions of appetite and the struggle for control.

Under the fluorescent light, far from weather or sky, she unfolded her legs and lay down to read.

After another few chapters, restlessness came. She had not, her voices reproached her, run that morning, or the previous morning or whenever it was that she had indulged her fatigue and turned back, and since then she had done nothing but sitting and lying around. *A walk*, they said, *at the very least*, so she unclipped the leads of her heart monitor, pushed herself off her trolley, waited for the dizziness to settle and made her way into the corridor. Excuse me, she said to a man wearing scrubs and holding a broom, could you tell me which way to the exit? You can't go out, he said, it's not allowed. I beg your pardon, she said. Patients can't just leave, he said, it's against the law. You can walk around the atrium if you need to stretch your legs. She knew, of course, that he was wrong, she was there voluntarily and could leave any time she wanted, but it was also plain that this man did not make the rules and her object was to get some exercise, not argue about liberty. The atrium would do. It had stairs up which she could run. But when he let her through the double doors into the upturned boat of the four-storey atrium, her legs again failed after a few steps and her chest hurt again, so she walked as fast as she could to the top where she waited for the dizziness to clear before circling the mezzanine. After a few rounds – feet quiet on the rubber floors, pot plants menacing in the dusk – she

wanted her cupboard again and made her way back to *War and Peace.*

Later, just before Pierre and Dolokhov's duel, the page faded and the book fell.

Her hands and feet were going numb.

She was cold, colder, and had the sensation of falling, freefall, sinking, as if a parachute should be about to open.

She called out for help but understood that there was no possibility of being heard from inside her cupboard.

She stumbled off the trolley and began to crawl towards the door, but as she reached the corridor the man with the broom saw her. Now then, he said, we can't have you on the floor like this, can we, you need a good rest, and he helped her back to the trolley where he put the white sheet over her and patted her shoulder before he turned off the light and closed the door.

Later, there was a lot of noise, machines beeping and binging and too many people in the cupboard. What happened, she asked a nurse, and the nurse said what do you mean, what happened, which seemed an odd response.

Later, she asked again, what happened to me, and a man who was obviously the doctor came over. You lost consciousness, he said, which she already knew. Your blood sugar went too low and your blood pressure and heart rate fell, that's why we have you on a drip now. She knew there would be sugar in the drip, but perhaps since she had been unconscious when it began the men of science would forgive her. She remembered the FAQs they liked to slap down on their podcasts: *yes, diet soda is forbidden during*

fasting hours because it still raises your blood sugar level even though it has no calories, and the same applies to chewing gum, we see through your ruses. No, you may not add milk to your coffee except during the eating window. No, it is the last mouthful of your dinner and not the first that must be swallowed when the eating window closes. Yes, you must refuse your friend's birthday cake, drink only water, decline dinner invitations or at least stop eating as the big hand reaches the hour. Extend, never contract, your fast to accommodate a time difference. You're not going to waste away, are you? Doctor, what if I wake from a hypoglycaemic coma and find myself on a dextrose drip outside the eating window? Because it will raise my blood sugar level, that's what it's for.

Can you tell me, the nurse asked her, your name, where you are and what year it is, and though she had lost count of years since lockdown broke all her chronometers and she could not recall which saint the hospital venerated, she knew her name, if not quite the version they had written down, and that seemed to be sufficient. Was it for this, she did not say, that one, the fairest of all rivers loved, to blend his murmurs with my nurse's song, and from his alder shades and rocky falls, and from his fords and shallows, sent a voice, that flowed along my dreams? I cannot see what flowers are at my feet, Nor what soft incense hangs upon the boughs. There was no possibility of taking a walk that day. We had been wandering, indeed, in the leafless shrubbery an hour in the morning. Orientation. Will you eat anything now, said the nurse, could you take a sandwich or a yogurt? The sandwich, she knew, would be made of

ultra-processed bread and filled with mayonnaise and margarine, the yogurt sweetened and thickened and emulsified, preserved and flavoured and anyway were her veins not already being pumped with sugar, was that not bad enough? No thank you, she said.

She thought she passed a day and a night and another day in the cupboard, but without sight of the sky, with no clock and her phone dead, she was lost to time. Every few hours someone put up a new drip, but when it ran out the machine sounded until she turned it off herself so she could read or sleep. She finished *War and Peace.* She began it again. She watched the numbers on her heart monitor with mild interest; she would not have guessed that a person could be sitting up and reading and thinking about Tolstoy with a pulse so slow. She thought that she would like to be able to brush her teeth and take a shower some day soon.

She was asleep when a nurse came to say that they had found a bed for her on the Acute Medical Ward. Take that wheelchair away, she said to the porter, I can walk and I can carry my own bag, thank you, but when she tried she could not walk, which made no sense considering that she had cycled to the hospital and had been able to go briskly up and down the stairs the previous day, or maybe a day or two before that. On the way to the Acute Medical Ward she saw that it was night, no cars on the road and no bustle in the corridors. It was still raining, or raining again.

Another nurse met her procession at the entrance to the ward, where she was allowed to leave the wheelchair and make her way into a dark room where others slept behind curtains. I need to take a shower, she said, before anything,

I have not had a shower for days. I need to set up your cardiac monitor, said the nurse. Yes, she said, after I have had a shower. And brushed my teeth, she wanted to add, but she had no toothbrush or toothpaste and no way of contacting her husband to ask for them.

The nurse gave her a worn towel and showed her to a tiled room that had a shower head in one corner, a pile of faeces and a pool of yellow liquid in another corner and blood smeared around the light switch and taps. We're short-staffed, the nurse said as she left.

She paved the less filthy part of the floor with paper towels and washed herself. There were more bones and less flesh than there had been last time she looked and she was relieved that the drip had not, not yet, made her fat.

During her time in the cupboard, she had thought of a bed on a ward as she had once thought of a hotel after a long flight. She had thought of a window with sight of the sky, perhaps trees and birds, of access to a bathroom, the chance to change her clothes and wash her hair, but on this ward the man in the bed beside the window kept the curtains closed day and night, so she had to walk down the corridor and stand by the fire exit to see the light and the weather. The nurses did not like it when she did that. She was supposed, they said, to be 'on bed rest', although they did not object when she fetched water for the woman in the next bed, who could not stand up, or when that woman went away and her successor needed help to walk to and from the bathroom. There were not enough nurses. Visitors were forbidden because of Covid, and so the more

mobile patients helped the less mobile, refilled water jugs, held cups to dry lips, wiped hands and faces with damp cloths, cut and spooned what passed for food. The generation of women in hospital was the generation who had had many children – no contraception for them in this country, nor divorce nor abortion – and whose work had been mostly unpaid care. They were not trained nurses, but their hands knew how to soothe the sick and fractious and in old age their instincts ran true. She woke several times in the first nights to find a woman of great age hunched at her bedside, arms thinner than her own' reaching to tuck her covers, contracted hand laid gently on her head, blessing murmured. If another patient hadn't come in fluffy slippers and pink dressing gown to lead the visitor back to her room, she might have taken the presence for an angel or a ghost.

The fluorescent lights stayed on all night. People called out, insistently, for hours, wanting pain relief or a drink of water or a bedpan or something they could not name. Machines bleeped and sang. Phones rang. It was too hot, the air stale as on a coach or train. She reread *War and Peace*. She was tethered to the drip in her arm. Her arm hurt. Under the skin, red lines flared.

Every few hours, at strange times of day, there was noise from the kitchen across the corridor and then two men of military bearing came pushing trolleys of food. Nothing was cooked in the kitchen. The meals came from long ago and far away, and they were worse than the school dinners she had rejected forty years earlier, brown slop and grey lumps, the smell of cat food and boiled milk. No thank you, she

said, and she drew her curtain so she didn't have to watch her neighbours eating it in their beds.

She was still wearing the clothes in which she had cycled to the hospital, which at least gave her the advantage of more or less professional attire when the psychiatrist came on the second day. She had found a comb in her handbag and was not, anyway, in the habit of make-up. The psychiatrist was younger than her, as well she might be. She was, ought to be, a grown-up, this mother and teacher of young adults once more enslaved to a disease of adolescence.

The psychiatrist's tactic was fear. Your organs are failing, she said. Even with our best care you are and will remain for some time at immediate risk of death. You are severely malnourished. Your blood chemistry is alarming. If we do not feed you now you will die, do you understand me? Having an elementary understanding of biology and being familiar with the idea of food, she did understand. But I want to go home, she said, partly because at home we have food. We have organic vegetables and fruit, home-made bread and real cheese. You need constant monitoring, said the psychiatrist. You are under the care of psychiatry but also endocrinology, gastrology and cardiology and we are all gravely concerned. You are not going home. This is not about organic vegetables. Your choice is between eating and being fed by naso-gastric tube, which is it? Forced feeding, she thought, suffragettes, women strapped to tables for torture, punishment for making a fuss, seeking attention, behaving as if you matter, but she also wondered, would the voices of reason be more likely to forgive the violation of their rules if she were physically compelled to disobey?

Another FAQ for the podcasts: if I'm tied to a bed with a tube down my throat, am I allowed to open my eating window? Do I have to go down fighting? Here it came, her comeuppance, the logical conclusion.

The hospital food, she said, is not food. It is not edible and it has no nutritional properties. If you will find a way for my husband to bring me food, I will try to eat it. And I am here voluntarily and I will not consent to tube-feeding.

She still thought that she was too sane to be sectioned. She had forgotten that she had left the country whose laws she knew.

The psychiatrist went away and soon a dietician came, a kindly young woman recently arrived from abroad who did not know the rules of the institution nor the customs of the country. We are going to make a meal plan together, said Fran, tell me what you like to eat. The idea was astonishing, the end of the road, it seemed, almost within touching distance. What she liked to eat! And then her husband appeared, masked, sanitized, having somehow charmed or finagled his way past porters and nurses, carrying a negative Covid test in one hand and in the other a bag containing clothes, books and also a small pot of salad from her favourite vegetarian restaurant. He and Fran sat either side of her while she ate.

There were no beds available in the Eating Disorders Unit, and so she stayed on the Acute Medical Ward, receiving treatment only for her physical trouble. There were drips, injections, tablets. She wore a heart monitor whose pads had to be replaced when she insisted on taking a shower.

She was surprised to find it more or less possible, most of the time, to follow her meal plan: it seemed that perhaps the battle was over, the endgame complete. She had followed the rules all the way to the end, until it was possible to go no further. She had met the experts' standards until her heart and liver and kidneys failed in quantifiable and quantified ways, until other experts told her that it was time to stop and now, surely, there must be a period of grace, a little mercy. She spent most of her days sitting on her bed, reading mostly the nineteenth-century canon whose comforts were familiar and enduring: Austen, Wordsworth, George Eliot, Charlotte Brontë, the voices and worlds to which she had retreated from when she could first read them. They had not failed her then and they did not fail her now. She could not see out of a window and was forbidden to set foot outside, but the worlds she had always known were still there for her. It was not that they were better than her own life and times – she was, now, well aware that the riches of Mansfield Park came from slavery, that Rochester's behaviour to Jane Eyre as well as his first wife Bertha constitutes coercive control eroticized by the narrator, that Eliot's omniscient narrators are schooled in the science of an 'Enlightenment' that brought darkness to millions of people – but they were familiar and beautiful and held wisdom of their own.

After a few days of sustenance, reading and eating the fruits and vegetables her husband brought daily on his bicycle through the autumn weather, her digestive system recommenced its work. Patients who could walk to the bathrooms traded disposable gloves, disinfectant wipes and

sprays acquired on illicit outings or smuggled in by relatives pretending to be outpatients to reach the hospital atrium. She wore shoes to leave her room and paved the bathroom floor with paper towels so her soles didn't touch the smeared and stained floor. She cleaned the door handle, light switch, taps and toilet handle with gloved hands before touching them and hovered to pee. There was always at least one pile of faeces on the floor. They sat for days, modelling the process of decomposition in the way of a dead rat or bird on your daily walk. Usually there was also vomit, blood and unidentifiable yellow and brown puddles and smears on the walls, basins and taps. There was, of course, a smell. It seemed to be what the patients deserved, what the nation had decided was fitting for those who in many cases through negligence, weakness and their own deliberate fault had come to the Acute Medical Ward during a pandemic. She had run reading groups and writing workshops in prisons where the sanitary conditions seemed better than this, but perhaps that was as it should be. She knew that anyone could become an inmate of either place at any time, through sudden mishap or the creeping accumulation of circumstances. People spend longer in prisons than in hospitals, she thought, and so maybe it is right that prisons should be more comfortable. It's probably better to walk through shit incidental to a place of healing than as part of a regime of explicit punishment.

She now needed a toilet seat on which she could sit. She asked her new room-mate Aoife, who had hospital-grade wipes, if she would trade a handful for some gloves. Of course, said Aoife, but why don't you go downstairs, that's

what I do, sure you wouldn't want to set foot in the jacks up here. Me too, said Rory from the curtain behind which he kept the daylight. Why, she said, what's downstairs? Clean toilets, Aoife said, it's where the outpatient clinics are, see, but they don't happen at weekends so now there are no visitors, those bathrooms are cleaned on a Friday afternoon and then no one uses them until Monday, see? But even during the week they do get cleaned, much better than up here.

I go there even in the middle of the night, said Rory, the smell in the corridor up here's bad enough, I can't believe you've been using them all this time.

I didn't know, she said. The situation seemed a synecdoche of the immigrant's mistake. She had been doing things the official way because she knew no better.

She waited to slip away until there was no one at the nurses' station, but the authority conveyed in hospital by smart shoes and a brisk carriage did not outlast her difficulty opening the door. A passing nurse stopped. What are you doing, she said, you're on bed rest, go back to your room. I'm going to use the loo downstairs, she said, I'll be back in a few minutes. You will do no such thing, said the nurse, go back to your bed right away.

She had not stood up to anyone for months, hadn't had the energy or the conviction. Here was novelty: bring it on, lady, she thought, we'll see who's best at words. I'm going to use the toilet, she said, the clean toilet, and then I'm coming back, and I'm going and coming of my own free will. You are going nowhere, said the nurse, the doctor said you're on bed rest. The doctor, she said, has probably not

seen the state of the bathroom, which is far more dangerous to me than walking down the hall. Go back to your room, said the nurse, or I will call the doctor. Please do, she said, I would like to speak to a doctor. They both knew, each knew the other knew, that it was Saturday evening and there were no doctors. Other nurses began to gather, like children around a playground fight, and the nurse who was always angry strode up. There are toilets for you up here, the angry nurse said, you know that. You are not allowed to leave the ward. These toilets are filthy, she said, they are not safe, and I am going to use the clean ones downstairs and then I am coming back. The clean toilets are not for you, said the angry nurse, and you are not to use them. Thank you for your advice, she said, I will be back in a few minutes, and with a surge of adrenaline she opened the door and went through it.

She had used to sweat at moments of tension, but her body had turned off that function months ago. She found herself shaky, heart hammering, in the after-hours peace of the corridor. The end of the winter afternoon seeped through the windows, streetlights already on. Her feet were quiet on the rubber floor and she felt small and fleet, ghost-like. She found the Ladies', leant hard on the door. Inside, there was a glorious smell of synthetic bleach and lemon. White basins gleamed. The floor was not sticky, there were no stains, not even hairs or drips on the counter, and the mirrors were spotless. After one glance she looked away.

She chose a stall by the window, to make the most of being able to see the sky, and did what she had come for. It was a long time since she had felt that sensation of new

internal space and order. She flushed, enjoying the clean handle, and went out to wash her hands and then her face twice. There was foaming soap and gushing hot water. She remembered some of the fine hotels to which festival organizers and her publisher had sent her in recent years. She remembered unnecessary abundances of white towels, soaps and lotions scented with flowers and herbs from local landscapes, marble counters and tactfully lit mirrors. She wondered if she would ever impersonate that person again – if there would be hotels and festivals, if the pandemic would end – and she remembered how often in those hotels she had sat on the large beds and guiltily eaten short-dated salads from the corner shop, worried about dropping tomato on the white sheets, ashamed to think that the hotel staff would find the plastic wrappers and know she'd been eating, sure that restaurants were for people who deserved them.

She looked at herself in the mirror again and then returned to the ward.

There was shouting in the hall, Rory and Aoife and several nurses, and the beds in Room 6 pulled about at odd angles like the aftermath of a car crash, as if there ought to be broken headlights on the floor and airbags hanging flaccid over the railings. I will not move, Rory was saying, it's bad enough in here in a three-bedded room, I am not moving to a six-bed with alcoholics off the street, is that clear? She was briefly, unkindly, flattered to be considered preferable as a room-mate to alcoholics off the street, but she thought also: none of us is better than anyone else; what, really, could be the moral difference between alcohol addiction and an eating disorder, but he with his tragically young and

blameless stage-four cancer diagnosis was clearly in a stronger position in the eye of the nurses if not the Almighty. The jacks, Aoife was saying, are a disgrace, you wouldn't use them yourself, I've never seen one of ye in there and ye must know the smell, would ye not call your cleaning company and have them sort it out instead of blaming your patients?

The angry nurse caught sight of her and pointed. This lady, she said, must be in a room on her own, she cannot be trusted, she must have a nurse at the door. She is not compliant and there will be a doctor here very shortly.

She realized that she was about to be sectioned, not because she would not eat but because having eaten she had insisted on using a clean bathroom. She was about to lose her liberty, her livelihood and her status as a citizen over an argument about shit on the floor. Her idea that she deserved a safe environment, that she was worthy of the most basic hygiene, was evidence of her madness. The clean toilets were not for her.

She remembered an experiment she had read about, one of the more colourful participant-observer studies of 1970s social science, published in a paper called 'On Being Sane in Insane Places'. The researcher, Professor David Rosenhan, participated himself and recruited seven others: a graduate student in psychology, 'three psychologists, a pediatrician, a psychiatrist, a painter, and a housewife.' Each participant phoned a psychiatric hospital and then 'arrived at the admissions office complaining that he had been hearing voices. Asked what the voices said, he replied that they were often unclear, but as far as he could tell they said "empty," "hollow,"

and "thud." (Three of them were women, that 'he' is just 1970s masculine normativity.) This statement was the entire extent of the participants' pretence of mental illness. They alleged no further symptoms and the only further misrepresentations were to protect their anonymity and the experiment. Those working in mental health and medicine gave false names and occupations, but apart from that answered every question about their lives, families, past experiences and present state of mind honestly. They were all admitted for in-patient treatment, seven with diagnoses of schizophrenia and one with manic depression. They said truthfully that, apart from being nervous and dismayed at being admitted to a psychiatric hospital, they felt fine, they were no longer hearing voices and they would like to leave as soon as possible. All of them were told that the more cooperative they were, the faster they would be discharged, which is to say that the measure of sanity was compliance with the arrangements of an institution for the insane. As many incarcerated women writers have noted, the only way out of the madhouse is to agree that you are mad and should be in the madhouse; the Cretan paradox comes to mind. It was not that she believed herself at that moment entirely sane, but she was making efforts with which the dietician and psychiatrist appeared satisfied to follow her meal plan, and there had, so far as she knew, never been any suggestion that she was mad in matters relating to sanitation.

The researchers had been concerned that the processes of research would expose the experiment. They needed to make copious daily notes, and at first tried to do so secretly and to smuggle the notes out of the hospital, but quickly

found that everything they did was regarded by the staff as a symptom of mental illness, including the note-taking. Other patients rumbled them very quickly, but the medical notes include 'exhibits constant writing behaviour'. Boredom was interpreted as pathological restlessness, concern for relationships and careers disrupted by hospitalization as paranoia. The doctors who controlled the patients' admission and release spent almost no time with them in between those moments of judgement: 'Those with the most power have the least to do with patients, and those with the least power are the most involved with them.'

Every participant eventually left with a diagnosis of 'schizophrenia in remission', but in one case it took fifty-two days to get out. The more the researcher insisted that he was a researcher and that his experiment was now concluded, the more the staff regarded him as deluded and unfit to leave. Later iterations had a lawyer and a writ of habeus corpus on standby.

She had written a book and given lectures about the history of psychiatry and of institutions for the insane. She knew that it is not possible to prove your own sanity under any circumstances – though if it were, declining to use a dangerously dirty bathroom when there is a clean one down the hall might not be a bad place to start – and she knew that no one has ever been able to convince a psychiatrist that a psychiatric patient is sane. You wouldn't be there, would you, if you weren't mad? But her expertise failed her. She was unable to recognize her own abjection. Please do call a doctor, she said, I would like to speak to a doctor.

Don't be ridiculous, Aoife said to the angry nurse. We

all know that you don't have enough nurses to give time-critical medication or lift your elderly patients off the floor when they fall out of bed. We've all been washing and feeding those who can't look after themselves, obviously you're not going to put a nurse on a chair at the door to stop someone going down the hall to pee. And you've people waiting days for a bed, you're hardly going to set aside a whole room for one person. Wouldn't it be easier and cheaper for you to get the bathrooms cleaned?

There was no reply. The nurses disappeared, like airline staff at the announcement of a delay, and the patients rearranged their room, put the beds and cabinets back where they had been and then put themselves back on their beds, as if they were resuming sickness. Aoife lay back and entered into communion with her phone, Rory closed his curtains again, she found her place, or a place, in *Middlemarch*.

But it was hard to stay with Dorothea's adolescent misjudgement, or even the dilemmas of Mrs Garth, which in recent rereading had become more interesting. She was half expecting the doctor, even though it was Saturday night and in that country doctors did not work at weekends. She knew the law on sectioning people in the country she still ambivalently considered home, not because it had recently seemed relevant to her own situation but because she had often written and spoken about madness, because she had grown up knowing that however hard she tried to be Jane Eyre, thin and virginal and subdued, really she was more like raging, gobbling Bertha, confined to the attic to spare decent people the sight of her greed and anger. She had always known that one day the truth would out and here,

perhaps, was the day, here would come the doctor, the voice of reason, to make the official declaration of her madness. She took out her phone – would they take her phone, when she was sectioned? – and looked up the law in her new country, which was, as she should have expected, obviously intended to maximize the power of those in authority. At home, two doctors had to agree that a patient's illness was so severe that in-patient treatment was necessary, that such treatment could not be provided except under section and also that the treatment was in fact available. Here, a country with a long history of locking away troublemakers especially when female, the law reminded her of the research she'd done in the archives of nineteenth-century asylums for the insane. A person's spouse, parents, police officer or priest, or 'a concerned member of the public' could apply to have her sectioned, no medical training required, and as long as a psychiatrist certified that the patient was 'suffering from a mental disorder' which 'could get worse', without reference to the severity, symptoms or prognosis of that disorder, nor indeed to the availability of treatment, she could be detained, restrained and medicated against her will. During the Covid lockdown, it was not necessary for the psychiatrist to see or speak to the patient before making this determination, which meant that the doctor wouldn't even have to interrupt his evening if the nurses decided to make a phone call, and also that she would have no opportunity to represent herself or explain about the dirty bathroom. She knew that if and when they came for her, these other experts and voices of reason, she had nowhere to go. She had been better with the voices in her head. She remembered the writing of Janet

216

Frame, Antonia White, Virginia Woolf and understood them anew: an urgent question for the psychiatric patient is whether the voices of coercion and judgement in her head are better or worse than the voices of coercion and judgement in the medical system.

She began to feel sick.

I think, she said to Aoife, I might leave now. I think I might discharge myself this evening. She would go home, and then she would leave this jurisdiction, before the comeuppance could catch up. She had friends in other countries who would take her in. It had been a mistake, to come to this hospital. She should have crossed a border, taken a train or a boat or a plane, before admitting herself. Her instinct for a geographical solution to her troubles ran true; the answer was always to go. And she was not yet sectioned, it was not too late.

Aoife looked up, took out her earbuds. They'd have the guards on you, she said, before you got to the end of the road, what are you thinking? How could they do that, she said, how could they call the police when there is no allegation that I have committed a crime? None of us is allowed to leave, said Aoife, surely you know that. That can't be right, she said, surely not, it's a hospital, not a prison, and we're here to be treated, not punished. Darling, Aoife said, trust me, we can't leave, did you not hear them bringing that poor man back last night and he'd only gone over the road for a fish and chips? It doesn't make sense, she said, even the state can't hold you without following legal process, it's against European law whatever they say here. Aoife shrugged, returned her gaze to her phone. It doesn't have to make

sense to be true, does it, she said. You must have had a nice life, Aoife did not say, if you got to your age thinking things make sense, thinking the system is fair. Where've you been in your forty-six years? Yes, she thought, fair enough, I have been, by and large, in places where I mattered. I have been a person to whom systems are often fair.

They heard the day-nurses leave and the night shift come on, but no one entered their room. It seemed to be one of the days when no dinner was served, which happened sometimes, perhaps because the catering staff were also overstretched or because the alcoholics and anorexics and chronic pain of the Acute Medical Ward were low priority. She decided to give herself a night off the salad boxes, which might after all be the last time she exercised her free will, and she wondered what else she might do with these possibly final hours. Call a friend, perhaps, but to do that with any privacy she would have to go into the hall and she had no intention of reminding the new nursing shift of her existence. Read.

When the trial came, if it was a trial, it was absurd. A pretty teenaged boy dressed in scrubs made for a grown-up came and stood in the doorway, looking from the sticky note in his hand to Aoife, who had not had her morphine drip and was now gasping in pain, to the curtain behind which Rory was streaming a film with loud car chases on his laptop, and to her, sitting in a half lotus position with *Middlemarch* open on her lap. He tried the hospital's approximation of her name. Yes, she said, more or less, that is me, and she readied herself, because it made a certain kind of sense that

this half-crazed institution would send a sweet boy as her nemesis. I am a doctor, he said, and I gather that you asked to see someone. I gather that someone put something in your eye. He was, she thought, like a student with his gathering, the way undergraduates need to propel themselves into a sentence by saying that it is possible to argue that, or the reader might perceive that, and consequently, thusly, furthermore. She wondered if he was himself a little deranged, with his tale of something in her eye, or if this preamble was intended as a test of her reason. I did ask to see someone, she said, avoiding the word 'psychiatrist' in case he did not already know that she was mad, but no one put anything in my eye. Yes, he said, I gather that someone put something in your eye, or at least that you complained that someone had put something in your eye, and you wanted to see someone. She wanted to ask if the someone who had put something in her eye was the same as the someone whom she wanted to see, but it seemed unwise to join his game too quickly. What kind of thing, she asked, did someone put in my eye, do you gather that someone put in my eye? This is your name, he said and you are in bed six, are you not? She thought it best to avoid direct contradiction. More or less my name, yes, she said, but this room has three beds in it and I am in the middle one, which is number two. Are you saying, he said, that you are not in bed six? There are three beds, she said again, and this one is between the other two. She was reminded of the verbal and non-verbal reasoning tests to which her children had been subjected at school, for which she had been unable to help them prepare because the tests reliably demonstrated

that she had no reason whatsoever of either description. Yes, said Nemesis, consulting his sticky note, perhaps there is some mistake, are you sure you're saying now that no one put anything in your eye? I am reasonably certain, she said – as if her own reason or certainty had any currency in this place – that no one put anything in my eye, and absolutely certain that I have not said that anyone put anything in my eye. (Not recently, she wanted to add, and not anyone else, but when her children were babies she had more than once put their shampoo in her own eyes to check the bottle's promise that it didn't sting. The sensation could not exactly be described as pain but it was unpleasant.) Ah well, said Nemesis, then I'll say goodbye now. Grand so, she said, goodbye.

I hope, Aoife said, those notes you're taking are for a complaint, you know you've ample basis for it. You forget that I'm an immigrant, she said, I can't complain, and anyway no one believes a madwoman. And anyway, she did not say, I brought it on myself, I've no one to blame but myself, on my own head be it.

III

A body of one's own: thinking

insane places

You saw the hospital psychiatrist at irregular intervals through the winter after your admission. The hospital had an outpatient treatment programme for adults with anorexia, but the waiting list was seven months long. It was not clear, to you or to your family doctor, that you had seven months, because you couldn't follow your meal plan once you were back at home. The psychiatrist had said that you must take time off, weeks off work, but two days after you were discharged you returned to teaching, biking a few miles to campus. You missed running so you started again, happily surprised to find that it took only a few days to recover fitness for the familiar routes. You pushed the familiar podcasts into your ears. The chorus took up its chant again. Your weight dropped obediently, reassuringly. You went on another book tour. I'm fine, you said to your head of department, to your friends, to your publisher, I can do it and I want to. You were not fine but you could do it and you did want to. Some part of you remained sane and civilized and you clung to that part, to books and teaching and thinking.

You knew you needed help, even though the chorus urged hunger. You wanted to be able to write again and you knew that whatever the experts said about fasting improving concentration and performance, your starved brain was incapable of creativity. Accustomed to Britain's universal

public healthcare, you had no idea how to perform in the Irish semi-private system as simultaneous patient and consumer, especially since much of the time you didn't want the care you needed. You hated being weak, cold, hungry and unable to write, but you couldn't bear to eat or gain weight. You oscillated, crashed, between intolerable hunger and intolerable eating. It seemed a strange idea, that you might seek and pay someone to support or compel you to do what seemed unbearable, and in any case you could find no local specialist whose list was not already full. You had lived in Ireland long enough to guess that probably access to a busy private practitioner depended on knowing someone who knew someone, and possibly, given where you worked and lived, who your new friends were, you did know someone who knew someone, but those networks don't work when you are ashamed to name what you need.

While you waited, you received 'supportive clinical management', which was not supportive, managed nothing, and seemed clinical only to the extent that the quantification of the body is clinical. At irregular intervals, every few weeks, you received a text message instructing you to attend the clinic thirty-six hours later. 'We expect you to prioritise attendance', the leaflet said. 'Appointments cannot be re-arranged.' You climbed the hospital's boat innards, the stairs to which you'd escaped from Resuscitation, and joined the skeletal girls for whom there were never enough chairs in the waiting room. There was a urology clinic using the same waiting room on the same day, so frail old men and frail young women jostled and sometimes there were arguments about who got to sit down. One by one you were called to

the corridor and weighed by an angry nurse as people walked past. If you left your boots and coat on, you were scolded for deliberately inflating your weight. If you took them off you were scolded for taking too long. You found yourself dressing for the purpose, ballet flats despite the weather, coat with a zip not buttons.

The first time, the nurse also measured your height and then asked you did you know how tall you were, as if it were a trick question, as if you might have reached the age of forty-six without happening upon this information. When you told him he said ha, no, you're wrong, out by over an inch. He made you three centimetres shorter, which made your BMI higher and your need for treatment less urgent. All these years, you thought, you had been wrong. How strange. And since you had always been two inches taller than your mother and four inches shorter than your husband, presumably they were also wrong about their own heights. A year later, when you reached the top of the queue for a bone scan, the technician who had already scanned you and therefore knew the answer asked if you knew your height. You gave her the number from the eating disorders clinic and she said ha, no, you're out by over an inch, all these years you thought you were an inch shorter than you are, think of that! It wouldn't matter, an inch either way, to doctors interested in your mind and your ancestral voices, but they were interested only in your BMI. When it did not rise, you were bad, non-compliant, undeserving. When it did rise, you were attention-seeking, usurping resources meant for people who had real problems. It is not a difficult part of medicine, to determine a patient's height, and for a

doctor who believes that the most important fact about the person sitting opposite her is weight divided by height squared it should matter that the measurements are correct. You must stop thinking about your weight, they said, you must stop weighing yourself. What was important to the doctors was not allowed to be important to you. You wondered again which side of the desk was for mad people.

Passers-by paused at the weighing station, entertained, catching thin women's weights and their scolding the way you'd catch an arrest in the street. Coming from work, you had your laptop and got on with teaching preparation and marking while you waited, which was not approved. You were not supposed to be functional at work or in your family life. If you were functional, you weren't sick enough to deserve help. You're not prioritizing your recovery, the psychiatrist said. She was an assertive middle-aged middle-class white woman like you, uncomfortable with someone of her own status on the other side of the desk, used, you thought, to dealing authoritatively with the skeletal girls. You had some sympathy. You too know how to be confident at work, but usually you're trying to flatten the hierarchy because students think better that way. She was asserting her power, your subjugation. If there was any need for thinking, she would be the one doing it. What, you asked, would you do differently if you were prioritizing your recovery? We make people give up their college places, she said. We expect them to focus on recovery. You'd take time off work. You'd stop all this travelling, you know we told you not to travel. Are you *actively writing* at the moment? As if there were some other, passive, kind of writing. Because

if you are, she said, you must stop, you will be absorbed in your writing and forget to eat. You could have told her, if she'd been interested, that you used to write with a plate of sliced apples and dark chocolate on your desk, because real writing, first draft hacking-through-the-undergrowth, road-building stuff, felt as physically intense as running or mountain-climbing and you ate because you wanted to keep going. You could have told her that the most grievous aspect of your sickness was that you had lost the ability to write fiction, that you could no longer build or inhabit the world of a novel, only document your own unravelling.

The psychiatrist spoke of something called 'your anorexia voice' which produced 'cognitions' you were ordered to resist, but she did not say how you might distinguish these 'cognitions' from useful or necessary ideas about Wordsworth's reflections on mortality or what your husband might like for Christmas, nor indeed from the scientific research of experts on obesity and metabolic health. Were double-blind, randomized controlled trials published in prestigious journals 'cognitions'? The instruction to eat and weigh as little as possible had not originated in your crazed head. There was no delusion in your idea that women are rewarded for being thin and punished for fatness. Your thoughts aren't facts, the psychiatrist said, you must teach yourself to ignore them, but she could not or would not tell you how the teaching self could be separated from the thinking self, nor what other self might perform the separation. You could not understand what entity was to oversee the fracture of your mind, how you might find a narrative position from which to judge your

own judgement. Wasn't it part of the problem, not the solution, that you been taught as you spoke your first words to distrust your own perception, that you had been brought up to believe that what you experienced and remembered as true was in truth delusion or fabrication? Your instinct was that recovery lay in integrity, in the trust and respect for your own mind and body that you had not learnt in childhood. It made no sense that dis-integration might be the condition of healing, and the psychiatrist was not able or willing to discuss the conundrum.

What would I do, you asked, instead of work, how would I spend my time, while not teaching or travelling or writing but focusing on recovery? You'd accept the medication, she said. They kept trying to give you antidepressants, although you were not depressed, the chosen drug was contra-indicated for a genetic condition and the side-effects included weight changes. I make my living by thinking, you said, as you had said for months, I don't want to mess with my brain, and also there are contraindications and also I am not depressed. You are not compliant, she said, if you were compliant you would give up your work and then you would be depressed and you would want the antidepressants. She wanted you to break down. Nothing short of a complete collapse was satisfactory. As people say of joining the army, you were to be destroyed before you could be rebuilt and she seemed much more excited about the destruction than the resurrection.

I have never been compliant with anything, you wanted to say, compliance is not in me. Unusually among women and especially Irish women, I was not raised to comply, in

my family we valued resistance. You missed Patricia, the psychiatrist of your teens, who was not a specialist in anorexia but understood from the beginning that your reading and writing, the work of your mind, offered you the only way out of the shrinking world of illness. Patricia had worked hard and taken responsibility for some serious risks to keep you out of hospital and protect you from becoming a full-time psychiatric patient, from having a career as a madwoman instead of a scholar.

How would it help me, you asked, to be depressed, and what would I do, if I gave up work, other than be depressed? And unwisely you added, better I should crawl around my bedroom pulling off the yellow wallpaper? If you can manage your professional life, she said, there is no reason why you cannot manage your recovery, you are choosing to be sick. As if madness had only one form, as if the possession of any kind of competence betrayed malingering. *You're a clever girl, you could do it if you wanted to, you're just not trying, are you?*

Wolf?

Wolf far thence, gone away.

You must follow your meal plan, she said, and you must not exercise and you must not write and you must gain weight. But if I could do that, you said, I would not need help, I would not be sick and I would not be your patient. I am here because I cannot do it. You are not compliant, she repeated. To the extent that you were not responding to her instruction to be well, she was correct.

The meal plan was impossible. I know it's scary, said the nice dietician, it will look like a lot to you, but she didn't

know: it wasn't that there was too much food on the plan, it was that there wasn't enough, that if you started to eat you might never stop, that if you ate the permitted quantity you would want more and more, be unable to stop yourself having more, that if you began with breakfast you would have nowhere to go later in the day, no margin for error, no defence against a lapse. The hunger you had held and carried for months would burst out like a fly from a maggot and pollute and gobble until you had eaten the whole world, until you were the size of the whole world, the devourer of everything. *Such self-control,* your friends' mothers had said forty years earlier, but you had self-control because you had to, because somebody had to, because the alternative was unthinkable. *Do you want to get like your mother?* (Why not, you think now, from a place of safety, a person could do far worse. Is it so bad, to take a size from the other end of the rack?) The only way to avoid excess was to follow the rules. *Fast. Low blood sugar is good blood sugar.*

Your husband Blu-Tacked the meal plan to the kitchen wall, beside the fridge. It stated times and quantities. It came with a leaflet that said: follow this plan to restore weight gradually and avoid bingeing. Don't eat between the stated hours, don't graze, because if you do you may lose control and overeat. However hungry you are, wait for the next authorized occasion. Don't eat cakes or chocolate or chips, your anorexia is not an excuse for treats. Don't eat alone, because you will be ashamed. (It had not previously occurred to you that eating alone was shameful. Did that mean that you couldn't be trusted, that you should wait to eat until there was someone to keep an eye on you? What

about all the time you were alone, working from home or travelling or just when the rest of the household was out? Best not to start eating in case you didn't stop.) You will be tempted to binge but if you follow our rules it will not become a habit. So the authors knew, it seemed, your nasty secrets, they knew you were just waiting, straining like a leashed dog, to get at the food that was not for you. Your disorder and its treatment shared an obsession with control. There was no suggestion that the body could be trusted, that some bruised part of you might already know when to start eating and when to stop, and as long as you could not trust your body, you could not eat.

Eventually your agent made contact with a colleague of a friend in private practice in London, a doctor who was happy to work internationally via Zoom as long as you had local clinical observations. You did, after all, know someone who knew someone. You are fully aware of the privilege involved in this arrangement. Without it, you would have died, or at least, as many do, entered a revolving door of hospital re-feeding, discharge and repeat starvation. It is not clear to you how that would have improved the world for anyone.

the person who cooks

Every week, your therapist listens to you pulling in everything you know and read, all your scholarly resources. You can do a Foucauldian analysis of diet culture. You can correlate the history of British fashions to the waves of feminism, comparing Victorian writing about the corset to 1960s bra-burning. You can explain the relationship between urbanization, social mobility and changing mealtimes in northern Europe from the seventeenth century onwards. You can explain, with reference to early hominid archaeology, Greek and Latin poetry, Early Modern European art and nineteenth-century fiction, why the experts on intermittent fasting are wrong when they make pronouncements about how 'our ancestors' never ate after nightfall, how 'prehistoric people' (in all their millions, across all their millennia and climates and technologies and terrains) adhered to the experts' preferred dietary regimes, why it's odd anyway to idealize the lifestyles of people who rarely reached the age of forty, though that doesn't stop you deciding that no calorie will cross your lips after a certain time of day or that you will never again eat any form of refined carbohydrate. This is all very interesting, your therapist says, but you can't think your way out of an eating disorder, you can't read or analyse your way to health, you have to eat and you have to keep eating, however you feel

and whatever the voices in your head have to say. I know, but – you say. Yes, but. I understand, but.

Thinking is what you do. Your education is your toolbox, you have no other.

Most of the years you were writing your PhD, you avoided the women of the coterie you studied. You still imagined, probably went on imagining until you had your first child, that while considering yourself a feminist you might escape the traps of womanhood, might keep yourself thin and clever enough to pass as intellectually masculine. You never wanted to inhabit a male body, but you very much wanted to be allowed to think like a man, and in Oxford in the early 2000s 'thinking like a man' was a recognizable act. Oxford colleges still provided their residents with daily cleaners and three meals a day, the idea being that great minds should be free from petty domestic concerns. This regime, you see now, could have seemed like the care you did not receive in childhood, but it felt more like infantilizing control. There were great scholars approaching retirement who had never chopped an onion, paid an electricity bill or taken out the rubbish, who feuded over the stocking of the college wine cellar or the arrangement of paintings in the Senior Common Room as primary school children are reproached for feuding over crayons and playground games. They wore the same clothes, tweed jackets and pastel shirts, for decades. You wanted that life, the life of the almost-disembodied mind, or at least you wanted to want it, but meanwhile you made yourself a red ballgown out of a roll-end of silk picked up at the market. You made pancakes for your housemates every Sunday morning and couldn't bear to see the apples

in the college garden fallen and rotten so you made apple crumbles and pies for whoever was hungry. You persuaded each new friend who could cook to teach you something from their repertoire: risotto from Rome, chocolate chip cookies from Canada, potsticker dumplings from Sichuan via Texas, spicy peanut sauce from Indonesia, all new and exotic to you in those days. You and Lucia shared a PhD supervisor and ambivalence about domesticity and scholarship; together you picked bags of damsons from the side of the canal and spent a day making jam, jam of shame and rebellion. It took you years to understand and then to say in public that a person can be good at making jam and ballgowns and fancy knitwear and also books and lectures and ideas.

The fashion in literary scholarship in the late 1990s was for 'New Historicism', which invited thinking about books in the context of other cultural forms: gardening, cartography, architecture, music, and in more daring circles than Oxford, shopping, handicrafts and fashion. New Historicism could have given you permission to think over your pans and knitting needles, but you weren't ready. Oxford wasn't ready. Scholars returning from maternity leave often begin research on reproduction and parenthood and in due course you would be among them, writing a monograph on food and gender in Romantic-era women's writing and taking a particular interest in eighteenth-century guides to pregnancy, birth and breastfeeding, but before you became pregnant you kept your eyes averted from all such work, writing instead about the influence of travel writing and voyage narratives on Wordsworth and Coleridge. All your

travellers and voyagers were white men, all your poets were white men. You wanted to play with the big boys. You thought if you had good enough grades the patriarchy would let you in. (You were not, obviously, thinking collectively. No sisterhood there. It's not an excuse that you were not brought up to think collectively, that both your father's family's escape from the pogroms of early twentieth-century Latvia and your mother's family's escape from English urban poverty depended on individual salvation in environments where the collective had been destroyed.) You thought, to put it in Freudian terms, that you were still in with a chance of becoming the father rather than the mother.

You eventually read Dorothy Wordsworth's journals because you were thinking about William Wordsworth's daffodils. It was one of the first poems you'd memorized, aged eight, because you knew that lakeshore and those daffodils, had seen the bright brushstroke along the water's edge from high above on wet March mountain hikes. Your grandmother, whose bones had become too fragile to carry her up mountains, liked to hear you say the lines while you cooked together. You enjoyed the word 'jocund'. Later, you liked the pendular rhythm of Wordsworth's thinking, the out and back, walking and home, seeing and remembering, the way the words never quite have faith that action will follow memory as memory follows action but the rhyme and rhythm of the verse make that promise. Back and forth, in and out, the heartbeat and footsteps of the English iambic.

For oft, when on my couch I lie

In vacant or in pensive mood,

They flash upon that inward eye

Which is the bliss of solitude;
And then my heart with pleasure fills,
And dances with the daffodils.

Writing is how we simultaneously entertain and defy mortality, a form of playing with time. Here is the writer recollecting, washed up on his couch, wanting the experience back and yet only now, only afterwards, able to make art of memory. For Wordsworth, mourning, belatedness, is the condition of poetry. You can write only of what is gone.

But on this occasion, for your PhD, you were curious about these particular daffodils. Were they nature or culture, wild or planted? (You can't quite remember now why it mattered; perhaps if they were planted – of course they were planted – they were a symptom of empire, politics presenting as aesthetics, culture masquerading as nature. You don't get a PhD for saying that they're just flowers and everything comes from somewhere.) William Wordsworth was living with his sister Dorothy in these years, the pair of them rebels against the bourgeois life laid out for them by aunts and uncles after their parents' deaths. William had dropped out of Cambridge after visiting revolutionary Paris and getting his French girlfriend pregnant, Dorothy had finally refused to be passed from one household to another whenever someone in the extended family needed a nurse, carer or housekeeper, and together they rented a small cottage in Grasmere where William planned to support them by writing.

It's easy to read Dorothy as the downtrodden servant of William's art, provider of hot meals and clean shirts to a man whose inspiration takes all his time and energy without

reliably paying the bills, but you find this a misreading. Dorothy cooks, certainly, but with verve and at times of her own choosing. Like your dinners, hers are often produced around reading, writing and outdoor exercise, a bit late, a touch ambitious under the circumstances, sometimes not quite ready in time for people to keep the hours dictated by convention. She's often winging domestic life a little, rearranging around the weather and unexpected visitors and the impulse to go for a walk, but underlying the winging is a steadfastness in care. She cares for the people in her household, always her brother and often also their friend Coleridge with his worsening opium addiction; Coleridge's mostly abandoned wife; William's future wife Mary; friends, strangers, hungry and homeless travellers along what your grandfather would later know as the Great North Road which passed the door of Dove Cottage. The work of caring is integrated with and not invariably prioritized over the work of reading and writing and Dorothy's own need to chat to friends and neighbours and walk the hills and valleys every day. She is, it occurs to you, in this regard not unlike Susan Walker in *Swallows and Amazons*, able to imagine the work of care as flexible and enabling to the carer as well as the cared-for. The carer, after all, also eats, wears clean clothes, washes herself. The more you read, the more Dorothy Wordsworth seemed to be describing a radically sane life, rooted in the hour-by-hour reconciliation of responsibilities and pleasures, acts required and desired in the short and long term for the welfare of household, community and self. She and William are financially precarious and in some ways living more plainly than the March

family in *Little Women*, yet pleasure is not only permitted but a legitimate and reasonable use of time and energy. If one of them fancies gingerbread and there's enough money in hand that week, she goes off to the village baker for gingerbread. If there's a bright full moon and she wants to go walking at night, she goes walking at night, even if William prefers to stay indoors to sleep or read. You can imagine Marmee's strictures: greed and self-indulgence, frivolous expenditure, gingerbread when there are children starving not half a mile from the door. There are children starving right by the door every day, and Dorothy invites them in and shares her food. But she's also allowed her gingerbread.

The daffodil walk is on 15 April 1802. Dorothy's account is plainly the basis of Wordsworth's poem, and second-wave feminist readers saw him stealing her ideas, taking credit for her literary talent. 'I never saw daffodils so beautiful they grew among the mossy stones about & about them, some rested their heads upon these stones as on a pillow for weariness & the rest tossed & reeled & danced & seemed as if they verily laughed with the wind that blew upon them over the Lake, they looked so gay ever glancing ever changing.' In the poem,

Ten thousand saw I at a glance,
Tossing their heads in sprightly dance.

The waves beside them danced; but they
 Outdid the sparkling waves in glee:
 A poet could not but be gay
 In such a jocund company.

No resting or weariness here, and feeling 'gay' (the original meaning, obviously) transferred from the flower to the poet. Dorothy's version is more embodied, keeps the daffodils closer to the walkers who also 'rested again & again'. In Dorothy's version the day is 'mild' but wildly rainy. William is not 'lonely as a cloud' – though clouds are rarely lonely, travel in groups – but accompanied by his sister and, until the rain puts her off, their neighbour Mrs Clarkson. There are signs of spring, 'a few primroses by the roadside, woodsorrel flowers, the anemone, scentless violets, strawberries, & that starry yellow flower which Mrs C calls pile wort', but mostly this is an account of a very wet walk. You are always pleased to remember that they pass the daffodils only because they're avoiding a field of cows like sensible people. Dorothy has to change her clothes at an inn where 'the Landlady looked sour but it is her way' and they splash out on 'a goodish supper, excellent ham & potatoes. We paid 7/ when we came away'. Over the following days, the pair walk, write, cook, rest, see friends. Dorothy notices, always: 'We watched the Crows at a little distance from us become white as silver as they flew in the sunshine, & when they went still further they looked like shapes of water passing over the green fields'. Shapes of water! Only a few lines later, 'I pulled of [sic] my stockings intending to wade the Beck but I was obliged to put them on & we climbed over the wall at the Bridge'. They sit in the garden all morning on Easter Saturday – 'William dug a little. I transplanted a honey suckle'. Dorothy goes to bed for the afternoon and then they take a long moonlit walk. On Easter Sunday she 'lay in bed late' and they both stay up late working on a

poem. On Monday 'Wm worked in the garden, I made pies & bread' and on Tuesday William finishes two poems, one written on a trotting horse while wearing gloves.

Victorian and twentieth-century literary critics tended to treat the journals as trivia, the foolish jottings of the housewife's mind, and to imagine that Dorothy's observations of the natural world were dictated by William for his own later use, although you'd think that a person who can write a poem on horseback can probably make his own notes on a lakeshore. Schooled by this tradition, in your first readings you quashed your curiosity about the baking, the transgressive lie-ins, afternoon naps and midnight walks. *Obviously* someone who writes about changing her stockings and making pies and bread can't be taken seriously, even if the pies and bread are fuelling the making of art that is taken seriously. Even more than now, young middle-class women were not supposed to wander the countryside alone, were asking for trouble by taking outdoor exercise unchaperoned, should keep regular hours and a regular diet, not talk to strangers, not take too much interest in food, curb and control and discipline mind and body, in those days for purposes of marriageability and salvation and now – well, for what? 'Wellness', which seems to be code for thinness and fragility as severe as any Victorian girl's. 'Wellness' requires you to internalize the corset, to replace its whalebone and bindings with diet and exercise, to declare yourself sensitive to and intolerant of major food groups, to find impediments (literally, things that get around your feet) to adventure, to imagine that your control of your body and your suffering can be absolute. Outside is dangerous

(in fact almost all violence against women happens at home). There are bad men in the bushes (it's far more likely that there's a bad man in your bedroom). Healthy people are not healthy enough and good health is an individual obligation (most of our health is socially determined).

Dorothy Wordsworth was not much interested in wellness and refused to fear solitary hiking. She walks for the pleasure of being outdoors, with the weather and the plants and the hills, alone and in company. She eats what she fancies within the constraints of her budget and location. When she's tired or unwell, she goes to bed until she feels better. After years spent helping to run other people's households, caring for other people's children and elders, she would have known how unusual were her freedoms in these years. She continued to live with William after he married Mary, and became again the extra pair of hands as their many children were born, although in midlife she developed a form of dementia and required decades of care herself. The Dove Cottage years cannot be a model for anyone who has a job, a family, any kind of externally imposed or chosen schedule, but when you needed it they gave you a way of imagining how to read and write, cook and eat, exercise and rest, without shame. You reread her writing when you became a mother, a carer, the person who cooks, and began to understand how your pleasure in and commitment to the work of care might, at least in theory, be reconcilable with your pleasure in and commitment to the work of art. Life in the kitchen might not be a betrayal but a counterbalance to life in the library.

Send her back, the wolf, with this insight. The Jumbly

Girl believed that when she cared, she risked everything, that you would devour her mind and her very self if she could not hold you off. You and your needs and demands and desires were dangerous to her, and so they seemed dangerous to you. You were too intense, too hungry, too sad and angry and fearful for her, there was too much of you, you needed cutting down to size, it wasn't safe to have you around until you were contained, silenced, diminished, until for everyone's sake you had learnt the hard way to contain and silence and diminish yourself. In your turn it would sometimes seem to you that the proper way to meet your children's needs was to obliterate your own, that co-existence was forbidden and motherhood a matter of self-erasure, that since it was impossible for both mother and child to survive motherhood you must save the children, but in saner moments you would take heart from the Grasmere Journals. You can walk the hills and bake a pie, write about the crows and feed the kids. If you sleep when you are tired and eat when you are hungry, the world will not end. You can put dinner on the table without being eaten up.

hyena in petticoats

The baby was, as they are, a delight and a shock. All the usual reasons – feeding, sleeping, not feeding, not sleeping – but also you were twenty-five and encountering mother-hood ten years earlier than any of your friends. You were unprepared for the blame. It began in pregnancy: ask yourself, one book instructed, with every mouthful, is this the best bite for my baby? If you ate the wrong things, the baby would be damaged forever. Its bones and nerves and biochemistry had no protection from your greed. But the rules were hard to divine: you must eat fish, for the baby's brain, but also all the pollutants in the sea end up in the fish so you should not eat fish, for the baby's brain. (There was no recognition that a pregnant woman might also give thought to the death or dearth of the fish; it would be selfish to prioritize your own sense of integrity over maternity.) You must eat enough for the baby's growth – frivolous to put your desire to stay slim above the baby's needs – but not imagine that pregnancy was an excuse for self-indulgence. The permissible weight gain varied between books and doctors, with some insisting that women should take the opportunity of the baby's energy use to lose weight, all weight loss being good, and others insisting that good mothers were willing to sacrifice their vanity to the baby's best interests by laying down fat to fuel later breastfeeding

as well as carrying the weight of the baby and its accoutrements. Its impedimenta. It was also selfish to permit yourself to become stressed or anxious as you tried to resolve these dilemmas or indeed experienced life events or geopolitical situations beyond your control. Cortisol would flood the baby's bloodstream, leading to cognitive deficits and a predisposition for obesity, which would be your fault. (At one appointment, the midwife took your blood pressure, told you that it was too high and that she would take it again in five minutes and if it hadn't come down she would send you to the hospital in an ambulance. Funnily enough under the circumstances, it did not come down.) The point, you rapidly discovered, was that even before the baby was born, to be a mother was to be wrong. You felt a small, muted pulse of fellowship for the Jumbly Girl, who had turned in her turn to resentment where your instinct was guilt. Mothers are bad.

You failed at giving birth. The Owl told you, *women in Africa just nip out into the fields, have the baby and get on with their work, there's no need for all this fuss, women have been having babies for millennia before there were doctors.* You were too scared of him to say that Africa is a continent and not a refugee camp, that maternal and infant mortality rates are high where women can't access healthcare, in the United States as well as some parts of Africa, and that archaeological and historical evidence show a great deal of care and ingenuity devoted to helping women in childbirth over thousands of years. *Weak excuses, who do you think you are, making things up to get attention.* You tried to have a home birth but your heart did its stupid things and you

ended up in hospital, where you haemorrhaged and were unconscious for one of the crucial first hours in which you should have been bonding with the baby. *Putting it on, there was nothing wrong with you, fuss about nothing.*

The opportunities for failure increased after the birth. Breastfeeding was hard, the discourse around it punitive. Everything you did or said or thought, every move you made, might harm the baby, now and for the rest of his life. *He's only crying to get attention*, the Jumbly Girl said. That's why I'm attending to him, you said; it had always been easier to talk back to her than to the Owl. *It's just comfort feeding*, said the nurse, *he doesn't need more milk.* He needs comfort, you said, and I can provide it. *Mothers in Africa*, the Owl said, *don't make all this fuss, mothers in Africa feed their babies while they're working in the fields.* The Owl, you think now, has better credentials as an ally against racism than most internet warriors. As a young man in newly desegregated America, he'd repeatedly put himself in clear and present danger as an activist, but his commitment to the importance of Black lives didn't seem to extend to mothers, or his need to imagine a reservoir of primitive maternity overrode his critical thinking.

You had better defences now. They didn't always work – thinking is rarely the best or shortest way out of trouble – but they were better than hunger. The year before the baby came, you had finished your PhD, which you now see was partly an investigation of some of the origins of modern European masculinity and the discourse of reason. You had spent years reading and writing about the (male) European encounter with other people and other ideas, about the

scholarly hierarchies invented on the fly, under sail, to keep everyone in their place. You knew about the dictionaries, encyclopaedias, maps and taxonomies made in the eighteenth century to hold the whole world and its glories and complexities under glass, and about the relationship between those systems of knowledge and the poetry and art celebrating the wildness and strangeness that eluded reason. You understood how the idea of Reason, of what was reasonable, could be both a liberation from superstition and a tool of oppression.

You went back to work and wrote a book about food and gender in the late eighteenth century, an era which for you is the beginning of modernity and the origin of current beliefs about science, discipline and the body. You wrote about the British women encountering the modern understanding of rationality and self-control in the first generation, and you now see it was partly a book about your battle with the Owl and his courts of reason. Eighteenth-century clergy and doctors were eager to police women's appetites, certain that without constant vigilance there would be no end to female hunger. William Buchan's bestselling *Advice for Mothers* reminded you of the feast at the beginning of Virginia Woolf's *A Room of One's Own* in its list of forbidden foods: 'highly seasoned meats; salt fish; rich gravies; heavy sauces; almost indigestible pastry; and sour unripe fruits, of which women in general are immoderately fond . . . can any woman, capable of the least reflection, continue to gratify a perverse appetite by the use of the most pernicious crudities?' You recognized the Owl's voice, calling from three centuries back. You were looking for foremothers, for

a cultural history of women's eating and taking up space. You were thinking. Curiosity in the library was the best trick you had.

You found in eighteenth-century British women's writing a point of origin for the puritan feminism in which you were raised. It's easy to expect too much of Mary Wollstonecraft, often imagined as the first British feminist. Like all of us, she saw through the glass of her own time and place, and saw further and more intelligently than most. She paid a higher price for publishing female intelligence than any woman in Britain would now, and her critique of marriage would take centuries to reach the mainstream. The venom with which the major thinkers of her day received her work is as alarming as any modern internet reaction to feminist writing. Samuel Johnson, author of among other important works the first English dictionary, called her a 'hyena in petticoats.' Despite, or because of, her insistence on the primacy of reason, of women's reason, she made two suicide attempts under the strain of single motherhood in 1790s London. She had been neglected and abused in childhood and suffered under the excoriation she received for publishing frankly about her life and ideas. (You hold her in mind now, publishing this, publishing and being damned. There's a tradition, a lineage, of hyenas in petticoats, defiant women who should keep silence for their own good.)

For Wollstonecraft and her readers, the cost of the female mind was the female body. You couldn't be clever and enjoy eating. You couldn't be a good woman and like sex. If you wanted to take on the patriarchy, you had to prove that you

weren't greedy, weren't interested in shopping or cooking, could discipline your appetites and control your body. Men already knew that women were always after cake and new dresses, their minds full of trivia about fashion and recipes, and so it was your job to prove them wrong.

'I wish,' Wollstonecraft writes early in *A Vindication of the Rights of Woman*, 'to persuade women to endeavour to acquire strength, both of body and mind, and to convince them that the soft phrases, susceptibility of heart, delicacy of sentiment, and refinement of taste, are almost synonymous with weakness.' Enlightened motherhood involves 'such an attention to a child as will slowly sharpen the sense, form the temper, regulate the passions as they begin to ferment.' The object of girls' education should be 'to enable [reason] to regulate their conduct,' for in the absence of such training, 'Women have seldom sufficient serious employment to silence their feelings.' Wollstonecraft is not wrong, then or now, that a woman displaying feeling is considered to be in charming need of protection if she is young, white and pretty, but hysterical or threatening in any other case, and the conclusion that therefore it is necessary to repress feeling if we are to be taken seriously is logical enough. 'Strength, both of body and mind' is an obvious feminist goal, empowering, and Wollstonecraft's rejection of (white) feminine fragility was radical. But like later puritan feminists, including *Little Women*'s Marmee and the Jumbly Girl, she ends up blaming women who fall short of her impossible standard of self-discipline and repression. Women who enjoy fashion are allowing 'the fripperies of dress' to 'weaken the mind'. She disapproves

of girls at boarding schools sleeping and washing together because 'many girls have learnt very nasty tricks from ignorant servants' and intimacy leads them to 'obtrude on notice that part of the animal economy, which is so very disgusting.' 'As a sex, women are habitually indolent; and every thing tends to make them so.' For this founding mother of British feminism, women's self-respect depends on body shame, constant self-surveillance and striving to overcome the natural and cultural disadvantages of being a woman. It is the responsibility of each individual woman to regulate her passions, silence her feelings, cultivate physical, intellectual and moral strength and resist the temptations of fashion, food and sex. Only by such regulation and repression might she prove that a woman's reason is equal to a man's. As the reference to 'ignorant servants' suggests, Wollstonecraft's feminism was for middle-class women; she refers to aristocratic women as 'weak, artificial beings' who 'undermine the very foundation of virtue and spread corruption through the whole mass of society.'

Wollstonecraft insists on maternal breastfeeding, which in those days was not instead of bottle-feeding (usually fatal before sterilization and safe drinking water) but instead of paying a poorer woman to breastfeed, which she finds objectionable because it allows working-class women to influence middle-class children at a formative stage as well as because it is an exploitative practice. Don't leave your baby with the servants, they'll teach her bad words and bad thinking. What else do you think your own breasts are for? Yes, it might be hard, try harder. Women should eat enough not be conspicuously fragile (only doing it to get attention)

but not enough to suggest pleasure in food (greedy, self-indulgent). 'A moderate quantity of proper food recruits our exhausted spirits,' she instructs, '. . . but, if we exceed moderation, the mind will be oppressed, and soon become the slave of the body.' The enslavement of mind to body is among the greatest fears of the Age of Reason, and, in 1790s London, with the transatlantic slave trade and the campaign against it at their height, the racial element of the fear is plain: no one used the terminology of slavery without its literal meaning close to hand. Whiteness, and especially white femininity, is founded in control. Even for an abolitionist writer, to lose control of one's appetite is to lose control of one's mind, to become a slave, to become Black, like mixed-race Bertha Rochester, fat and mad in the attic at Thornfield fifty years later. Wollstonecraft, like most of her liberal contemporaries, opposed the transatlantic slave trade, but she lived, read and thought in a culture rooted in slavery, genocide and colonialism. Some of us now have better tools for thinking about that culture, mostly tools made by scholars of colour working on race theory and post-colonialism, but its violence remains foundational and not always easy to see. Wollstonecraft's ideal of white femininity existed in unacknowledged opposition to white people's ideas about Blackness.

You have read some of the scholarship on race, gender and the body, learnt how 'self-control' is often a metaphor for or symptom of the control of others, the corollary or shadow of power. Whiteness fetishizes self-control as the justification of domination; it's obvious, if not to Wollstonecraft, that the politics of the body is not limited to gender.

You know that the shared narratives of eating disorders, misogyny and white supremacy make diet culture doubly harmful to women of colour, invited to erase themselves twice, simultaneously hypervisible and invisible where you pass quietly in your thin white privilege. You remember Sabrina Strings' *Fearing the Black Body*: 'abstemiousness in England during the eighteenth century laid the groundwork for moralizing surrounding the oral appetites that would be seen in subsequent eras.' You read Kate Manne's *Unshrinking*: 'Fatphobia is not only rooted in racism; it continues to uphold it. For one thing, it gives privileged – and thin – white elites a way to believe in their superiority to other groups while maintaining plausible deniability of their racism and classism.' You have been avoiding this thought, that your single-minded pursuit of thinness and self-control constitutes a performance of whiteness, brings you into communion with racist as well as misogynist ideas. You don't think you find fatness repellent, you don't think you believe that thinness is superior to larger bodies, but you certainly act as if you do. You can see exactly how the moralizing of health and strength and thinness complies with supremacist thinking; you just can't stop behaving as if you agree. Your eating disorder has made you a hypocrite. Your integrity, your wholeness, has failed.

Wollstonecraft failed too. Like Virginia Woolf, she went into the river to die, but because her nearest river was the Thames in central London she was seen in time, pulled out and lived a few more years until she died of an infection following the retained placenta of her daughter Mary, future author of *Frankenstein*, which is another book about bodies,

judgement and control. Wollstonecraft behaved inconsistently, couldn't meet her own standards, couldn't hit the one true note of moderation in love and food and money. She was damned if she did and damned if she didn't; she published and she was damned.

She took up space and she paid for it. In reading her, her rationalism, her whiteness, her puritanism, her ability to read but not defy the cultural forces driving her crazy, making her complicit, you read your mother, and yourself.

my hound

You are slow to tell people in your new country about it. About the unravelling, the hospital stay, why you bring a home-made lunch to the faculty club and phone up restaurants in advance to request green salad without dressing, why you wear a concealing swimsuit ordered from a designer of sportswear for Muslim women. Your old friends know, in your old country. Turns out they knew all along. High-functioning anorexic, they say, all these years, always had to remember your food and body stuff was about you not me, bit worrying sometimes but mostly you seemed to have it under control. (You find this perversely funny, the idea that you had your need for control under control.) You, who thought yourself so introspective, your life so well examined, are surprised. You were fine, weren't you? You ate everything – well, nothing fried, not meat, not fast food, not pastries, not much you hadn't cooked yourself. But chocolate, the darker and more intense the better, and your own low-sugar baking. Ice cream, especially chocolate ice cream, which you had once believed was forbidden to girls. Peanut butter, likewise, daily. You confided yourself to markets and restaurants all over the world, went round rural Japan eating whatever was put in front of you with curiosity and delight. For years you cooked joyfully, abundantly, paying attention, as if your wolf trotted with you from fridge to counter to

stove, as if you were dancing with wolves in the kitchen, and you fed everyone, children and friends, colleagues who'd missed the train home, graduate students having a bad day, there was always enough for an extra body.

There isn't now. You cook not-quite-enough, use no oil, no cheese, halve the sugar. You serve your family amply, so there's little left for you, and fill up your plate with raw greens which you guard jealously and resent anyone else eating. You have to stop inviting people to dinner, because you can see that your cooking is no longer good, that no one wants vegetables cooked without fats or cakes made with wholemeal flour. These are new people, new friends. They don't know who you used to be.

You start to tell people. You're writing about it, after all. These are things that happen, and so we need words for them. There is an art to the howl, to writing *de profundis*, *in extremis*. Art is not required to be tranquil.

E, who will become a good friend, a partner in thinking and reading and craft of all kinds, listens and then sends you a poem, May Swenson's 'Question'. It becomes an incantation for you, a mantra.

Body my house
my horse my hound
what will I do
when you are fallen

Where will I sleep
How will I ride
What will I hunt

Where can I go
without my mount
all eager and quick
How will I know
in thicket ahead
is danger or treasure
when Body my good
bright dog is dead

But you hate dogs, your friends say, when you recite it to
them. Not hate, you say, I'm terrified of them. It's a primal
fear that shapes your life. You can't go to a house with a
dog in it. You can't run in parks. You cross roads to avoid
even leashed dogs. When people bring them into cafés, you
have to abandon your coffee and leave. Dogs make you feel
like prey. You map their gazes, attend to their demeanour
as to that of angry men. You bend every nerve to move
silently where you think they might be, hide behind cars
and trees so they don't see you, note the wind direction so
they don't smell you. When this fails and a dog comes at
you, you lose your dignity, scrabble up trees or walls or
rockfaces if they are to hand, scream and panic in public,
and then dog owners echo the Owl. *Hysterical, neurotic,
you bring it on yourself, what do you expect shouting and
crying like that?*

Except that in the case of dogs, the Owl was magnificent.
It was the one fear you were allowed, the one situation in
which your feelings were permissible. Sir, you remember
him shouting at one owner whose dog was barking and
leaping as you screamed, wept, lost control of your bladder,

sir, if you don't get your dog away from my daughter this minute I will kill it with my bare hands, I am counting down, ten, nine, eight. He was shameless, fearless, his appetite for confrontation for once working spectacularly in your favour. I don't care, madam, how friendly your dog might be, it is frightening my daughter and you will control it or I will kill it here and now. Right through your adult life, long after dog owners lost whatever reluctant sympathy they might have had for a scared child, even when you were about to give birth and otherwise representing everything he found disturbing about women, he defended you. Your companions usually see your fear before they see the dog, some flicker of your attention, some tensing, some atavistic communication of threat, but he seemed to share your attunement to the presence of a dog and would place himself in the line of attack. Your defender, your protector. In those moments, those moments of abject fear, he looked after you. You imagined him horsed, armoured, sword-wielding, yourself precious and important to him, your vulnerability answered by care rather than shame.

And so perhaps dogs have remained the antagonists of safety, the repositories of all you fear, carriers of the terror and disarray you were not allowed in other contexts. Dogs want, you think, to eat you up, to annihilate you, and no one is willing to stop them, there is nothing between their devouring fury and your vulnerability, the only people who can control them refuse to do so however distressed you become. And then you remember the nightmares that were not nightmares, the way the Owl comforted you then, with his wolves which must surely be the forebears of your wolf.

For you dogs are aggression and violence incarnate, they are other people's ids running loose on the streets, performances of the repressed. What would Freud say, you wonder, about their proxy acts of defecation and rage?

Body my good bright dog.

Could you befriend your body, as the Owl befriended the wolves?

three mountains in Italy

I: THE WEIGHT OF WATER

You did not stop climbing mountains. In some ways it seems obvious that you would never have laced another boot, never unfolded another Ordnance Survey map, never set foot on another public footpath when there was no one compelling you, after all those years of hiking in all weathers, in all states of body and mind, regardless of hunger and tiredness, as if you had spent your childhood weekends and holidays fleeing an approaching army. It would have been Adolescence 101 to stop, to take instead to the shopping malls and sports stadia or wherever it was that normal people went to have fun, to eat burgers and chips for lunch with everyone else.

You didn't. At university in the south of England, you pined for the Pennines, the Lake District, the Yorkshire Dales, the austere landscapes that are still, after an itinerant and transnational adult life, your closest approximation of home. You assumed that the only reason the friends and boyfriends of your early adulthood didn't spend their days climbing mountains was the regrettable absence of such landscapes from southern England, and that they would want to spend as much time as possible in the poor simulacra of the Cotswolds, the Fens, the Downs and whatever

other weak shadow fell within reach. In most cases you were, approximately, right; among the offspring of the European intelligentsia who were your natural allies, the habit of hiking was ingrained. Most of you had grown up in families referred to by your mother in a moment of self-awareness as 'public sector ascetics'. Your parents owned large, shabby houses or – in the cases of Amsterdam and Berlin – apartments, which they couldn't or wouldn't heat. Put another jumper on, probably hand-knitted from scratchy wool, or go out for a brisk walk if you're really cold, with the implication that your claim to be cold is probably the fiction of boredom or attention-seeking or moral weakness. They regarded cleaning as a petit-bourgeois preoccupation; you could rebel by washing the bathroom floor. Despite the high value placed on intellectual life and exam results – you were not aristocratic, you would all have to pay your way in life – it was better, healthier, to be outdoors than in, better to be moving than at rest, better to be making your own fun than spending money.

You can mock this thinking. You can locate it historically, culturally, in relation to race and class and geopolitics. Your and your friends' parents had good reason to believe in the welfare state, in public service and in education. They had been born, most of them to working-class, socially aspirant parents, in the early days of post-war Europe, educated by states that selected a few children for scholarship, housed and fed by the state through their own university careers. They had received free and good healthcare all their lives. When you, their children, were born, they had additional state benefits and support. Many of your grandparents had

not finished secondary school, had survived cold, hungry childhoods at the sharp end of the 1920s, and they had grasped every chance to make better futures for their children, your parents, in the mid-century socialist rebuilding of European nation states. For you and most of your friends, one of the consequences was that your own lives and assumptions were utterly alien to the grandparents who had devoted themselves to making sure that your lives would not be like theirs. You had the privilege for which they had worked and sometimes they resented your difference. (God forgive your fifteen-year-old self for correcting the Latin pronunciation of your grandfather who had left school at twelve.) The upward social mobility for which your grandparents had worked very hard separated them from their children and grandchildren.

Your friends' parents were the beneficiaries of the post-war idealism that, at least in Britain, worked well for a particular sector of the working class it was intended to help: hard-working, entrepreneurial, happy enough to see the social mobility of the few as the vindication of continuing social injustice for the many. Most of your parents, with faith justified by their own experience, went on to lives of public service: healthcare, education, civil service. They did not believe in luxury partly because they had always had, had always trusted that they would have, sufficiency. They could afford plain living and high thinking because they had a safety net. They owned their houses. Their pensions accumulated. Disposable incomes were modest, but there was no need to save for healthcare or education. You had all spent childhood holidays camping, walking,

travelling within budgets often smaller than necessity dictated, because unnecessary expenditure was in poor taste even if the money was there.

Hiking seemed more democratic, and therefore in better taste, than team games and other forms of organized fun because its modes of exclusion were invisible to them – couldn't anyone have a car, couldn't anyone learn to read a map and read the sky, couldn't anyone be or become physically capable of ascent and descent? Anyone who did not had only themselves to blame. You can analyse it all, but you continue, in practice, an adherent. You like mountains. You like weather. You like to be in motion, outdoors, under your own steam, and if you like these things for reasons you can locate historically, culturally, in relation to race and class and geopolitics, you still like them. Now your children like them too.

Your husband knew by the time you married that he was making a lifelong commitment to hiking. His background is different, dog-walking not climbing, woods and fields not mountains. He had been as thoroughly taught to read maps at school as you had at home, and though he never experienced the need to scramble to the top of a stony or muddy summit for ideologically questionable reasons regrettably related to colonialism, imperialism and the need to look down on everything, he was happy enough to go along with it most of the time. For some years, anything you could afford to do that took you all out of the house and made your children tired at the end of the day was a sensible pursuit.

And so like you, from toddlerhood your children walked the best landscapes available, by which you mean those

most like northern England and Scotland, wherever you were living at the time. You always carried ample food, like the Swallows and Amazons. You even copied Susan's menu-planning, Cornish pasties and home-made fruit cakes, apples and hard-boiled eggs, plenty of chocolate and nuts, not the kind of fusion wholegrain/ Mediterranean food you ate at home. You always stopped for meals and snacks, and from early on you equipped each child with a pocketful of small treats to be consumed at their discretion as you walked, no need to ask or tell. You carried extra clothes, sunscreen, sun hats and woollen hats, plenty of whatever might be required. You were reimagining, re-inventing, what it meant to care for children on the hills. Your wolf walked at your side. Hiking became your successful family activity, one of few pastimes all of you enjoyed as the boys grew up. At first, the adults planned short, easy routes with places to play and explore along the way. Later, you encouraged the children to manage more adventurous terrain and longer days. When you could afford it, you took a summer holiday in the Alps, often hiking between mountain refuges where you joined other hikers at the dinner table for soup and dumplings, sausages and potatoes, apple cake and ice cream, the Alpine versions of Swallows and Amazons food, served in quantities that satiated even growing teenagers spending long days making steep ascents. The hostel staff and other guests took it for granted that hikers would be hungry and should eat, and though you were always careful to limit your own portions and avoid meat, you accepted the premise with relief. It was a less austere, more sociable rendition of your own childhood holidays camping

wild in similar places. In the last few years the boys have wanted to go higher, further, faster, as you find yourself thinking it would be nice to be back in time to have a cup of tea and read the paper before dinner.

The first summer after lockdown, you return to the mountains between Austria and Italy. Things have changed since your last family holiday, one son adult and the other well on the way, both eager and competent in independent exploration. We'll have some family mountain days, you say, and some days where everyone can do their own thing. The holiday takes on a new shape, a looser fit. You still provide meals, but some days the boys are out at lunchtime, finding their own supplies. They don't need a Susan any more. Some days your younger son sleeps until breakfast is lunch. They are on hand, strong-armed, when you make ridiculous purchases of watermelons and ripe peaches two bus rides from your rented apartment. This could be all right, you can see, this new mode could be easier than the old family holidays where you organize everything and cook everything and book everything and feel responsible for everyone's moods and experiences and castigate yourself for spending too much or not enough money to buy other people's satisfaction and for the way your anxiety is spoiling their relaxation, because you could never really rise to Ma or Susan's example of calm. There's still plenty of all that, more than enough, but you're glimpsing another way of doing things.

You don't eat much, but the real problem is water. There's a heatwave across Europe. Even your fifteen-year-old sees

the need to set off early enough to reach the cooler altitudes before the day heats up too much to climb mountains, and you plan walks that keep you above 2,000 metres until the worst of the afternoon's heat has passed, but four people making that ascent in these temperatures still need a whole lot of water for the day. It doesn't matter, you remind the boys, if you run out of food towards the day's end, we're not climbing Everest here or even Mont Blanc and you always have sweets and nuts in the bag, but recreational hiking can go badly wrong if you run out of water on a hot day, because the effort needed to reach a water supply depletes your body to the extent that you may be unable to replenish before you get into trouble. Carry water. Once you no longer have water you don't expect to need, reroute the day's plan to find more water before you do anything else. Your husband thinks you're exaggerating, objects to the weight, but he didn't grow up hiking and for once you're adamant. You learnt these lessons. When we start the last litre of water is when we divert as far as necessary for more, you say. If all the bottles are empty at the end of the day, we cut it too close. It feels odd, to be insisting on abundance, to be digging your heels in over having more than enough of something, inconveniencing and displeasing other people for a sufficiency, you who will spit out a biscuit if you hear a family member approach, who will not eat for the duration of an intercontinental flight or a day's train journey for shame, in case the sight or sound or smell of your eating offends a stranger nearby. But the water is not for you, or not only for you. This, you realize, is a matter of not being duffers, not drowning. You are not second-guessing yourself,

not consulting the voices and watchers in your head. No experts make podcasts telling everyone how to restrict fluids. There is no chatter, no one chanting at you that you're being greedy and demanding and making a nuisance of yourself, even though you are – as far as your husband is concerned – doing exactly that. You feel as if you've changed roles, put on someone else's mask. No, you say, the water is not negotiable, we carry it, enough of it, as much as I say is enough, or we don't go. Is this how it feels to be a man? (No, you know that, not really, men also suffer self-distrust and shame and anxiety, you mean: is this how it feels to be a patriarch, an expert?)

One day you are hiking at a lower altitude than usual, a long but easy walk tracing a river from its mountain source all the way down the wooded valley to the main road and the main river and the train station. You planned the day for the geology, for the whole Alpine landscape writ small in a day's walk, and you planned in rebellion against your upbringing because there's a hikers' bus to a mountain refuge a few hundred metres below the summit, allowing a brief high-altitude ascent followed by a whole day of walking gently downhill. *Oh, straight for the easy option, the lazy shortcut, what else would you expect of her.*

You start among jagged rocks. It's arid up here, above the trees, above the grass, above anything green, and the sky is so thin you can see the black at the top of the blue and your breath is short as you climb the faint path around outcrops of red rock. You're already thirsty. Drink, you say, drink all you need, we'll refill at the hostel on the way down, but even so you watch worriedly as your older son drains

a half-litre bottle. You reach the top – inevitable self-congratulation, your inevitable mini-lecture on the ideological problems of summits – drink some more water, head on down into the morning.

As you pass the hostel you go in to refill the bottles and buy more water. There's a glass cabinet holding chocolate cake, apple strudel, cookies, plum tart. You allow yourself a moment to gaze. There are groups of young men in Lycra, probably the owners of the bicycles piled outside, chatting as they fuel themselves with cakes and cream for the next stage. They are, of course, the rightful owners of such things. Two young women share a piece of Apfelstrudel at a table by the window: girls' cake, mostly fruit, carefully halved. You can never understand how your husband and sons, who could eat all the cakes and pastries and ice cream they want whenever they want them, can walk unmoved past so much pleasure, not even bother to come in and look. (*Exactly that*, your therapist says, *preoccupation is the consequence of restriction, if you ate enough you wouldn't be fascinated by cake.* But you know that you have always been fascinated by cake, that your love of cake is an innate moral failing, not a symptom of deprivation.)

They're sitting outside in the shade, putting on more sunscreen, not pleased to see another two kilos of water. I'll carry the bag, you say, but we need the water, you really don't want to run out, the only reason you think it doesn't matter is that it hasn't happened. Your men exchange glances, sigh, put on their sun hats and you set out again. You don't care. You know you're right.

You hike across the high plateau to the sound of goats'

bells. The whole landscape, the whole continent, is drier than it should be, but up here the pasture is still green, the Alpine flowers in bloom. Unlike in England and Ireland, you can still hear the meadows: bees, crickets, birds, and there are still butterflies attendant on long grass and flowers. The stream trickles around its wide bed, as if someone has left a tap running higher up, no chuckling or tinkling, its bedstones dusty and marked by the feet of goats and birds. Sweat runs into your bra. The boys stop to drink and stop again, finish the half-litre bottles and start on the next ones. You're pacing yourself more carefully, maybe 300 ml down, more would be good. Your husband is not drinking, proving his point.

You come to the treeline as the day's heat rises. In your plan, you'd reach shade at about this time, and walk under the trees until you reach the village, where there's a café and a shop, late in the afternoon. On the map, the path runs at the edge of the wood but inside the trees. On the ground, it runs right above the river, a few metres outside the trees, and the angle of sun puts you in its glare. You're chatting, it's fine, you're all in good health, strolling down-hill very comfortably within everyone's exercise tolerance and as long as you stay hydrated and protect your skin the temperature is a wholly manageable risk. It's pleasant after a few days of more challenging hiking, this easy walk down a well-signed path wide enough for comfortable conversation, the river bubbling and gleaming beside you. Across it, rocky slopes rise. Classically picturesque, you say, and then find yourself explaining the cultural history of the sublime, the picturesque and the pastoral. So it's basically a function

of altitude, says your son, who is studying engineering. Sublime above say 2,000 metres, picturesque between about 800 and 2,000, pastoral below. In the Alps, you say, more or less, away from the cities; doesn't work elsewhere, it's a western European idea, and you start imagining a map with contours and shading indicating the aesthetic tendencies of the landscape. Urban realism, surrealism, industrial sublime, the kind of pretentious silliness you enjoy, and between that and the courage of your conviction about the water you find that when you stop for lunch, food seems like a good idea. You sit on a log where insects live and eat a cheese sandwich and an apple like everyone else. It was not clever of you to bring a packet of chocolate biscuits, now a packet of warm ooze and biscuit-bones the boys still want to open. When you take off the rucksack, the back of your shirt is wringing wet. The boys' T-shirts are dark and clinging. The bottles filled at the hostel have sucked in their sides like women walking around a swimming pool. You share more water, pick up the bags, set off again. If it comes to it, you think, there's the river, but it's not a great idea to drink untreated water flowing slowly downstream of sheep and goats.

You're down to the last half-litre when you come out onto the road. There's a hotel and restaurant set back under the hill, and outside it a fountain and trough. These fountains and troughs stand in every village centre and often at trail-heads and crossing points, and there are frequently walkers refilling bottles. This one, however, is clearly on private land, part of the hotel. You walk up to the hotel, dusty, sweaty, wearing a sun hat you wouldn't choose for polite society.

There's no one around. You cross the veranda where tables are set, open the door, peer into the hall. There's still no one around. You go back out and start filling bottles, your younger son hovering, anxiously convinced that you're doing something wrong or embarrassing, your older son capping the bottles as you fill them and handing you the next.

A man in a waiter's dark suit and white apron crosses the grass shouting. He must be speaking German or Italian, both of which you understand, but you can't even distinguish the language. He's still shouting. I'm sorry, you say, I'm very sorry. You say it again in German, in Italian, and then ridiculously in French and even more ridiculously in Icelandic, one of very few phrases surviving from the year you spent there a decade ago. He's still shouting, German, something about coffee and soup. We can pay for the water, you say in German. No, he yells, I don't want you to pay, you wouldn't come in, you wouldn't even buy a soup or a coffee. It's thirty-five degrees, soup and coffee are the last things you'd want. I did go in, you say, I saw no one, I'm sorry. I'm very sorry. *Entschuldigung*, forgive me. *Es tut mir leid*, literally, *it makes suffering for me. Mi scusi*, and then you remember *è colpa mia*, it's my fault, as if that wasn't obvious. *Sono desolata*, I am desolate. In all your languages you don't have enough words for how sorry you are, for how much you need to propitiate this male anger, how much you need to make this stop. Let me pay you for the water, you plead, in German, Italian, French. He spits on the ground between you. He's a manifestation of the voices in your head, he knows the score, and he's here, for real, beside you, in front of your sons. You don't give money for water, he says, I

don't want your money, you come in and you order something, a coffee at least. You look helplessly at your husband, who is standing outside the hotel, not getting involved. To be strictly fair, not speaking German or Italian, though it must be clear enough what's going on. You don't want a coffee. You don't want to sit in a hot dark room with this angry man. I'm sorry, you say, starting to back away with a half-full water bottle in your hands. I'm very sorry.

You're still shaking as you return to the road, stuffing the ill-gotten water into the bags. I would have paid him, you keep saying, I'd have paid him a lot to stop shouting at me, I wouldn't have minded paying. He didn't want paying, your husband says, he wanted customers. Did I say it wrong, you ask, do you think I used the wrong tense, I'm never sure how formal I'm being in Italian, I don't really speak it. It's not your grammar he doesn't like, your husband says, he just wanted you to order something. I'm sorry, you say again, I'm really sorry, but we were nearly out of water, there's another five kilometres at least and it's so hot, I'm so sorry.

After a bit your older son puts his hot hand on your sweaty shoulder. Mum, he says, the innkeeper will always be angry. But I would have paid, you say, I didn't want a coffee and anyway there was nobody there. Yeah, your son says, and he's still angry. The innkeeper will always be angry, you have to choose how much you think about it. About all the innkeepers, you think, all the fathers, all the experts, all the enraged men who can't or won't stop shouting, for whom you can't make yourself small enough or quiet enough or absent enough. All the dogs, barking, in your head.

Wolf? Where are you, wolf?

You keep going, come to the town where the others have ice cream and your husband, at last, drinks some water. You take the train, plod up the hill to the apartment where you wash the hiking clothes by trampling them in the shower because there is no washing machine here, start the evening's cooking. You feel hemmed in, trapped, don't want to eat. In your head the innkeeper is still shouting, and you're still caught between trying to propitiate an angry man and needing water for your children even if they're adults, and you still know you have to prioritize water for the children but the man's anger is ringing around your head like a fire alarm in a lift. You can't win, you can't get away. Mum, your son says, watching you move salad around your plate, somewhere in the world there'll always be an angry innkeeper, you still need your dinner. Yeah, you say, I'm not hungry, too much sun, probably. You have heard him, you just don't know how to eat right now.

You run further than usual the next day, set out at dawn, see the sun edge over the hill and the shadows form. There's dew on the grass, cool on your legs, birdsong, no insects yet. No cars, no people, the hills and valley all yours. You run up the mountain, through the dark pine woods, back across the meadows as the farmers are starting the milking, leading cows from the fields to the barns. Fruit ripens in the orchards along the farm roads, grain stands tall in the valley. It's a good place for thinking about food, but you are listening to a science and nutrition podcast. You almost stop, if your feet weren't so settled in the rhythm of the

'fat-burning zone' you would stop, when one Ivy League science researcher asks the other about the evidence for the long-term effectiveness of the intermittent fasting regime she imposes on her patients. Well no, says the first scientist, it probably won't work in the long term but nor does any diet, we all know that. But if we all know, you think, if the researchers know what the evidence says, if they agree that intentional weight loss doesn't work and never has, why do they go on requiring it – even so, when you come back to the apartment their voices have trickled through your ears into your brain. No breakfast today. Stay in control. Make up for the white flour in yesterday's bread roll.

You make breakfast for the others, pancakes because you're on holiday and you have new-laid eggs and creamy milk from the farm next door. You breathe their scent, don't taste. You make yourself a cup of mint tea. The boys pack lunches and snacks for their adventures and you watch, hoping for and fearing broken biscuits and crumbs of gingerbread you might eat later, or might not be able to stop yourself eating later, when the window opens. Fragments and remnants of forbidden foods sometimes feel dangerously possible, as if the experts might not notice, as if the difficulty in counting crumbs means they don't exist and won't be held against you. I need to work this morning, you say, by which you mean that you ran so far you lack the willpower to compel yourself to further physical exertion without food. The experts chide, remind you of their own capacity to exercise and put in a day's research while fasting. *Actually we find fasting improves athletic performance, actually we concentrate better without food.*

But there's also, now, your therapist's voice: *however hard it feels, you still have to eat. Nothing bad will happen. You can't think or reason your way out of this, you just have to eat. How does it feel, to be refusing to go out with your husband on a summer morning in Italy because you ran so far and your eating disorder won't let you eat enough to walk down to the village?* You don't want to think about that.

Your husband takes a book to the hammock in the orchard; you sit in the bedroom with your laptop, too hungry to write because you don't concentrate better without food, distracting yourself until you're allowed to eat. After an hour or two he says he's going down to the village and do you want anything, would you join him for a coffee at the café in the square? You're too tired to walk in the sun, and also if you go to the café you'll see the cakes and if you see them you'll want them, and though you haven't eaten a cake for a couple of years you don't trust yourself when you're as hungry as this. No thanks, you say, I'm busy, you go, have a nice time.

He's not back when the eating window opens so you have to wait, because if he comes in and finds you eating he'll know greed got the better of you, and anyway the longer you wait, the smaller the window and the less likely you are to lose control. *Don't conscript me into the voices in your head*, he'd say, *I'm not singing from that hymn sheet.*

You know, your therapist says, *it's the need for control that creates the fear? You're desperate for food because you haven't eaten, that's all. He wants you to eat, he'd be happy to come back and see that you've made yourself a sandwich.*

And you shouldn't be fasting, you're not trying to lose weight, that's not what we're doing.

When he comes back, it takes him another half-hour to suggest lunch. OK, you say, if you're hungry, sure. I had cake with my coffee, he says, I'm not all that hungry but it's lunchtime, we should eat. You watch in dismay as he makes himself a small sandwich and slices a peach, which means that you have to have half a small sandwich and half a peach and that will have to last until you can have two rice cakes at half past four. That's not enough lunch, he says, how far did you run this morning? It's fine, you say, it'll do, I'll manage, you're not having much either. It's not a competition, he says, you eat what you need, what I need is different. But you're a man, you say, men eat more, everyone knows that. Most men, he says, are bigger than most women and therefore in general, other things being equal, need more energy to do similar things. In this case, you're comparing a woman who's run twenty kilometres and not eaten for eighteen hours with a man who's had a good breakfast, sat in a garden and sauntered off for coffee and cake, of course you're hungrier than I am. But hunger is no excuse, not for a woman, you think, the experts are perfectly clear on that. You do know, he says, there's nothing intrinsic to masculinity that burns calories? You know the Y chromosome isn't some magic power plant fuelled by cakes and ale?

You look at him. Fuelled by steak, you think, by red wine. By the chocolate bars advertised for years as 'Not For Girls'. By the partridges with all their retinue of sauces and salads, the sharp and the sweet, served to the men at Cambridge colleges in *A Room of One's Own*.

No, you admit, I didn't know that, or at least I didn't believe it. Obviously being male requires more resources than being female, it's common sense. *Women have served all these centuries*, Woolf murmurs in your ear, *as looking glasses possessing the magic and delicious power of reflecting the figure of man at twice its natural size.* Not, you know, that your husband has any taste for such magic. You remember that women were allowed half of men's calories in the diet books of your teens, without reference to height or activity, as if the Y chromosome were exactly a power plant fuelled by cakes and ale. Do men not after all get paid more for doing the same work as women, are their pensions not bigger, their portions of everything – space, budgets, food – larger? Men need the fat of the land or they'll shrivel up and die and then where will we be? It's only natural. Or how our ancestors have always lived since time immemorial, since the olden days—

Call yourself a feminist?

You accept a commission to write about an eco-resort in Lombardy. You love these travel writing gigs, which have brought you some of the happiest memories of the last few years, taken you to places you would never otherwise go while requiring you to pay attention unadulterated by anxiety and self-doubt. As the hospital psychiatrist observed, you function just fine for professional purposes, which means that sometimes work gives you a break from yourself, invites and requires confidence as well as competence. This time the food is important, all from close by the nature reserve, prepared in traditional Lombardy ways which tend to be long on cheese, butter and red meat and short on wholegrains and raw vegetables. You think you can manage well enough to make a professional job of the restaurant reviewing required. You've done it before. One bite is enough to describe flavour and texture.

In the event, you struggle. The resort is everything prom-ised: wooden lodges on a hilltop with a reception and restaurant in a converted barn. Drivers have to leave their cars at the bottom of the mountain and phone for the rattling Land Rover to take them to the top. Once you're there, it's hard to leave and there's no reason, really, no need, all meals provided, a swimming lake and a tennis court and a whole mountain to explore, plenty of places to sit and read. It's all done with taste and conscience. The staff are attentive and

friendly, small wants anticipated. You can see the woods and the stars from your bed.

Don't you dare complain, not one word, such luxury wasted on you and you're not even paying, you're actually being paid, how dare you, who do you think you are, do you have any idea—

You remember your friend T saying once years ago, when you were knotted with remorse about leaving your young children so you could speak at a book festival where you would also spend time with friends, and knotted again by guilt at the undeserved good fortune of the travel and the opportunity, *it's sad that you've achieved the success you wanted and you get all these invitations to cool places and you feel so bad you can't enjoy it.* Does your self-reproach alleviate one mote of injustice? Chatter is not activism. The ego's noise changes nothing outside your head and in fact a quieter mind might have more resources for making change, or making art, or both.

You realize that the premise of the all-inclusive resort, eco-friendly or mass-market, is a form of care, if not a return to the womb at least a return to an idealized childhood. A holiday is always a fantasy and clearly for many adults the cessation of responsibility offered by the all-inclusive resort has deep appeal. Be a child again, play, rock up for a meal whenever you feel like it, eat as much as you like. There is abundance. Guests (customers) pay in advance for the fantasy of a week or two without money, without having to acknowledge that care is purchased. For some adults the situation is as delightful in practice as in imagination; your grandparents, prosperous at last in retirement, loved to take

cruises, gloried in being served and minded, in being able to pay to be served and minded, after lives of service and minding. For you the return to childhood is disastrous. You cannot tell care from control. All-inclusive is all-seeing, under surveillance, dependent. You have miles of woodland to roam and run unseen, but there is no centre of civilization within walking distance, nowhere you could buy food unobserved, no way out. No possibility of secret eclairs here. You are criminally ungrateful.

You get up as the sun rises over the mountains and run the forest trails. Every morning there's fresh wolf poo in the same place, and prints on the dusty track; every morning you hope to glimpse the wolf. Owls – real, feathered ones – conduct conversations across the hillside in the night, and for the first time you understand why they are said to laugh. You take a yoga class by the wooded lake but it's not hard enough, there's no work, and the injunction to relax sends you as ever into a tightening coil of panic. You do not relax. You are not compliant.

You cannot eat. If you did, the staff would see your greed, know the secret shame of your gluttony. Better to starve yourself than wait for someone else to starve you. Your only power as a dependant is to hurt yourself harder first. *How dare you, you know you don't deserve any of this? You know one fine day everyone else is going to realize that you're mad, that you ought to be locked up?* You know that the staff in a good hotel have no interest in depriving their guests of food and no reason to care who eats what, that any additional attention paid to your plate is because they know you're writing about the place, but in a position of de-

pendence you can't find the way to your adult self. You pick your way through the menu, requesting half-portions of salads and soups. You eat a quarter-slice of exemplary bread with a quarter-teaspoon of cultured butter. You eat half an olive, a crumb of cheese, a centimetre of cake – enough to write about flavour, texture, presentation – and you are hungry all the time, beginning again to see a large body in the big bathroom mirrors, the muscle and bone of two days ago disappearing hour by hour. You know you can't have grown so much, but your eyes and your brain conspire in misrepresentation, and if you're seeing what is not there, what other delusions could you harbour? The less you eat, the more you want food and the more you want food, the more frightening food becomes. You message your therapist, who says, *observe the difficult feelings and move through them, challenge the guilt and shame, remember that you end this vicious cycle by nourishing your brain*, because she saw very early that you value your brain and its function far more than your physical health, even though one of the constant rediscoveries of what you already knew is that bodies include brains, that thoughts and feelings are not Cartesian ghosts haunting the flesh on their way somewhere else. You know you write with your body, not only because the fingers pressing the keys as you sit there on the veranda of a lodge in Lombardy are running on the energy of the salad you ate beside the lake two hours ago, but because the consciousness deciding which word to write next runs on that same fuel. You don't much care about the thinning of your bones and the collapse of your white blood cells, but you do care very much about this experiment in writing,

about the work of choral prose, about the narrative of con-
tested memory, and you know that you can't think without
eating, you've proved it repeatedly, but still—

Insight doesn't naturally lead to action. Understanding
a problem is not the same as solving it. It is possible to exist
for a surprisingly long time with life-limiting difficulties
whose solutions are known. The human capacity for getting
used to things can be a terrible strength.

You won't think your way out of this, your therapist says.
*You won't feel your way out of it. If you wait to feel like
eating when you don't feel like eating it won't happen. You
have to act, and it will be difficult and uncomfortable and
you will have to do it consistently.* You know she is right. You
understand. But—

You and another guest spend a morning making cheese.
You look forward to it. You like making things and you like
cheese. You walk together through the woods down the hill
to a small farmhouse, where there is an old stone cowshed
and an old stone dairy. The cows glance up as you pass and
go back to their munching. The cheesemaker comes out to
greet you and you discover that your Italian, with its dual
sources in medieval poetry and cooking blogs – there's some
overlap between the Inferno and the kitchen – is more or
less up to the job. She is Rosa. She has lived on this farm
all her life and she supports herself by making cheese and
yogurt by hand, using the milk from her own cows.

You know in theory how to make cheese from researching
the food and gender book and because Ma makes it in *Little
House in the Big Woods*, when the Ingalls family still have
a cellar where the cheese can ripen. You and B put on sterile

aprons, caps and shoe covers, go into Rosa's workshop and scrub your hands. There's an electric heater for the milk, large enough to bathe in, but apart from that her tools would be recognizable to Ma. There's a stone trough, round wooden forms for straining the curds, a whisk strung like a harp for cutting them. The floor is stone-flagged, the windows high and facing the hillside to minimize direct sunlight, and though everything is clean the barnyard smell from outside drifts in. Manure, hay, milk, what goes in and what comes out: somehow reassuring.

Rosa explains slowly and clearly and, assisted by Ma, you translate for B. A churn is a *centrifugio*, which makes sense. Whey is *siero* (serum, you think, salute your glamorous Latin teacher across thirty years). Curds are *cagliata* (coagulated, thank you, Mrs Bankes). Rosa has already heated the morning's milk to blood temperature and added *caglio*, which must be rennet because that's what makes the *cagliata* coagulate in *Little House in the Big Woods*. You are enjoying this fast acquisition of a new vocabulary, the absurdly specialist expansion of very basic Italian. *Si*, you say, *capisco*. Your brain wasn't up to this six months ago. Rosa invites you to touch the curds wobbling now in their warm bath, the texture of *budino*. Pudding, you tell B, one of the rare Italian borrowings from English, mostly it's the other way round. I suppose there was never an Italian word because the Romans didn't have that kind of pudding, you say, I don't think they made much cheese, I wonder if there was a lot of lactose intolerance. In America, she says, we still use 'pudding' for a custard like that. You try to remember what 'pudding' means to the Ingalls family

but of course they rarely get dessert of any kind: pies, sometimes, when they have a cow for milk and butter, and an oven, and visitors come. Blackbird pie when the blackbirds eat the corn crop. You've always wondered if they were malnourished most of the time as well as the winter the trains couldn't run and everyone starved. Portions seem small, a slice of cornbread as lunch for a child who has walked three miles to school, a bowl of bean broth for dinner. Ma plants a vegetable garden every time they settle but some years they don't settle and anyway you don't get much of a harvest the first few months. Vitamin C, you'd think, would be an issue. Calcium, especially for Ma, five pregnancies and presumably years of breastfeeding. Rosa shows you how to use the whisk to cut the curds into a sort of cottage cheese, and then takes over when you're not fast enough. You and B reach deep into the vat, arms bared, scoop the curds into the cheese forms whose size and indentations you recognize in the finished cheeses in the cold store and from the hotel's breakfast buffet. Now we knead them, you tell B. *Impastare*, to make something into paste, though most European languages don't distinguish between paste, pastry and pasta, and eighteenth-century English cookbooks tell you to make a paste which is baked to become pastry. And eighteenth-century girls are warned off eating pastries, a greedy habit leading to worse kinds of sensual indulgence. You watch Rosa's hands. Kneading, yes, but not the movement your hands know for making bread. Rosa's kneading is more of a pressing, pushing the curds into the round flat shape of their form, no folding or pulling. You watch

and copy and you are happy to be making, doing, learning something new.

Rosa seals your new cheeses into vacuum bags so you can take them home, try to mature them in the fridge though really a cold, dry storeroom is required. You would love your cheese to come out like Rosa's but you know there are reasons why even inveterate home-makers of jam, yogurt and bread don't make proper cheese. (Why does Ma's cooking never go wrong? With no refrigeration, kitchen scales or thermostat, she must sometimes have had the butter go off, the bread bake too fast on the outside and not fast enough inside, maggots in the meat, and how was she 'putting up preserves' anyway, carrying glass jars – with screw-top lids? – across the prairies in a wagon?)

You stop by the cows again on your way across the field. B pats one, scratches its head, and you stand there looking at the sun on the grass and listening to the cows pulling and munching, to the birds in the trees around the field, thinking that this has been a familiar human soundscape for centuries longer than we've heard traffic and planes, that Europeans have been living, sleeping, eating, peeing and pooing with cows longer than they've been writing. You amble together across the meadow to the café at the visitor centre, where the staff set a table for you under the trees, with a view of the mountains and the sound of wind in the leaves. The waitress brings warm bread, salad, and a plate of Rosa's cheese in all its stages. There's a small bowl of the estate's honey and one of preserved wild berries, and for now, for this sunny moment, you're not scared, it's just good food in a good place. You spread fresh bread with ricotta

and honey. You take more than your share of the tomato salad. You try the berries with the harder cheese. You don't want the wild herb ravioli in a sauce of butter and white wine reduction, and you certainly don't want the chicken liver pâté or the plate of sausages B enjoys, but you sit at the wooden table in the dappled shade, breathe in the pine-wood and the wild flowers, take a second slice of bread and another sliver of cheese. There is the dairy, there are the cows, here is their meadow, here you are.

Sunlight, earth and water become grass becomes milk becomes cheese becomes you becomes walking and thinking and writing.

The moment is the opposite of anorexia.

On the last morning, you get up especially early so you can have a long run before you leave for the airport. Summer dawn is late so far south. If you had a head torch you'd use it, but your eyes adapt and it will only get lighter.

The sky is paler over the mountains to the east, but as the track enters the forest you're almost in darkness again and for once not listening to a podcast, enjoying instead the last of the woodland conversation, because a healthy wood-land is no quieter than a healthy hillside or cliff. The owls are still on the wing somewhere away to the north, up the hill, and there are small rustlers among the leaves and low branches; something bigger, deer maybe or boar, among the trees, and your own footsteps and your breathing settling now and behind them the iambic rhythm of your heart. You can mostly see the shape of the track ahead, outlined by darker branches, held between the raised arms of old beech

and oak trees, but you can't really see the ground under your feet, have to run slow and light for your feet to sense stones and branches. The air stirs, smells of night and green growing, and minute by minute, pace by pace, the sky behind the moving leaves brightens and colours take hold of the woods.

The sun is rising as you come to the clearing where the trail crosses open ground and you can see far over the Alpine summits, down to the wide flat valleys where scurrying windscreens are already reflecting its light. You stop, lift your face to the sun, let sunlight shine through the skin and blood of your eyelids as your heart and breathing slow. The crickets have begun their day. Sweat settles on your neck and arms. The smell of the land is changing already, toasting grass and seeds. You set off again, pick up the pace now you can see what's underfoot and there's the wolf poo, fresh, smelly, and a clear print on the dusty track. She's not far.

You run on through a tunnel of trees, following an old stone track around the curve of the hill. It's still cool and damp here, clouds of gnats in the still places and you fan your nose and mouth, cough and inelegantly spit insects onto the fallen leaves. Birdsong, everywhere, and your feet drumming their steady beat.

You loop the hilltop and pick up the broader track along the other side, in sunlight now, your shadow loping at your side, running above the high fence separating the fields of cows from the nature reserve where the wolves live in their bordered freedom, wilderness preserved. No cows in sight, but you're happier on the wolves' side. You know where you are, with a wolf.

Oh, and here. Here you are with a wolf. She's on the skyline, sitting, nose tilted, watching where the cows might be. You stop, want your sharing of this hillside, this sky, these trees and stones, to last as long as it can. You want her to howl. You want her to come to you. You want her to eat you up. Mother wolf, Romulus and Remus. Never mind the boys, wolf, let's found a city. Let's found a fucking empire, mother wolf. She senses your gaze or catches your whiff, glances, is gone. Because she's a wolf, she's not you, she's not yours, you didn't invent her or imagine her, she's not a metaphor, not a god or a monster, maybe not she at all.

She's real. Here you are with a real wolf, on the mountain.

III: PRECIPICE

A year later, you are offered an artist's fellowship in Italy. You didn't expect it. You didn't think you were the sort of person who gets such things, nor, with the family and the full-time job, the sort of person who can accept them. But the children are older now, and outside the teaching term you can work remotely. We'll make it work, your boss says, you should go. Your friends are envious. Aren't you a lucky girl? What a privilege, to have a room of one's own with all meals found, all housework done, for six weeks! You can live like an old-fashioned Oxford don, like Virginia Woolf with her servants. You have nothing to do but write your book, no distractions or demands, nothing but the life of the mind. Such luxury.

You should have known.

You prepare. The journey is complicated – bus, plane, bus, train, train, ferry. It is not possible to carry enough books for six weeks of solitude. You will have to read less and write more, or reread. You take books for rereading, but when you get there, you find Virginia Woolf in the library. You resisted Woolf at university. She belonged to the posh Londoners, the students who heard your accent and asked if you had indoor plumbing at home, if your dad was a coal miner. Modernism wasn't for the likes of you, with your northern plain speaking and romantic taste in landscape. You were more at home in the nineteenth

287

century, with its realist fiction and faith in progress, but now you meet Woolf again, take all seven volumes of her diary to your bed. If you can't write, you'll read.

But you cannot do it. You are not Virginia Woolf. You are not Mary Wollstonecraft. You are Susan Walker, Dorothy Wordsworth. You are a maker of well-turned dresses and wholesome bread. You feel watched and judged by the women employed to clean and cook for the artists. You become embattled over food, your vegetarianism causing offence. You can see that you are playing out the psycho-drama of your childhood, finding in the housekeeping staff the god-and-monster Jumbly Girl, but you cannot stop. Insight, as so very often, is of no discernible practical use.

You stop eating again. The housekeeper offers you nothing but long-boiled vegetables and fat-free yogurt, makes it easy to lose weight fast. Hunger comforts you. Bones comfort you. You get up earlier and run further, which also comforts you, and when your brain can't make fiction, which is most days, you hike up the mountains instead. You lecture the other artists, who are too busy making art to climb mountains, on mountain safety, on the need to carry a map and waterproofs and extra water and energy-dense snacks, to make sure someone knows where you are going and when you intend to return, but apart from the map you don't bother. Duffer best drowned. Duffer in search of drowning. No one to blame but yourself.

Not all the troubles, you see now, are ones you brought with you. There is no desk or table in your room. You find an old fleece blanket in the wardrobe and unfold it to sit on the floor and write, but the housekeeper objects to

bedding on the floor and scolds you. You hide the blanket and use it when you know she's busy in the kitchen. You walk an hour to the nearest supermarket and buy fruit and rice cakes, which you smuggle in your backpack and hide in the wardrobe. You refuse the housekeeper's rich food, her meat. She serves you absurdly austere substitutes, a plate of boiled fennel while the other artists, the real artists, eat pasta with sage fried in butter, fat sausages with roast potatoes, cheesecake. You eat half your fennel, mostly for the triumph of sending half of it back. You refuse dessert. You refuse wine. She serves you bitter greens while the others have gnocchi with parmesan and olive oil, roast chicken, ice cream and sugared berries. Bring it on, you think, amateur. Call me Jane, call me Goblin Market's Lizzie, *would not open lip from lip / Lest they should cram a mouthful in.*

You need to go home now, your therapist says, I'm really concerned. I'm fine, you say, I'm managing, I can't leave, everyone else is coping, there's no reason I shouldn't, I'm nearly halfway through. *You do know how lucky you are to be here, you do know what an astonishing privilege you're throwing away? Wasted on you, all this, she sees through you, you know, the housekeeper, she knows what you're really like, why do you think she knew to give you the room with no desk, you might have got away with it all so far but she knows, she knows you're a fake.*

You find spots in the garden where you can read and write. Was it you, the housekeeper says, who took the cushions outside? No, you say, though you both know it was you, everyone else works indoors like civilized human

beings, like the proper artists they are. The cushions will get wet, she says, they will get dirty, they are expensive. *Who do you think you are, taking up space, treating the place like a hotel?*

She finds you looking at the fruit in the fruit bowl. It's very expensive, she says, this year, and you are all eating a lot of fruit, so many bananas! She's right, you have been stealing a daily banana from the bowl, because your runs are now so long you miss breakfast. *Did you think it was for you, all that expensive food? Did you really?*

You're very dissociated, your therapist says, I don't think you know how slowly you're speaking. The longer you stay there, the longer it will take you to recover when you go home. Please book your ticket today. You know you don't have to stay, your friend says, you know nothing bad will happen if you leave? If you need help with the journey, your husband says, I'll be on the next plane, I can come and help.

The weather changes, rain. You keep running in the mornings and hiking in the afternoons but you can't sit outside with a laptop or a book. You sit on the floor and the housekeeper comes in and scolds you, and one day, after she has scolded you and left the room, something shifts. There's less air, less space. The walls have moved in, maybe an inch or so, not much. You go on reading, research for your new novel, but out of the corner of your eye you see another movement. There's no sound, just the rain falling outside. The room edges again, not a jerk but a step, an adjustment. There's still enough space, you think, and you go on reading, but then it happens again, and again, like a game of grandmother's footsteps, and you understand that

the room will continue to close and you have to leave but also you can't leave because there is nowhere you're allowed to be and the walls shrug again and you must leave but you can't

must leave

can't

can't leave

must

must now

can't

must

can't

and you try to keep reading

and the room steps in

and you have to get out but there's nowhere you can go, you could crawl to the balcony, it's barely a metre away, but then the only way off the balcony is over the parapet

which would make a mess

and the walls inch again and you have to get out

and this time you crawl to the door where you grab your shoes, ballet flats, no time for running shoes or hiking boots

and you're running down the stairs and out, fresh air, rain, up the track to the mountain and on, up the path

sliding a bit in these silly shoes, feet hurt by every stone, up, scrabble scramble, up, out above the trees

and here the path narrows and runs across the ravine, this is where the others won't go, too dangerous but it's not, you've walked this path most days, fine if you look where you're putting your feet, if you're not a duffer

but if you were going to fall, this would be a good place

if you wanted to solve the problem

anyone might go over here, wet day, slippery ground, silly shoes, even someone who wasn't a duffer, right here

you'd have to skid, to leave a mark like this one, and grab maybe at that branch on the way, to make it look as if you hadn't meant it, like the carvings you sometimes see in the Alps, *Er fand ein Bergestod*, he met a mountain death, strong young men usually, could happen to anyone, a nice tidy solution, slipped and fell in the rain

knew what she was doing in the mountains

had it coming

she'd even written a novel about it

asking for it

it's always a risk

probably for the best anyway

everyone better without you

right here like this

And what about your boys, says the wolf, who must have tracked you here, followed your fool's prints through the woods. Aren't you their mother? Even if they think it's an accident – and they're not stupid, your boys – doesn't do them any good, does it?

You remember what your friend S calls the small print on the birth cert that says stick around, at the very least don't off yourself, no offing, not any more, you can't do that. The boys.

better without you, what kind of mother have you been these last two years, you're leaving them enough money, adequately

*provided for, relief all round really wouldn't you say – take
a little run at it, don't even need to jump, one small step,
there you go, one foot and then*

– but the boys. The boys.

You walk away. The wolf trots behind you back down
the path to the house, where you check that the housekeeper
is occupied in the kitchen before you trail your dripping
self up her nice clean stairs. You take a shower, change your
clothes, go on reading. It doesn't occur to you to tell anyone
about the precipice, not until you talk to your therapist a
few days later. But doesn't everyone have these moments,
you say, isn't it common enough? I'll get over it, pull myself
together, nothing to make a fuss about. No, she says, it's
not common, I'm on the verge of coming out to get you,
book your plane ticket by the end of the day or I'm going
to intervene, I have to. You're not safe. No one's safe, you
say, who cares, what does it matter. I mean it, she says, let
me know when you've made the booking.

Looking back, for now, from a place of greater safety, you
think you'll always have a precipice behind the house, ivy
and foxgloves in the garden. You've always noticed, where
you might – plenty of places to walk into the sea near
where you live. Dark night, stones in your pockets, keep go-
ing long enough and the decision makes itself. Gaps in the
railway fence, low rail on the multistorey car park, but if
you cycle in Dublin, any taxi driver would do it, no bother,
you would only have to work slightly less hard at avoiding
them, if killing a cyclist would spoil their day they wouldn't

drive like that; possibly one of the reasons you continue to cycle in Dublin is that it requires a constant remaking of the commitment to staying alive.

You don't mind, you think, living like this, by choice, seeing all the ways out – *death hath ten thousand several doors* –

and choosing all the time not to take them.

Months later, you tell S you're writing about what she said about motherhood and suicide when you were in Italy and she says oh, I don't remember saying that, I remember when I talked to you that week you said Virginia Woolf was terrifyingly rude in her correspondence and I quoted Elizabeth Bowen saying some people ought to be left in the car like dogs and you said you were one of those people and I said surely you were more likely to be driving the car. Yes, you say, I remember that, but you also said about the birth certificate. If you say so, she says, it's the kind of thing I might have said.

Later still, you find Jenny Offil's *Dept of Speculation* on your shelves and wonder why, since you admire her other work, you haven't read it. You take it up to bed. Clean sheets, early night, wild wind outside. Halfway through, you read, 'Also she signed away the right to self-destruct years ago. The fine print on the birth certificate, her friend calls it.' You and S quote to each other from books all the time, once unnerved a friend by being able to prompt each other through long sections of *Jane Eyre* at a hen party, so if S did say it she would have been quoting. You were in no state to remember conversational citations, only S's voice

saying something funny and characteristic and true. And maybe Offil invented the line and gave it to her fictional narrator's fictional friend, or maybe she had a real friend who really said it and she borrowed it for a novel, and maybe your real-life friend invented the line in parallel to Offil's fictional friend, and maybe you're making it all up, because the only witness doesn't remember the conversation at all and you are after all a novelist.

Good line, anyway. Life-saving, in the right circumstances.

body my house

One of your students comes to see you. He has left Canada for the first time. He is homesick and lonely. He misses his boyfriend. When he left, he says, his boyfriend said don't you have your feet in Ireland and your heart in Canada. Take your heart with you. But it's really hard, he says, his heart doesn't want to cross the water. He's having to drag it, to rend and force, here, alone, away from his family and friends. It occurs to you, not for the first time, that an advantage of your upbringing was having little to miss, no home to pull you back. It was never hard to leave where you grew up, often unbearable to return. Hearts are not your preferred image, but now you imagine his heart pulsing on a surgeon's table in Canada. Explanted, not yet transplanted, and his heartless body here waiting to live again. You imagine a heart dragging across the land, dirtied and grazed, wormy blue veins trailing. I don't think you have to drag your heart, you say, dragging your heart doesn't sound like a good idea. You decided to be here, you say, so I think you have to make a way for your heart to come too. I think you have to make a safe landing place, so your whole self can take flight intact.

Le coeur a ses raisons que la raison ne connaît point, you think; one of Pascal's aphorisms you encountered for the

first time in your first week at university, scrawled on the door of a stall in the women's toilets in the Bodleian Library. *The heart has reasons whereof reason knows nothing.* You thrilled to the outrageous intellectualism of the eighteenth-century French on a bathroom door, even as you recalled the disturbed and disturbing images etched on the doors at school. Now you think maybe it was written by a young woman who like you, like many who pulled their knickers down behind that door, might have been elated to find at the heart of the Age of Reason this salutation of the heart's own logic. It's not a choice, between feeling and reason, between sense and sensibility. Feelings have reasons. Many reasons are feelings.

Your friend the opera singer has a new baby. The baby had a difficult coming into the world. He did not know how to breathe. He was in intensive care for a long time. There was not much care for your friend, and now she cannot let the baby out of her sight, in case – I know I have to, she says, I'll just have to force myself, I know it's not rational, my fear, I'm probably being neurotic. Rational isn't relevant, you say, your fear is true fear. I don't think you have to force yourself to leave your baby against your instinct, you say, I think you have to build a place of safety, which will be a better kind of hard work. I think you should show the baby, when it's true, that you trust him to keep breathing, not show him how to use willpower to force your way through the fear of loss and death.

◆ ◆ ◆

You tell your friend E, who gave you the wolf poem, about these conversations. See how you have changed! Yeah, she says, no shit, dude, life's not about punishment and discipline, restriction isn't the best way through the world. E grew up with barely enough food or money and an abundance of kindness. She still lives with forms of precarity – housing, employment – from which your various kinds of capital protect you, and also she has forms of security that you have never known. Now tell yourself, she says, you don't have to endure, instead you have to make safety in the place where you'd like to be. It's still work, it's not easy. You can still use all that willpower.

Safety at the table, you think. Safety in your blood and bones, in your muscle and fat, in your skin. Then you can act. Then you can write. Then you can make change.

Body my house my horse my hound.

You think about Virginia Woolf again, about the room of one's own, about that book's insistence on the importance of food for thinking. You have often said to students, it's not true, that the precondition of writing is the modern equivalent of five hundred pounds a year and a room of one's own, who has that, who has any hope of that? Think about your book while you push the pram, you've said, while you pull pints at the bar, while you fetch a different dress for the woman in the fitting room, and then when you have an hour to yourself late at night or before anyone else is awake in the morning you will be ready to write.

Write at the kitchen table, you've said, on the train, even on the bus it's possible. If you wait for a room of your own only people with property will write books. And in recent years you have felt the tug of hypocrisy, saying this, because you do have property now, a home, and it includes a room of your own, a tiny space in the roof with big-sky windows and cedar shelving, small and secret and full of light. You feel safe there. You write. And like you, Woolf knows her own luck. Financial security and space to make art are her desiderata, not preconditions, of women's creativity. Sometimes a metaphorical room of one's own will have to do, and one should hold out for but not anticipate a living wage for art. Woolf is thinking critically from a position of privilege, and her privilege offered little shelter from the voices in her head that called her eventually to the river.

It has been hard, writing this, not to be defensive, not to be forever saying how lucky you are, how loudly you wish to acknowledge that there can have been no serious suffering in a childhood of ballet lessons and private school, in an adult life of home-owning and secure employment; not to keep announcing how deeply you understand that the socio-economic advantages of your upbringing led directly to the socio-economic advantages of your adulthood, how well you know that without those advantages you would not be here now, writing this. The purpose of writing is not competitive suffering. The making of art is always both privilege and necessity, always dependent on other people doing other work in the kitchen and in the nursery and in the library, in the fields and the factories.

No making of art – or love, or war, or peace, or dinner – without a body, no body without food.

Come then, wolf, to the table, for soles with a counterpane of the whitest cream, for partridges with potatoes thin as coins but not so hard. Let's eat sandwiches of bunloaf, marmalade and butter, seed cake dried out after shipwreck and fried. Let's call at the inn for a goodish supper of ham and potatoes. Let us toast Woolf's fantasy of a woman writer invited to the scholars' feast, sharing the 'roast and its retinue' followed by 'a confection that rose all sugar from the waves', eating for good company and joy. 'And thus by degrees was lit, half-way down the spine ... the ... profound, subtle and subterranean glow which is the rich yellow flame of rational intercourse. No need to hurry. No need to sparkle. No need to be anybody but oneself.'

Body my house. A body of one's own.

Watch over me, wolf, while I eat.

This is, obviously, not a self-help book. I am interested in reading and writing as art, not therapy. Equally obviously, it is rooted in experiences which some readers will share. If you seek the therapeutic resources which this is not, some suggestions:

Better thinking about eating and the body

Cat Bohannon, *Eve*, Penguin, 2023

Emmeline Cline, *Dead Weight: on hunger, harm and disordered eating*, Picador, 2024

Aubrey Gordon, *What We Don't Talk About When We Talk About Fat*, Beacon Press, 2020

Christy Harrison, *Anti-Diet*, Yellow Kite, London 2019

Michael Hobbes and Aubrey Gordon, Maintenance Phase podcast at https://www.maintenancephase.com

Nigella Lawson, *How to Eat: the pleasures and principles of good food*, Vintage, 1998

Alan Levinovitz, *The Gluten Lie*, Regan Arts, 2015

Kate Manne, *Unshrinking: How to Fight Fatphobia*, Penguin, 2024

Tressie McMillan Cottom, *Thick: and Other Essays*, The New Press, 2019

Caroline Criado Perez, *Invisible Women*, Vintage, 2019

Chris Sandel, Seven Health podcast at https://seven-health.com

Evelyn Tribole and Elyse Resch, *Intuitive Eating*, St Martin's Essentials, rev. ed. 2023

Emily Troscianko, Hunger Artist blog: https://hungerartist.org

Jessica Wilson, *It's Always Been Ours: reclaiming the story of Black women's bodies*, Hay House, London 2023

Works cited

Louisa Alcott, *Little Women* (1868), Abbey Classics, 1954

William Allingham, 'The Fairies', *Poems of William Allingham*, OUP, 1967

Charlotte Brontë, *Jane Eyre* (1847), ed. Q. D. Leavis, Penguin Classics, 1966

William Buchan, *Advice to Mothers, on the subject of their own health: and on the means of promoting the health, strength, and beauty of their offspring*, T. Cadell and W. Davies, 1811

Edmund Burke, *A Philosophical Enquiry into the Origin of our Ideas of the Sublime and Beautiful* (1757), Cambridge University Press, 2014

John Keats, 'Ode to a Nightingale' in *Complete Poems of John Keats*, ed. John Barnard, Penguin, 2003

Edward Lear, *The Nonsense Verse of Edward Lear*, Penguin, 2012

Michael Moseley and Mimi Spencer, *The Fast Diet: the original 5:2*, Short Books Ltd, rev. ed. 2023

Sarah Moss, *Spilling the Beans: Eating, Cooking, Reading and Writing in British Women's Fiction 1770 – 1830*, Manchester University Press, 2009 (Since I wrote *Spilling the Beans*, I've developed better thinking about and knowledge of colonialism and race. I would do it differently now.)

Sylvia Plath, *The Bell Jar* (1963), Faber, 1995

Beatrix Potter:

> *The Tale of Peter Rabbit*, Frederick Warne & Co. Ltd, 1902

> *The Tale of Squirrel Nutkin*, Frederick Warne & Co. Ltd, 1903

> *The Tale of Mrs Tiggy-winkle*, Frederick Warne & Co. Ltd, 1905

> *The Tale of Jemima Puddle-duck*, Frederick Warne & Co. Ltd, 1908

> *The Tale of the Flopsy Bunnies*, Frederick Warne & Co. Ltd, 1909

Arthur Ransome, *Swallowdale* (1931), repr. Puffin Books, 1982

Irma Rombauer, *Joy of Cooking*, 6th ed., Scribner, NY, 1975

David Rosenhan, On being sane in insane places, *SCIENCE*, 19 Jan 1973, Vol 179, Issue 4070, pp. 250–258, DOI: 10.1126/science.179.4070.250

Christina Rosetti, 'Goblin Market', *The Complete Poems of Christina Rosetti*, Penguin 2021

Constance Spry and Rosemary Hulme, *The Constance Spry Cookery Book*, Dent, 1956

Sabrina Strings, *Fearing the Black Body: the Racial Origins of Fat Phobia*, NYUP, 2019

Alfred Tennyson, *In Memoriam*, ed. Susan Shatto and Marion Shaw, OUP, 1982

Leo Tolstoy, *War and Peace*, trans. Anthony Briggs, Penguin, 2016

John Webster, 'Dirge' from *The White Devil*; *Selected Plays of John Webster*, ed. Jonathan Dollimore, CUP, 1967

Laura Ingalls Wilder:

Little House in the Big Woods (1932), Puffin Books, 1963

Little House on the Prairie (1935), Puffin Books, 1973

Little Town on the Prairie (1941), Puffin Books, 1974

Naomi Wolf, *The Beauty Myth: How Images of Beauty are Used Against Women*, Chatto and Windus, 1990

Virginia Woolf, *A Room of One's Own*, Vintage, 2018

Dorothy Wordsworth, *The Grasmere and Alfoxden Journals*, ed. Pamela Woof, OUP, 2008

William Wordsworth, *Poems in Two Volumes, 1807* and *The Prelude (1805)*

ACKNOWLEDGEMENTS

I live a thoroughly (if not sufficiently) examined life. I thank all the friends who listen to and share my examination, even when it's late and they're tired. Some of their voices are here. Henrietta Blackmore; Cecily Crampin; Sharon Dixon; Elanor Dymott; Samir Guglani; Alyson Hallett; Finola O' Kane; Deborah Lee; Éireann Lorsung; Tina Lupton and Heather Love; Margaret Macdonald and our beloved, constantly missed Kathy Macdonald; Mary Minihan; Sinéad Mooney; Emilie Pine; Max Porter; Chantal Wright.

For the suggestion that led to the Wolf, Jan Carson.

For reading drafts, discussing and helping me to shape the book: Emilie Pine, Margaret Macdonald, Debbie Lee, Tina Lupton and Éireann Lorsung.

For meticulously designing a room of my own, Neil Crimmins of Cathal Crimmins Architect; for beautifully making it, Stephen and T. J. Gorman of Cruise Park Construction.

My colleagues and the students on the MA and MFA programmes at UCD have helped to shape my thinking about fiction, non-fiction and the lives of writers.

I would not have published this book without a publishing team in whose integrity and kindness as well as professional brilliance I have complete confidence. Sophie Jonathan's excellence covered every possible aspect of an editor's job and many beyond it. Mary Mount's encouragement and

interest made a big difference at an early stage and through-
out. It was a joy to work with Anne Meadows again. Camilla
Elworthy's kindness, wisdom and frankness accompany her
expertise (and joy in a cheese picnic). I thank Daisy Dickeson
for all her work on permissions, Andrea Henry for thoughtful
questions and reassurance. Lyndon Branfield for expert and
minute attention. In the US, my thanks to Jenna Johnson
and the team at Farrar, Straus and Giroux, and to Jennifer
Carlson at Dunow, Carlson and Lerner Agency.

I thank my agent Anna Webber at A. M. Heath for her
decades of friendship and care as well as her work.

I thank Éireann for the poem.

I thank Dr M.E. for her kind and imaginative care of my
teenaged self.

I thank Dr Omara Naseem for saving my life and my mind.

A NOTE ABOUT THE AUTHOR

Sarah Moss is the author of the novels *The Fell, Summerwater,* and *Ghost Wall*. These and others of her books have been listed among the best of the year in *The Guardian, The Times* (London), *Elle,* and the *Financial Times* and selected for *The New York Times Book Review*'s Editors' Choice. A fellow of the Royal Society of Literature, she was educated at the University of Oxford and now teaches at University College Dublin.